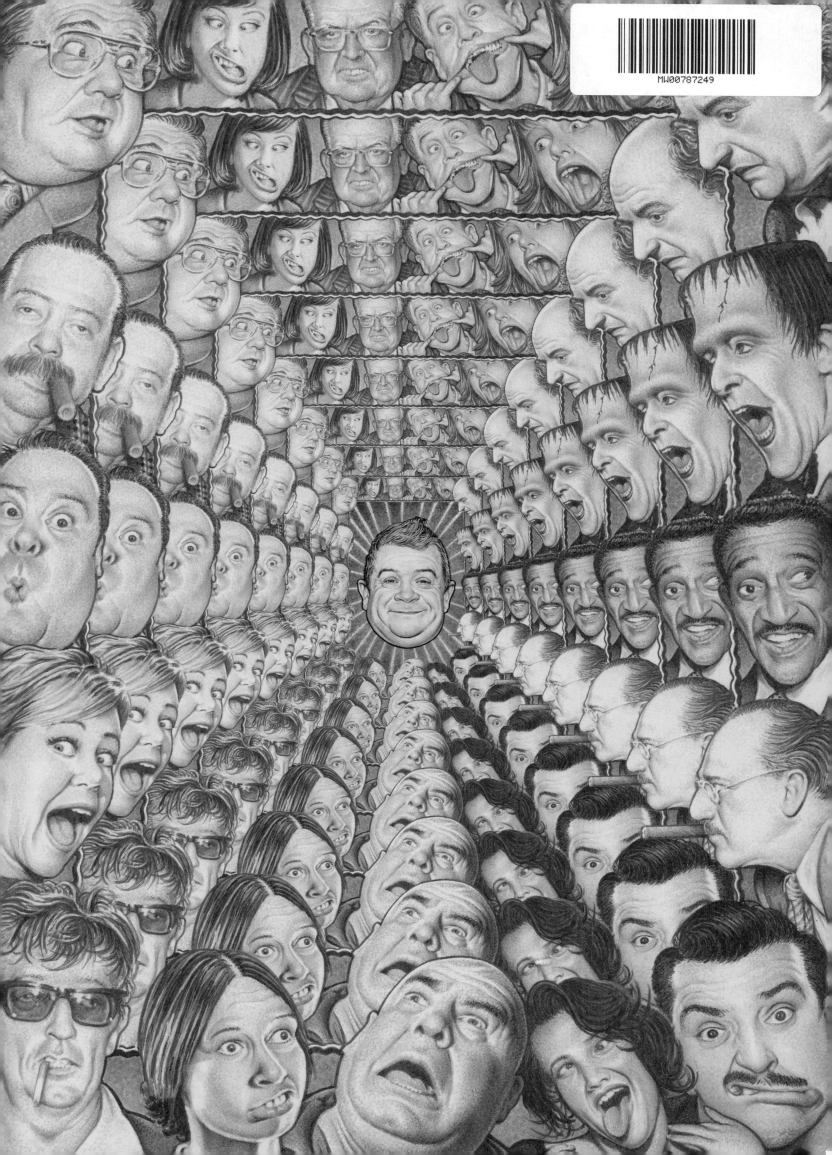

SCHTICK FIGURES

THE COOL, THE COMICAL, THE CRAZY

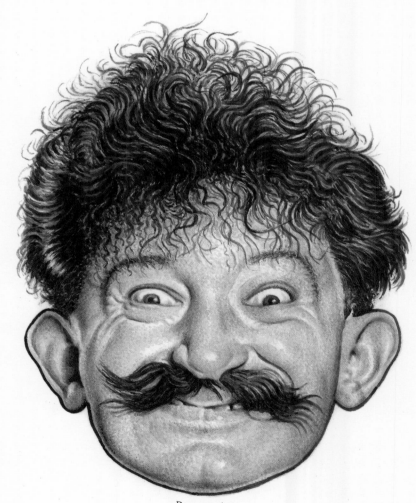

Bert Gordon

DREW FRIEDMAN

FANTAGRAPHICS BOOKS INC.
7563 Lake City Way NE
Seattle, Washington, 98115
www.fantagraphics.com

DESIGN: Kayla E.
PRODUCTION: Paul Baresh
COVER LETTERING: Phil Felix
PROMOTION: Jacquelene Cohen
VP / ASSOCIATE PUBLISHER / EDITOR: Eric Reynolds
PRESIDENT / PUBLISHER: Gary Groth

ISBN: 978-1-68396-934-1
LIBRARY OF CONGRESS CONTROL NUMBER: 2023951388
FIRST PRINTING: June 2024
PRINTED IN CHINA

Drew Friedman is a real artist. Everyone else is a bum.

by Kliph Nesteroff

Drew Friedman is an expert on the things that matter most in life: Borscht Belt comedians, the filmography of Tor Johnson, and that utterly disgusting hair growing from the wart on your grandpa's nose. He belongs to a (very short) list of legends who have considered nothing sacred in the pursuit of a laugh: Gilbert Gottfried... Robert Crumb... Gene Baylos.

Those of us who grew up hypnotized by the renderings of Crumb, the outrageous satire of *National Lampoon,* or the acrid stench of Joe Franklin's office feel alienated today. The reactionary concepts once punctured by satirists are promoted now by a generation of comedians with unlistenable podcasts. *MAD* magazine has gone out of business. Corporations manipulate public opinion. And traditional comic book anarchy has been supplanted by the crass commercialism of the Marvel Universe. The smoldering ashes are all around us, but thankfully, gratefully, Drew Friedman is our lifeline. He understands that nothing is above ridicule — including comedians themselves — and that nothing is below celebration, including Raymond J. Johnson, Jr.

What each of the people rendered in *Schtick Figures* have in common is that they were uniquely themselves, a virtue more important than ever in an era of corporate homogeny. And while Hollywood may never make a biopic about a forgotten star like Bobby Clark or an icon like Moms Mabley, Friedman portrays them with an artistry more interesting than anything you'll ever find on the big screen. For many of us, Drew Friedman is our non-conformist bulwark, single-handedly crafting a heroic and necessary antidote to the vast array of junk that engulfs us today.*

Kliph Nesteroff

Not including the "junk" of Forrest Tucker, Milton Berle, and Huntz Hall.

KLIPH NESTEROFF is a historian and the author of *The Comedians: Drunks, Thieves, Scoundrels and the History of American Comedy*.

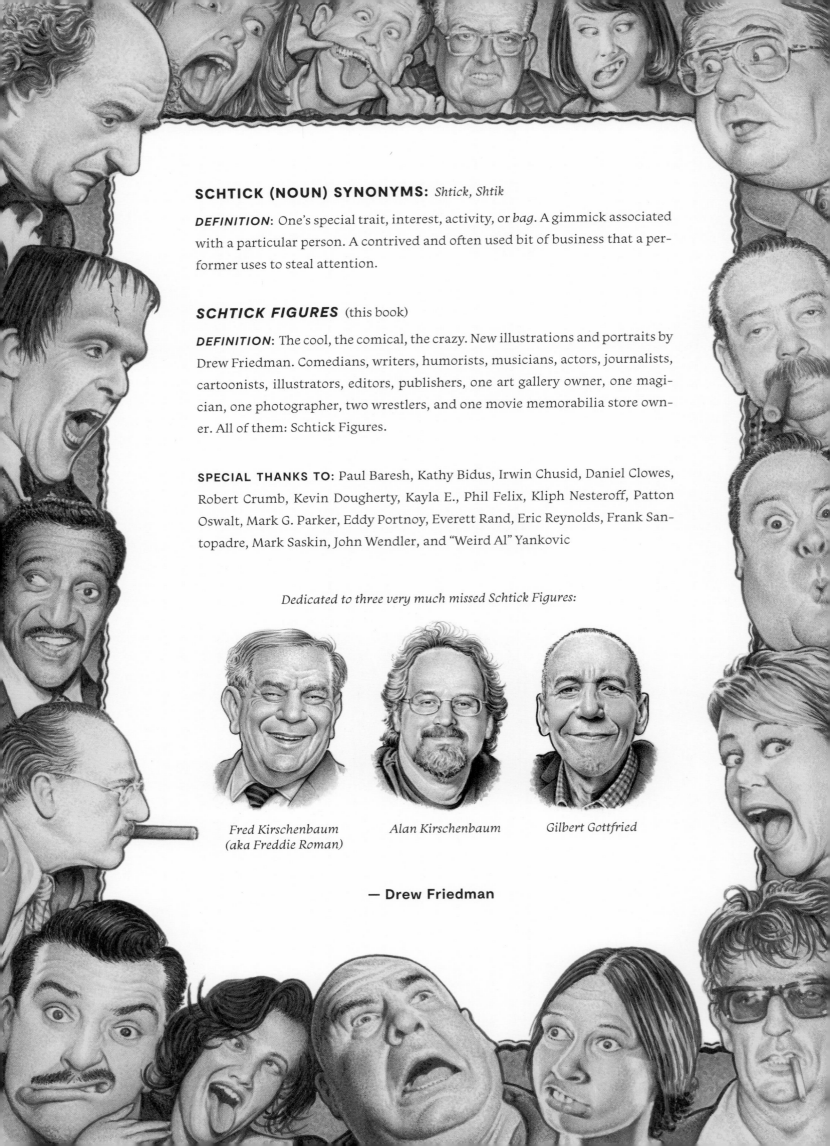

SCHTICK (NOUN) SYNONYMS: *Shtick, Shtik*

DEFINITION: One's special trait, interest, activity, or *bag*. A gimmick associated with a particular person. A contrived and often used bit of business that a performer uses to steal attention.

SCHTICK FIGURES (this book)

DEFINITION: The cool, the comical, the crazy. New illustrations and portraits by Drew Friedman. Comedians, writers, humorists, musicians, actors, journalists, cartoonists, illustrators, editors, publishers, one art gallery owner, one magician, one photographer, two wrestlers, and one movie memorabilia store owner. All of them: Schtick Figures.

SPECIAL THANKS TO: Paul Baresh, Kathy Bidus, Irwin Chusid, Daniel Clowes, Robert Crumb, Kevin Dougherty, Kayla E., Phil Felix, Kliph Nesteroff, Patton Oswalt, Mark G. Parker, Eddy Portnoy, Everett Rand, Eric Reynolds, Frank Santopadre, Mark Saskin, John Wendler, and "Weird Al" Yankovic

Dedicated to three very much missed Schtick Figures:

*Fred Kirschenbaum
(aka Freddie Roman)* *Alan Kirschenbaum* *Gilbert Gottfried*

— Drew Friedman

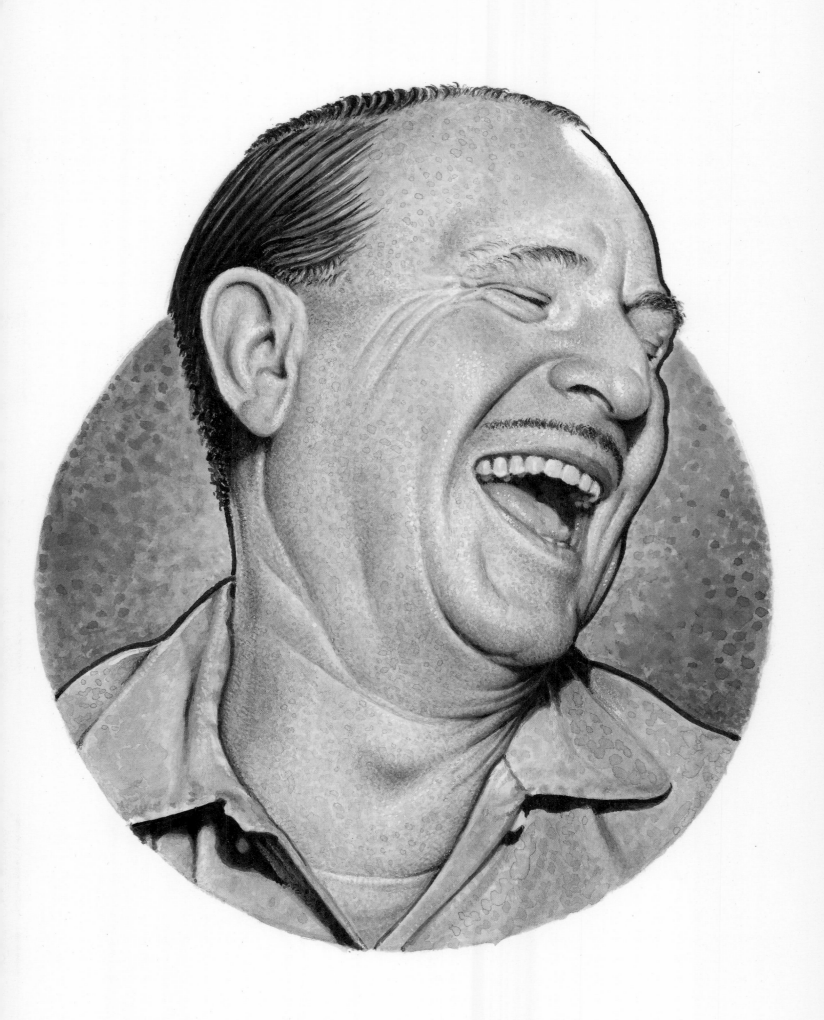

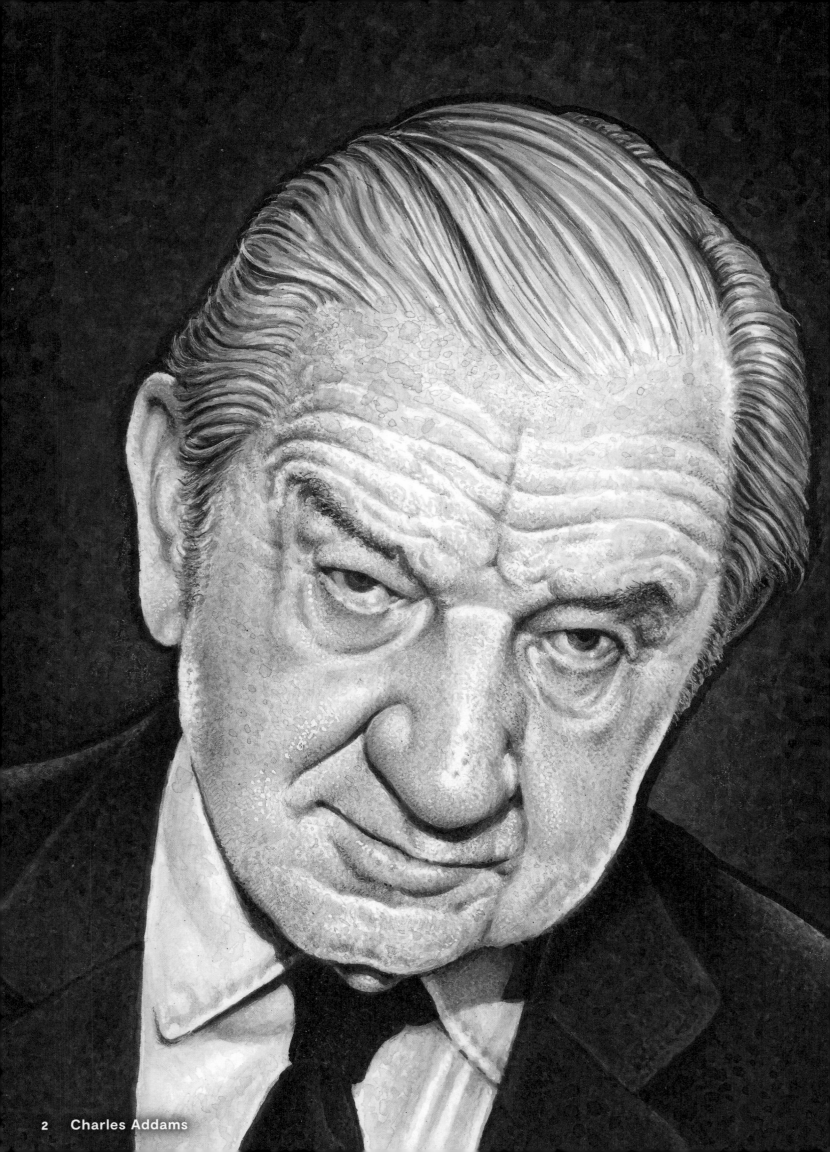

Charles Addams

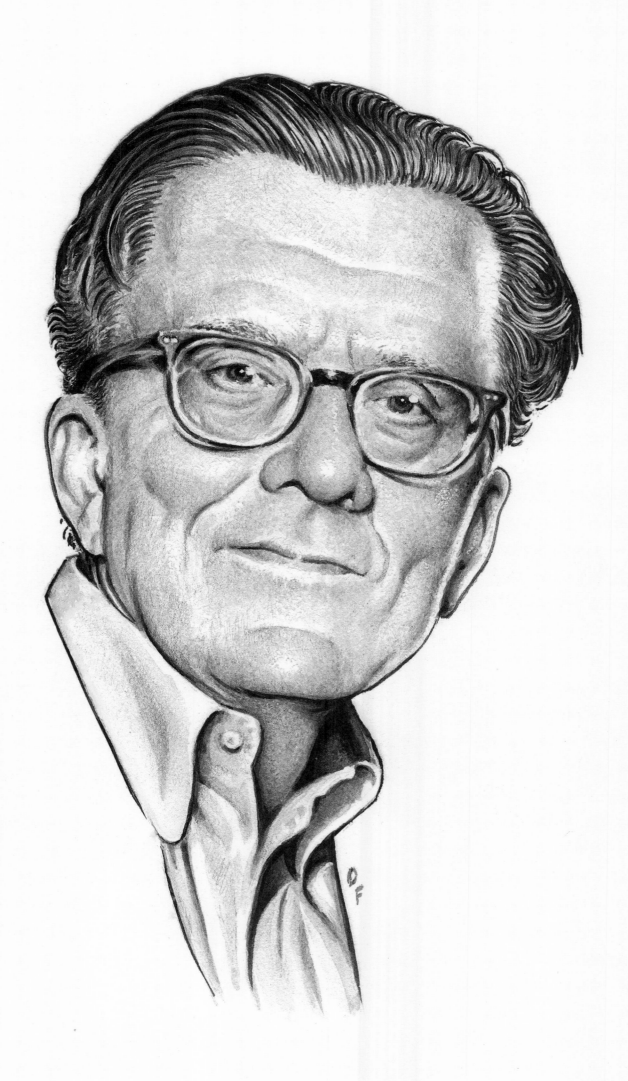

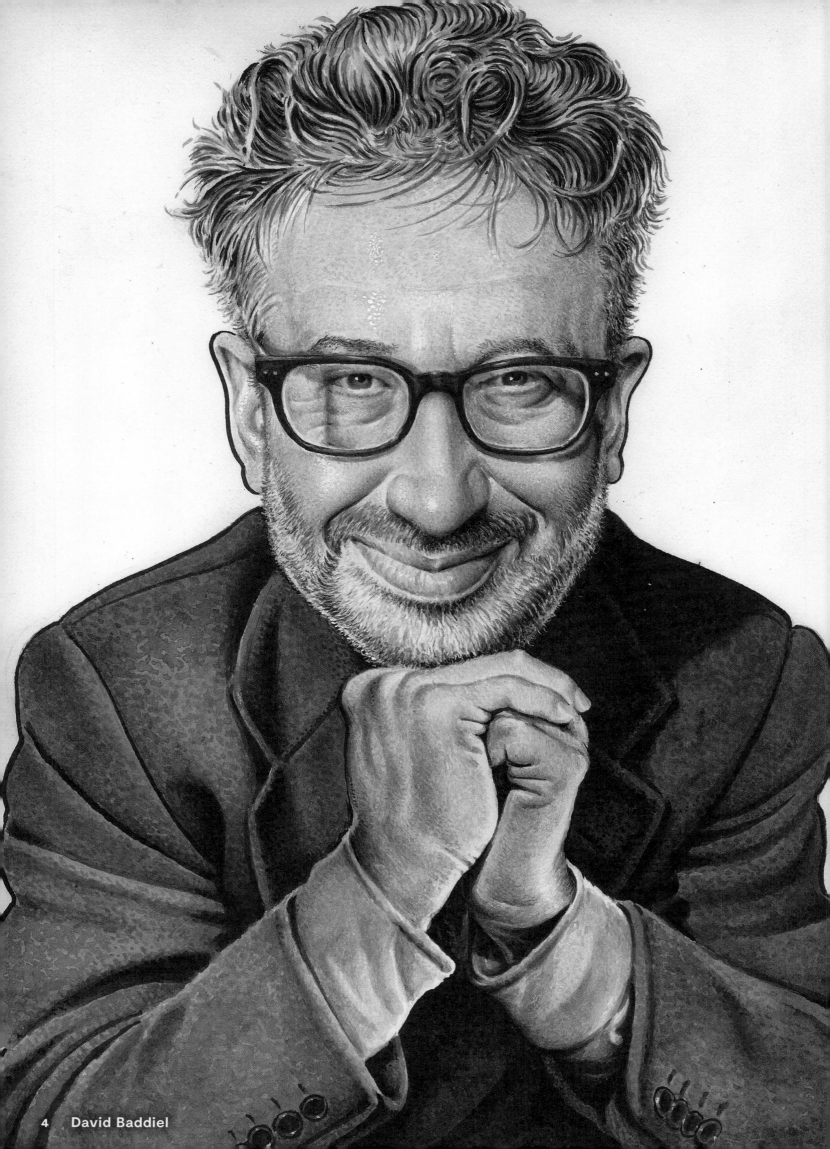

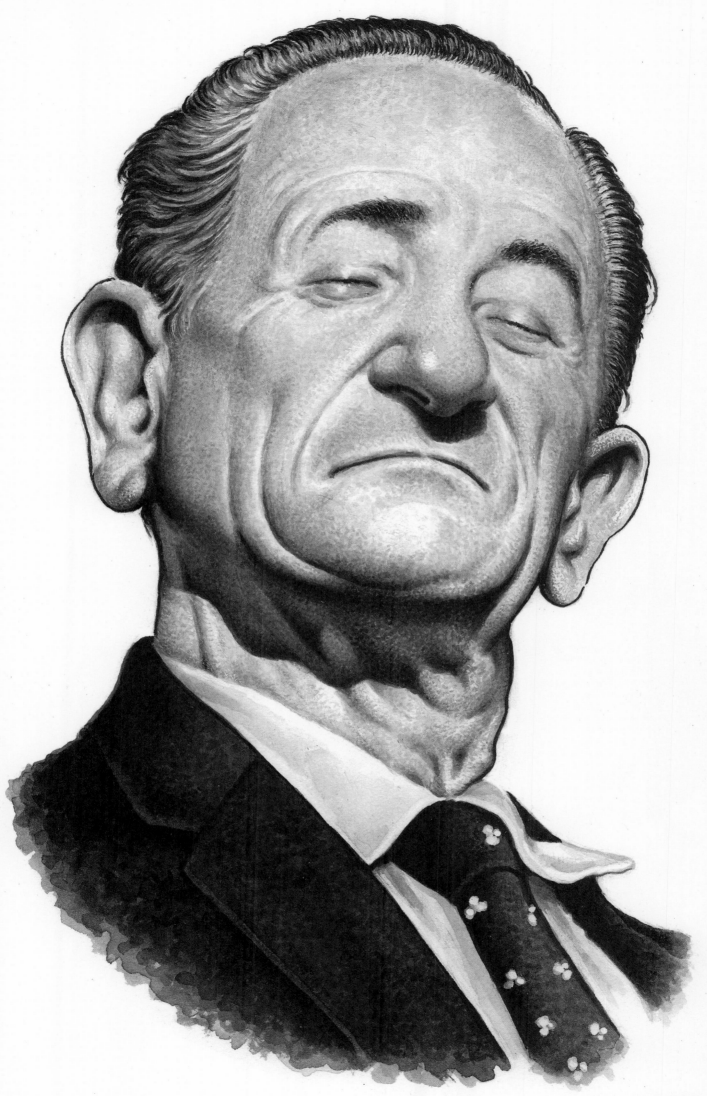

Eli Basse 5

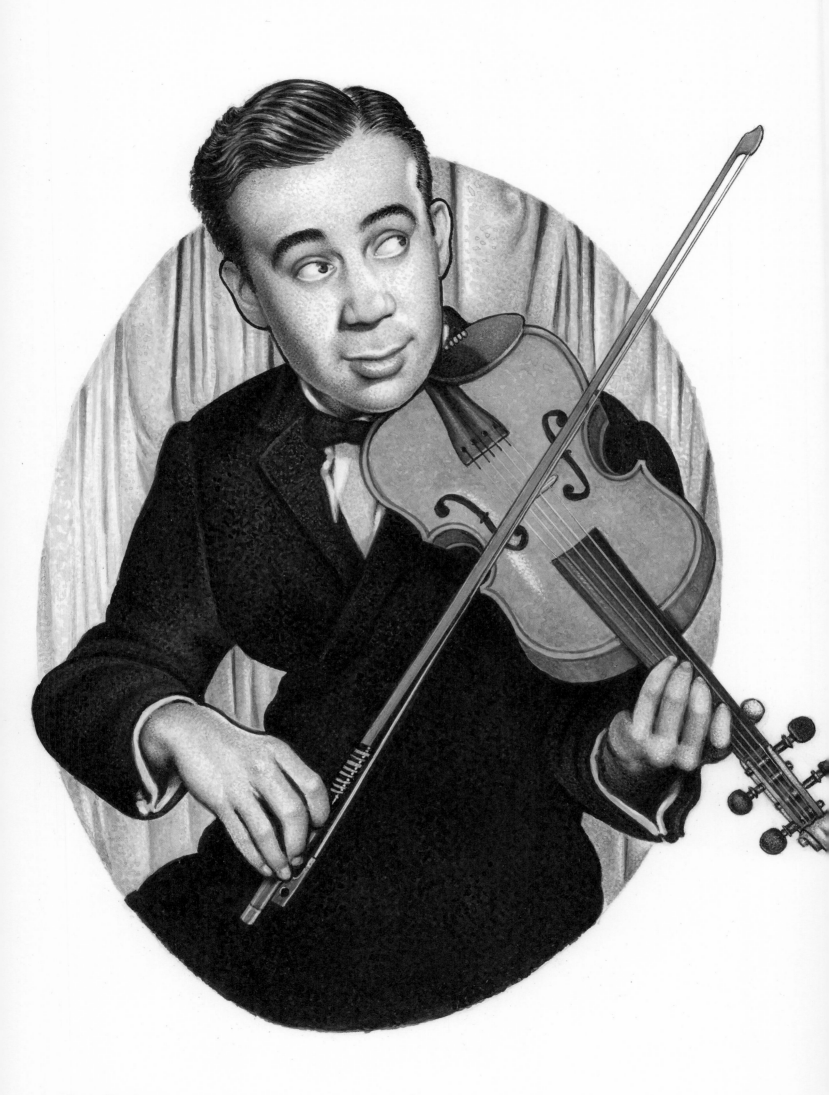

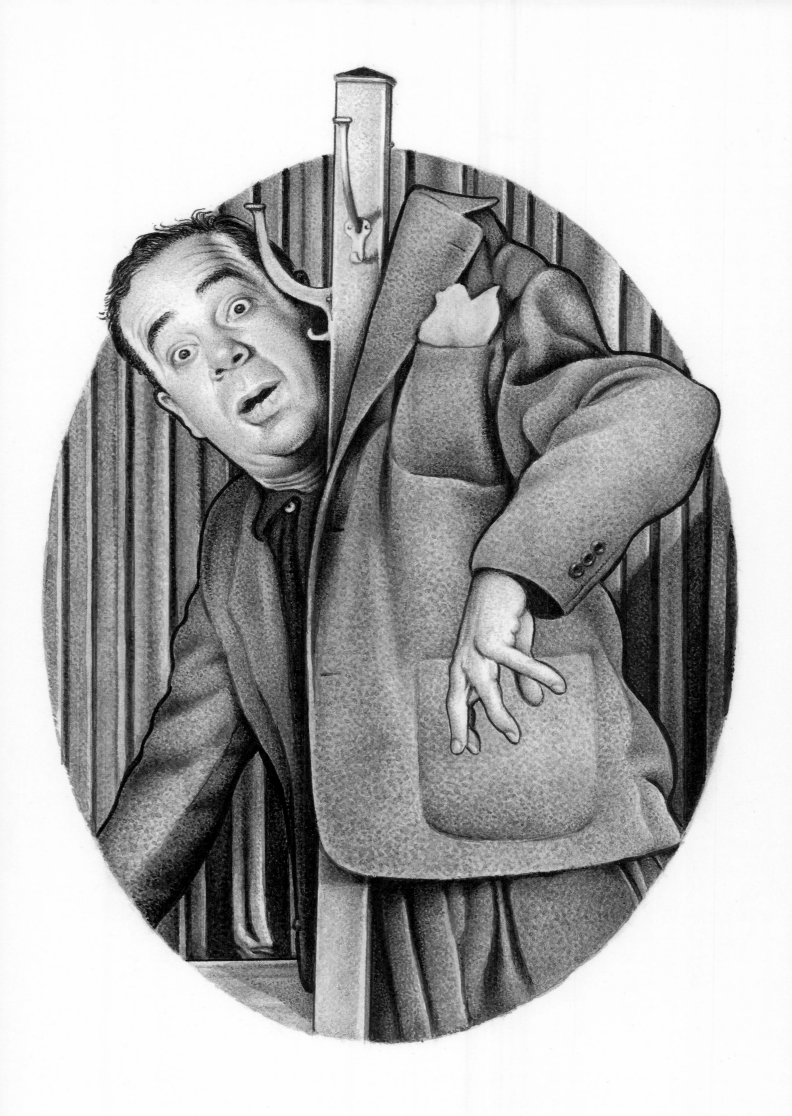

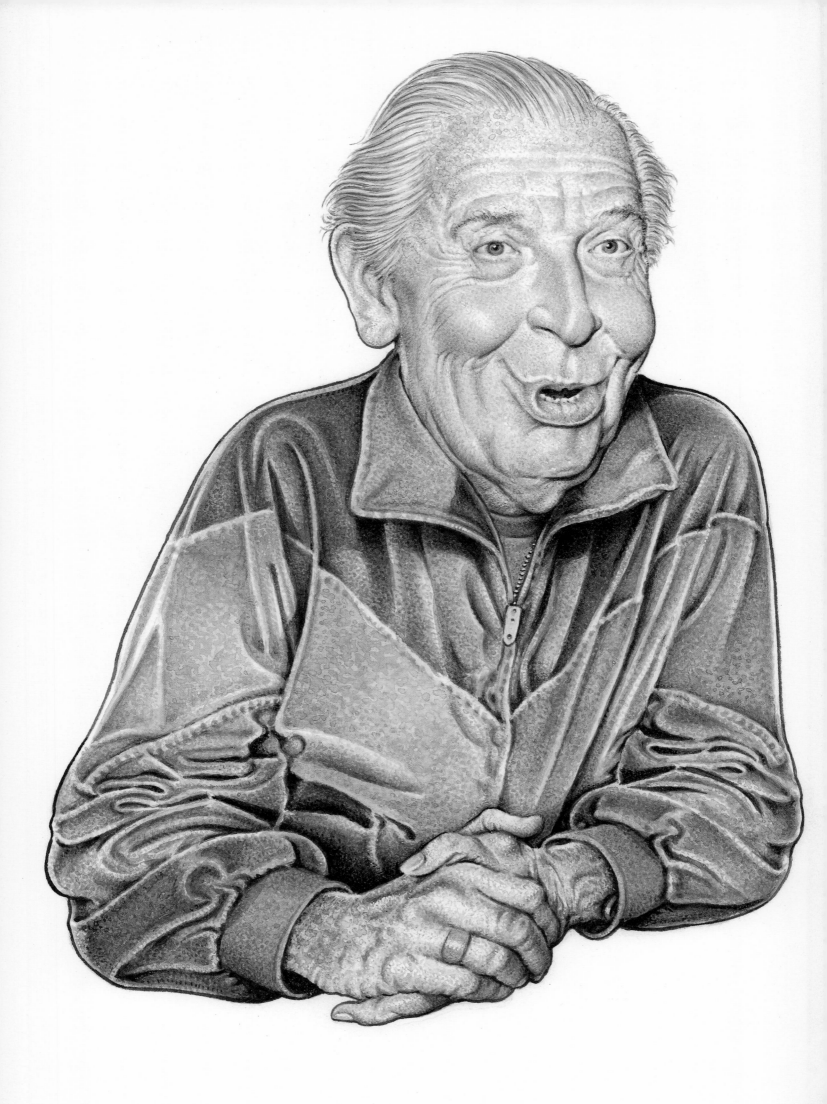

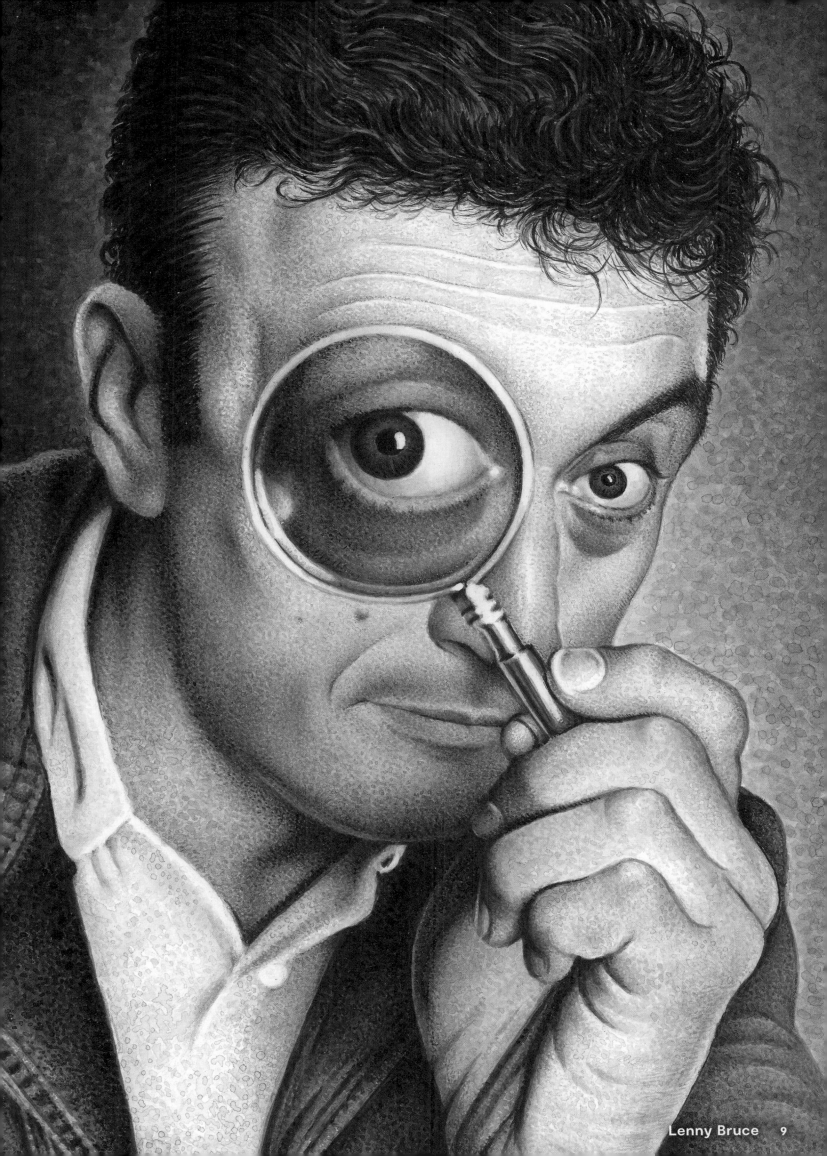

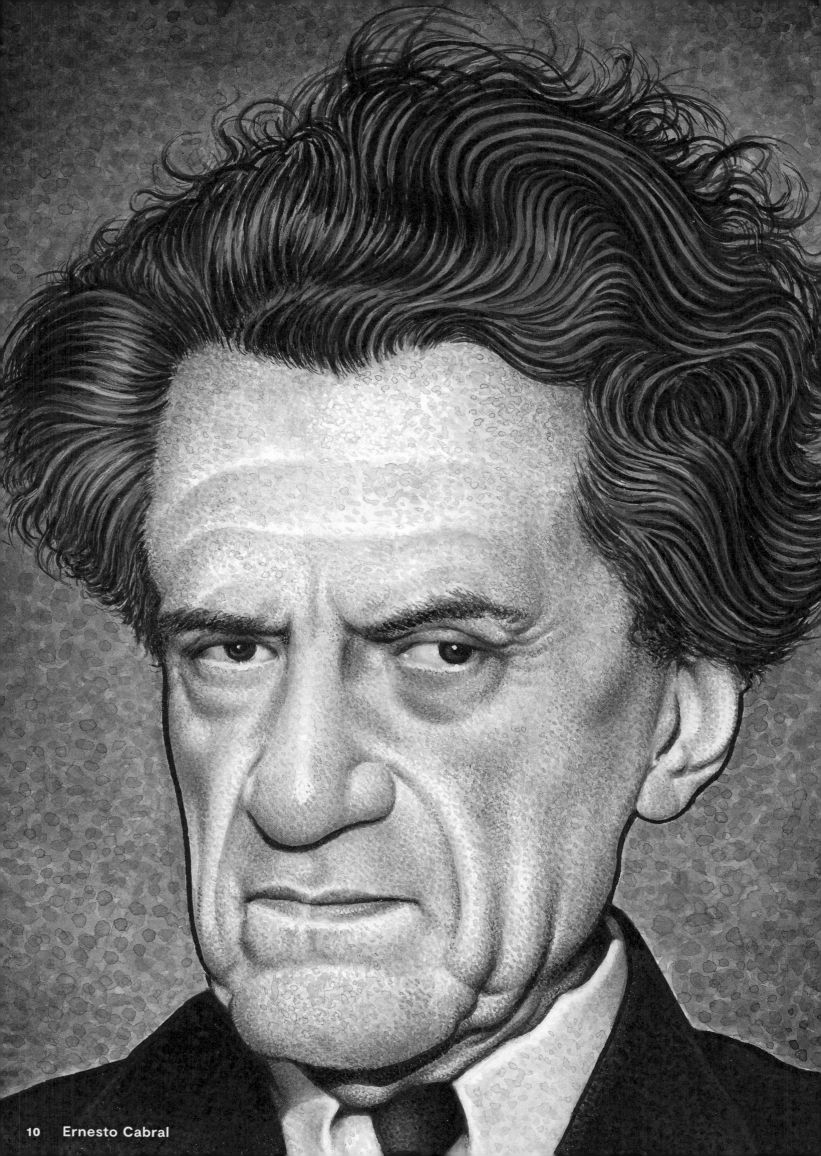

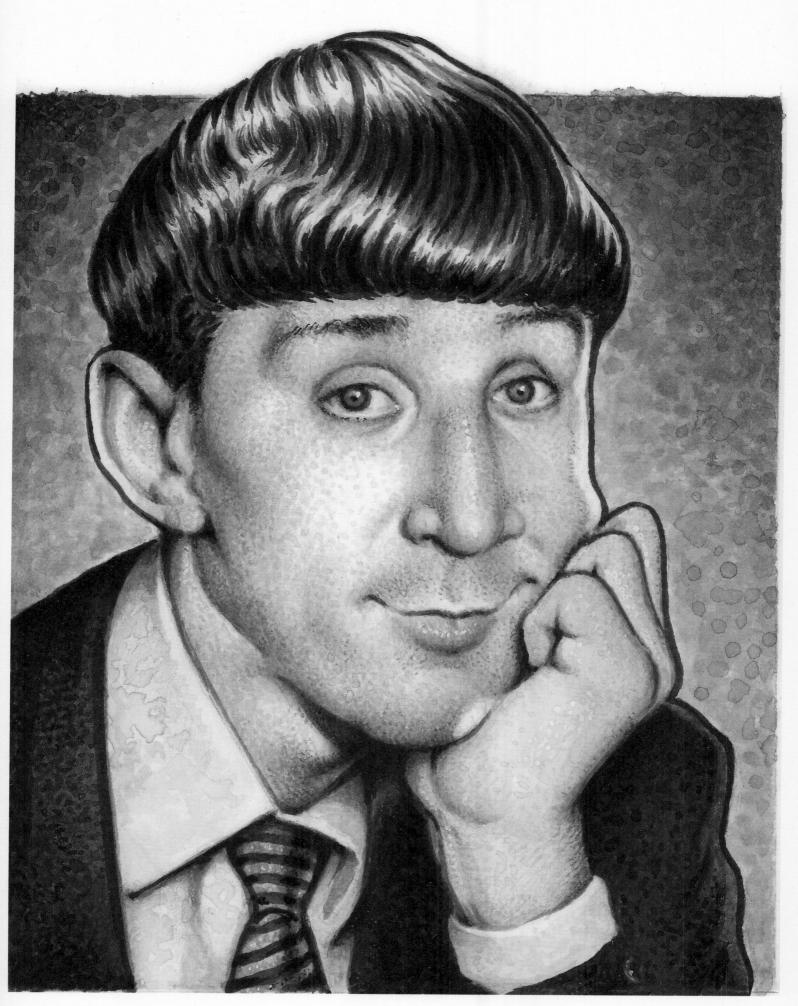

Jimmy Caesar 11

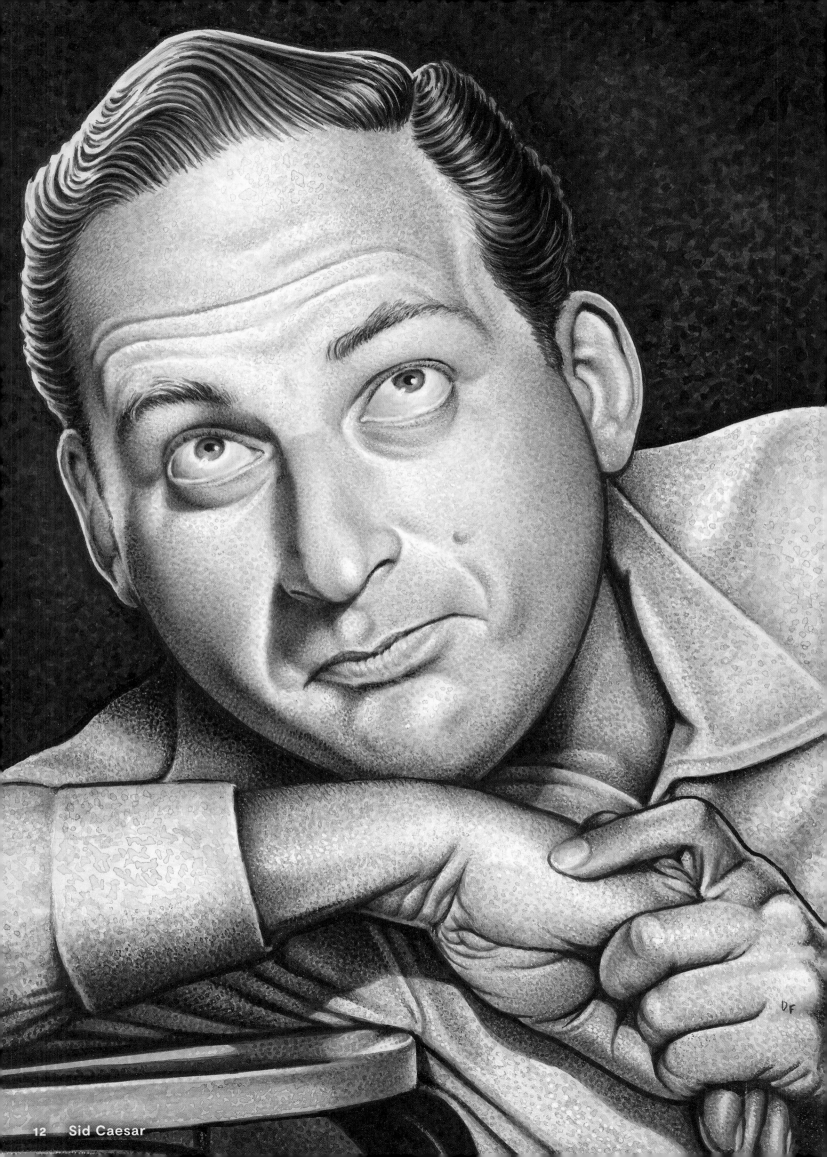

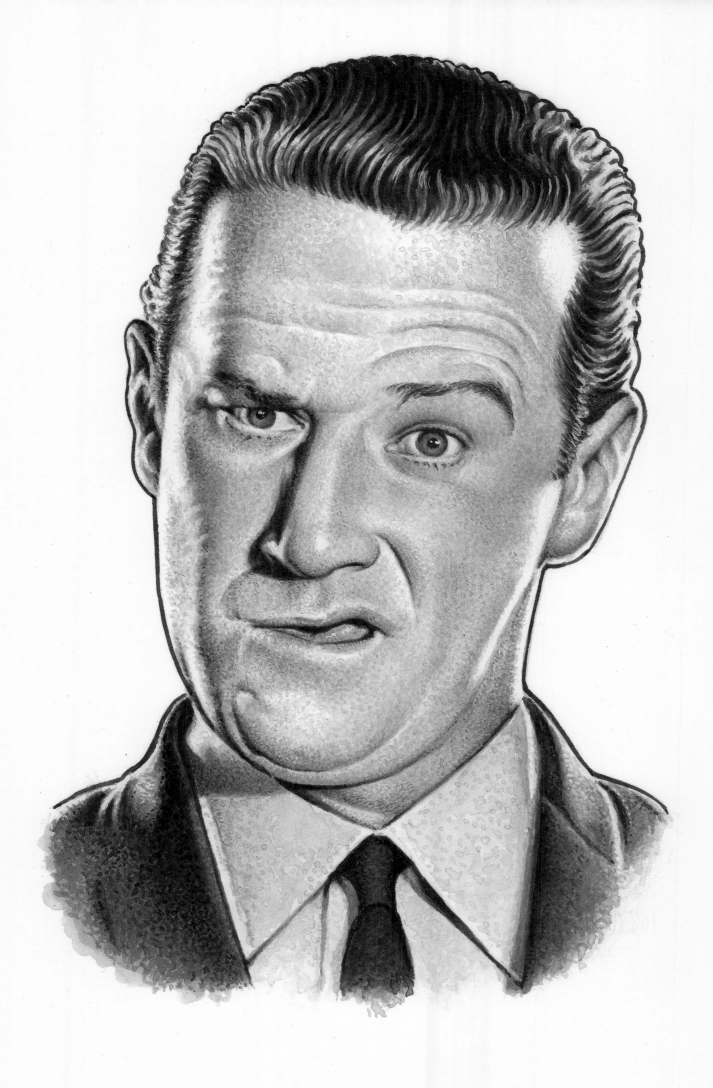

George Carlin 13

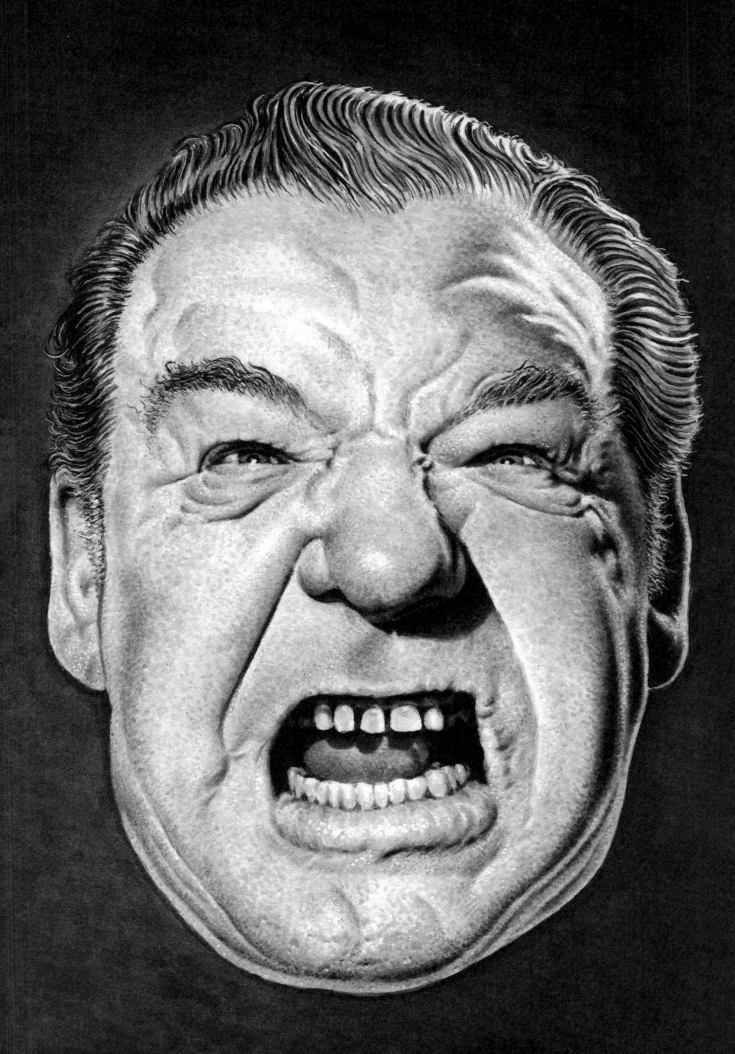

Lon Chaney, Jr.

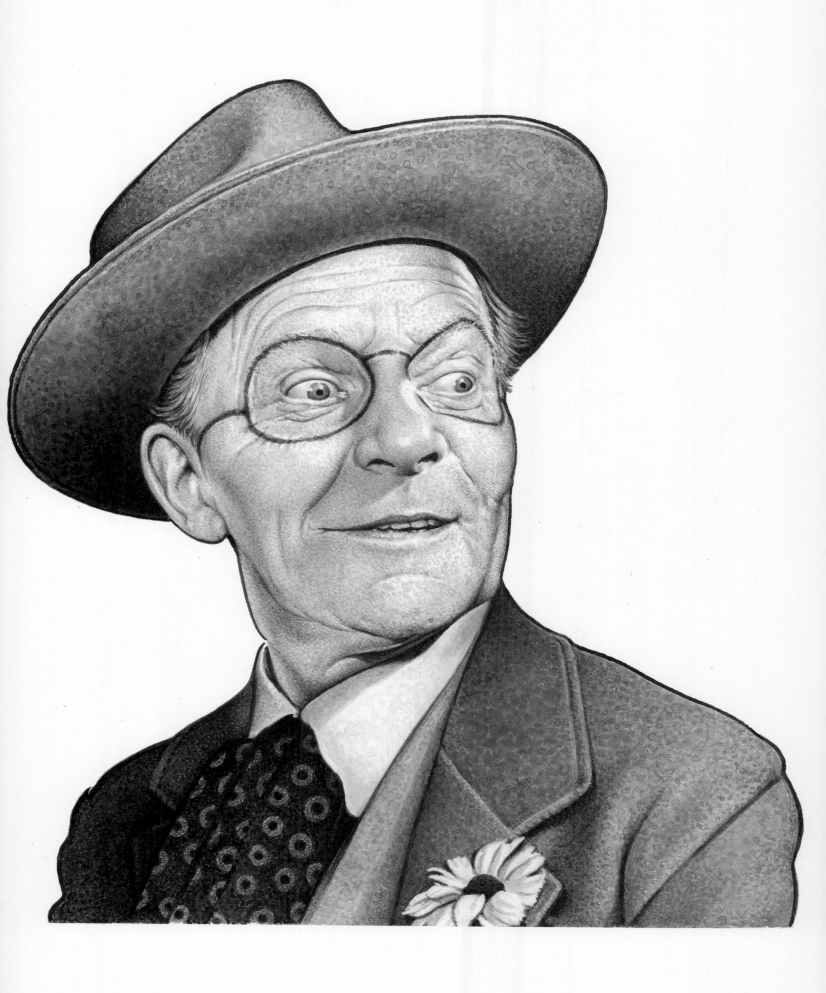

Bobby Clark 15

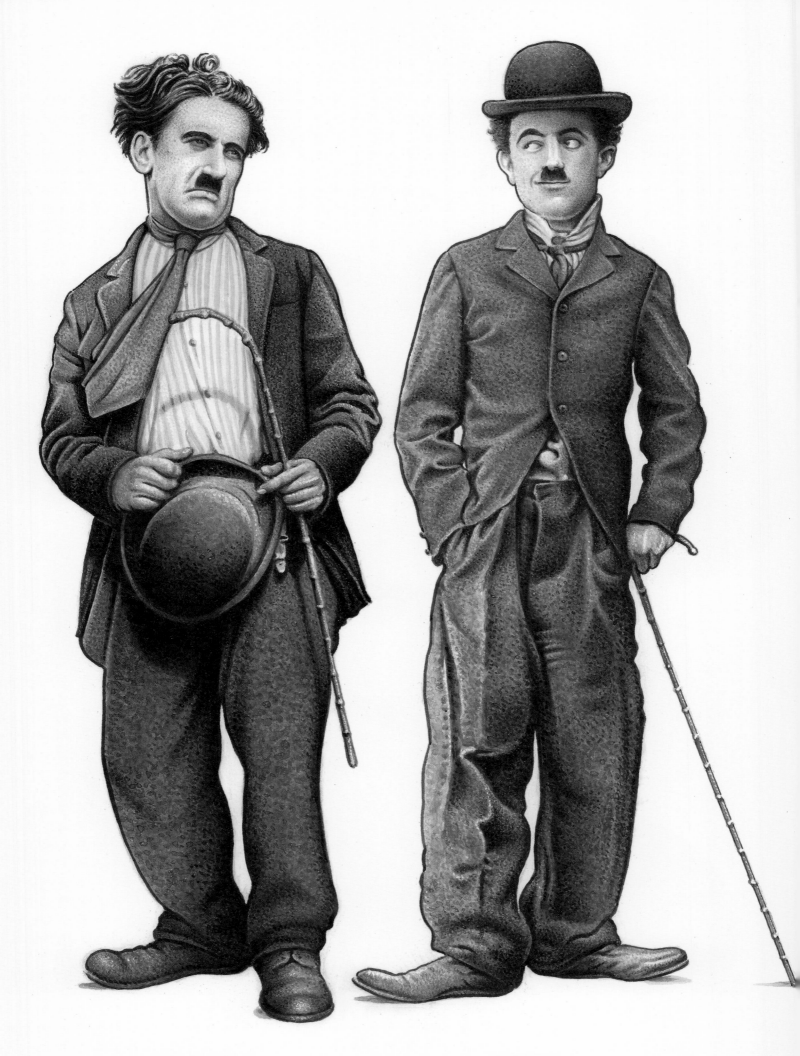

Charles Amador *Billy West*

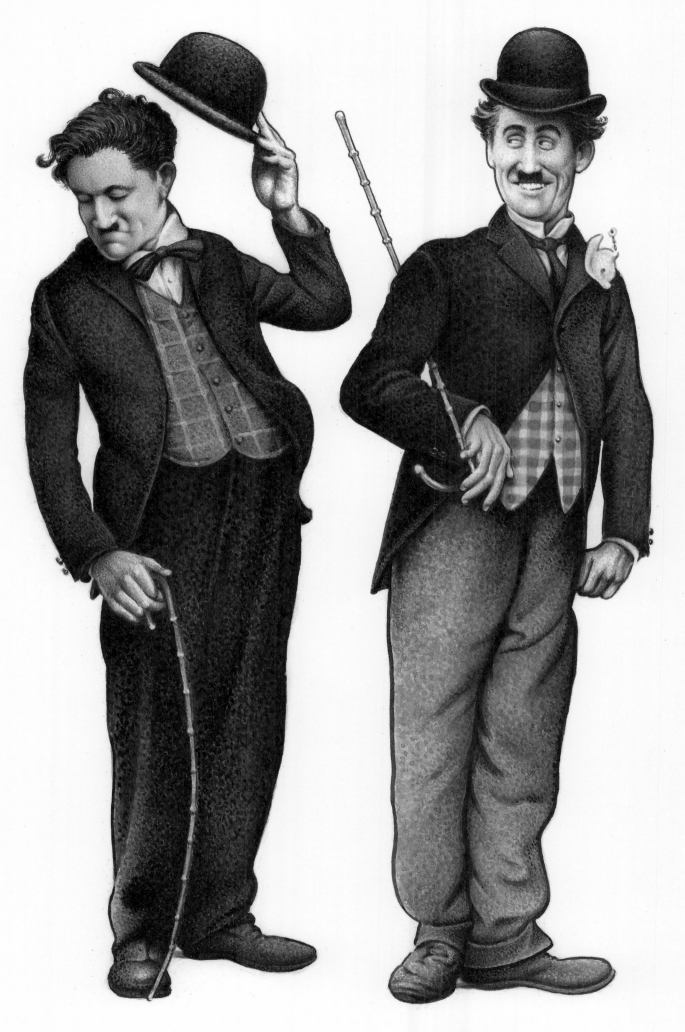

Ray Hughes

Billy Ritchie

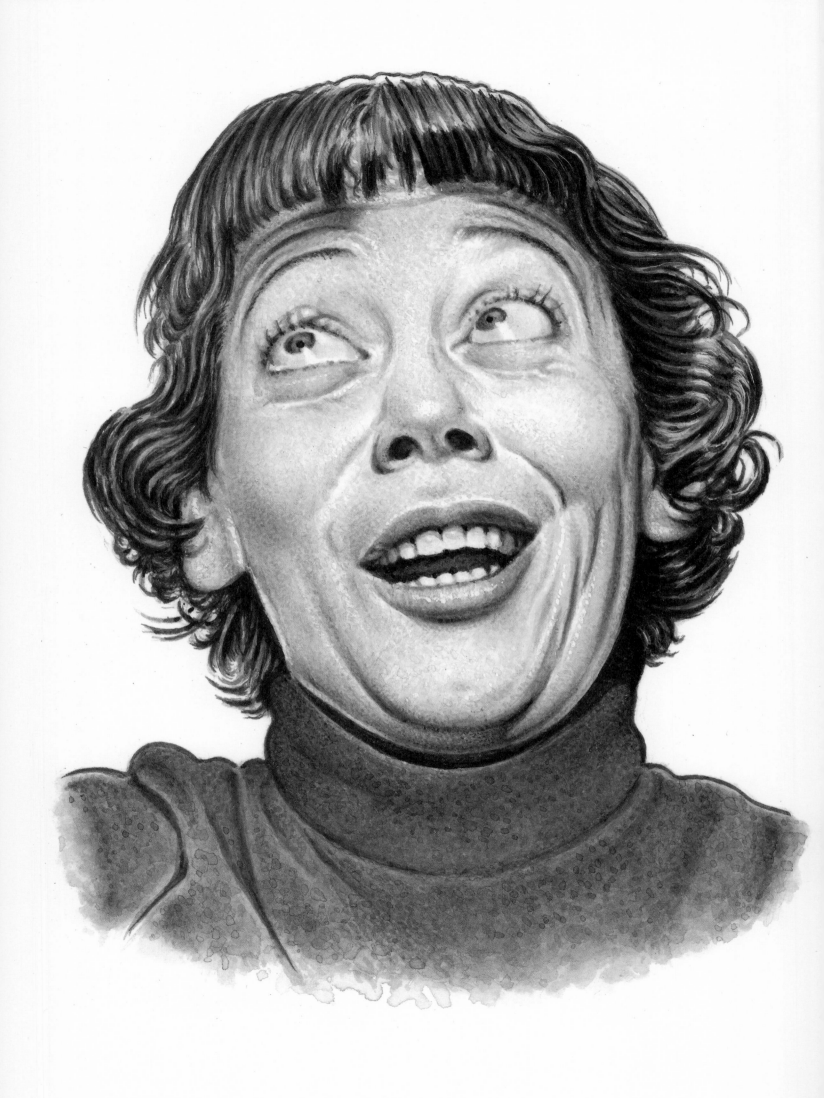

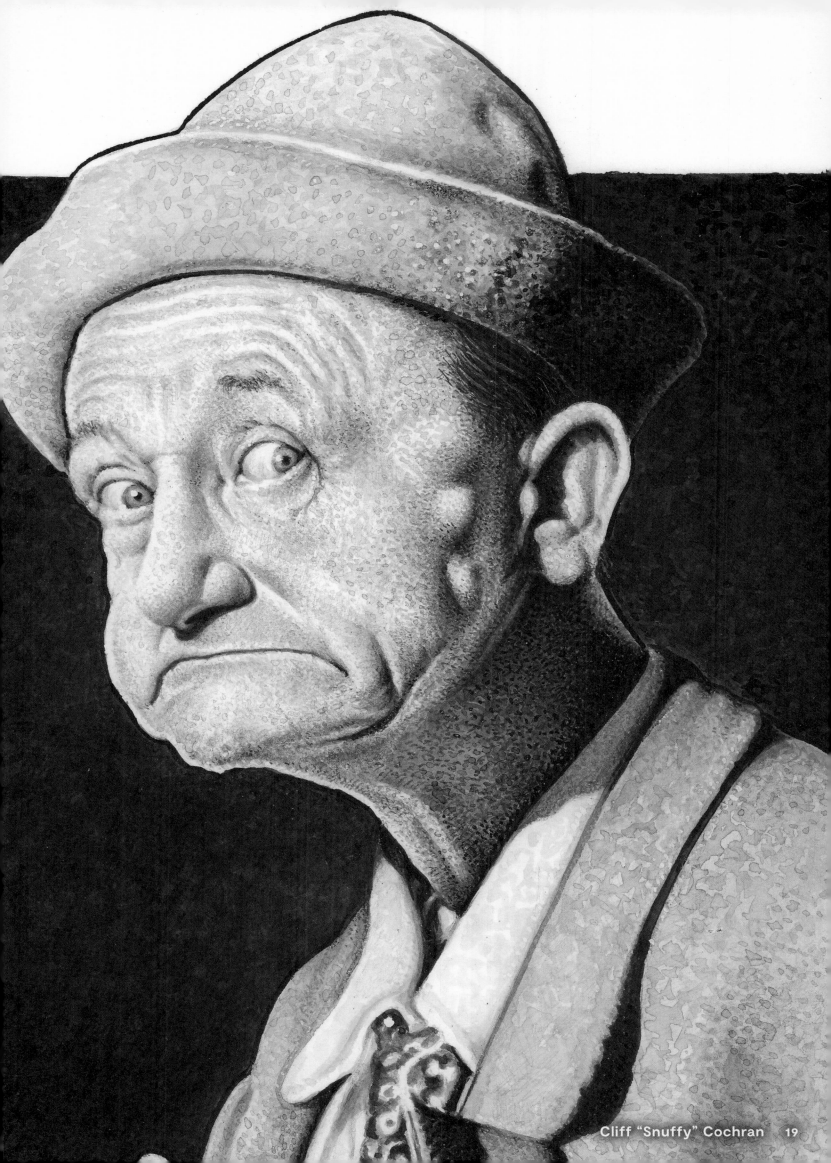

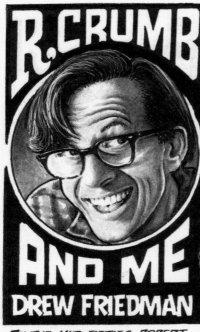

R. CRUMB AND ME
DREW FRIEDMAN

ROBERT DENNIS CRUMB WAS BORN IN PHILADELPHIA IN 1943, THE MIDDLE OF FIVE CHILDREN. ROBERT AND HIS OLDER BROTHER CHARLES QUICKLY BECAME OBSESSED WITH "FUNNY ANIMAL" COMIC BOOKS.

THROUGH CHARLES' URGING, THE TWO BROTHERS BEGAN TO DRAW THEIR OWN COMICS TOGETHER. ROBERT SOON EMERGED AS A NATURALLY GIFTED CARTOONIST.

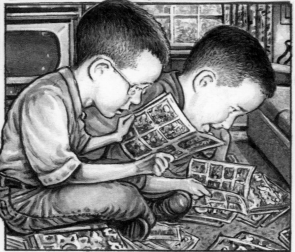

COMICS, ROBERT!

IN THE MID-FIFTIES, ROBERT STUMBLED UPON ISSUE #11 OF MAD, EDITED BY HARVEY KURTZMAN. HE RECEIVED THE JOLT OF HIS YOUNG LIFE.

ROBERT ALSO BECAME A RABID COLLECTOR, SEEKING OUT CASTOFF AMERICAN ARTIFACTS, ESPECIALLY OLD BLUES AND JAZZ RECORDS, WHICH HE HAD DEVELOPED A PASSION FOR.

IN 1962, ROBERT CRUMB HAD HONED HIS DRAWING ABILITIES TO THE POINT WHERE HE WAS ABLE TO LAND A COVETED POSITION AT THE "HI-BROW" DEPARTMENT AT AMERICAN GREETINGS IN CLEVELAND. HE SOON MARRIED HIS GIRLFRIEND, DANA, AND BEGAN TRAVELING AROUND THE WORLD, CREATING SKETCHBOOK FEATURES FOR HARVEY KURTZMAN'S HELP! MAGAZINE.

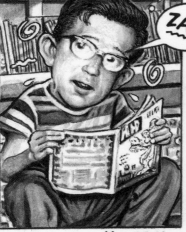

ZAP!

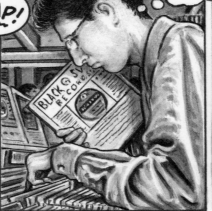

JOHN HARDY BLUES!

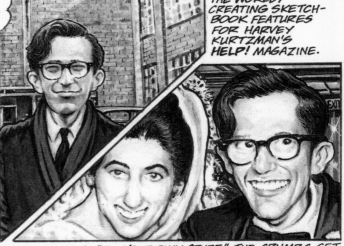

KURTZMAN WAS SO IMPRESSED WITH ROBERT'S ARTWORK AND WRITING, HE INVITED HIM TO NEW YORK TO WORK FOR HIM AT HELP!

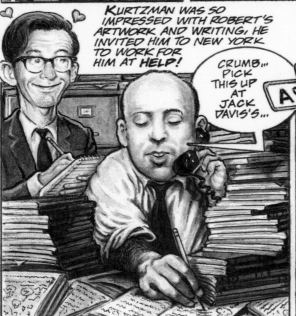

CRUMB... PICK THIS UP AT JACK DAVIS'S...

ENCOURAGED BY KURTZMAN TO "DO YOUR OWN STUFF," THE CRUMBS SET OUT TO JOIN THE "PSYCHEDELIC REVOLUTION" IN SAN FRANCISCO. INFLUENCED BY SEVERAL ACID TRIPS, HE BEGAN CREATING WORK FOR ZAP COMIX. BY 1968, R.CRUMB HAD EMERGED AS THE REIGNING KING OF THE UNDERGROUND COMICS MOVEMENT, A TRUE COUNTER-CULTURE HERO...AND...

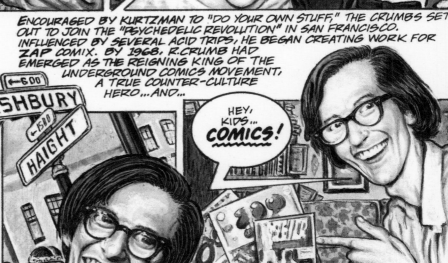

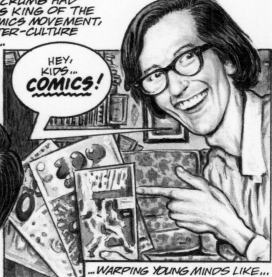

HEY, KIDS... COMICS!

←600 ASHBURY
←1580 HAIGHT

...WARPING YOUNG MINDS LIKE...

LETTERING BY PHIL FELIX

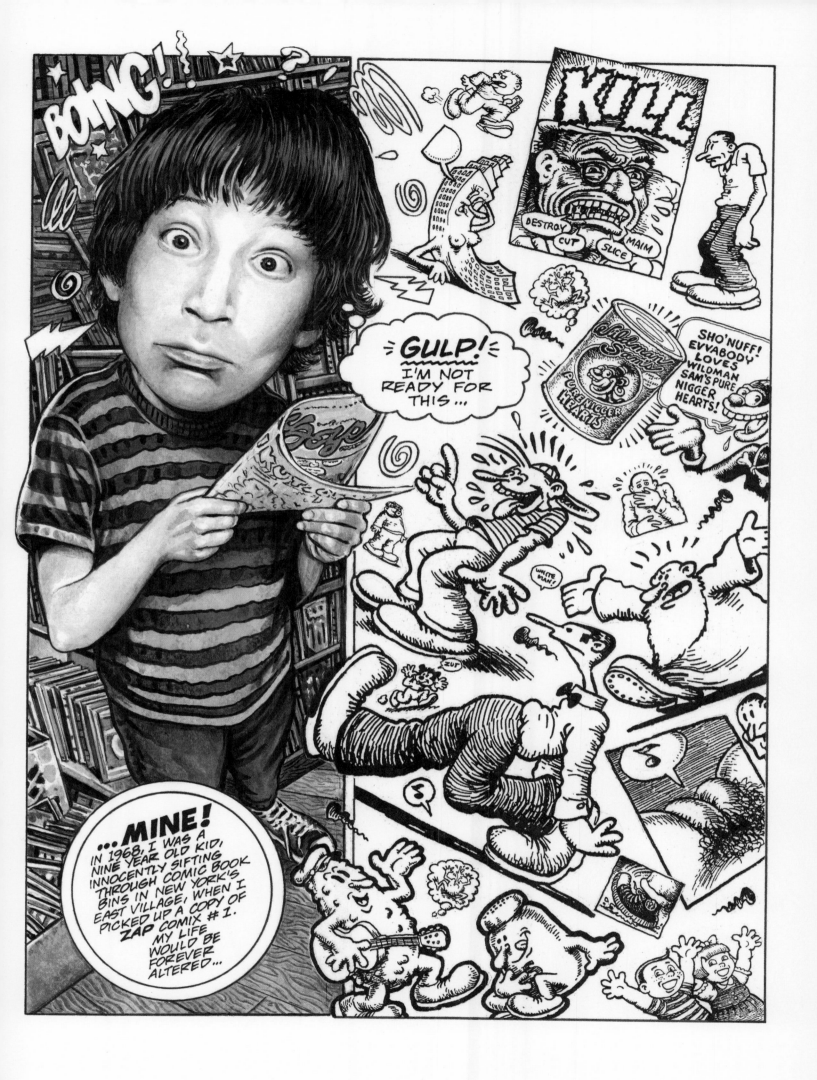

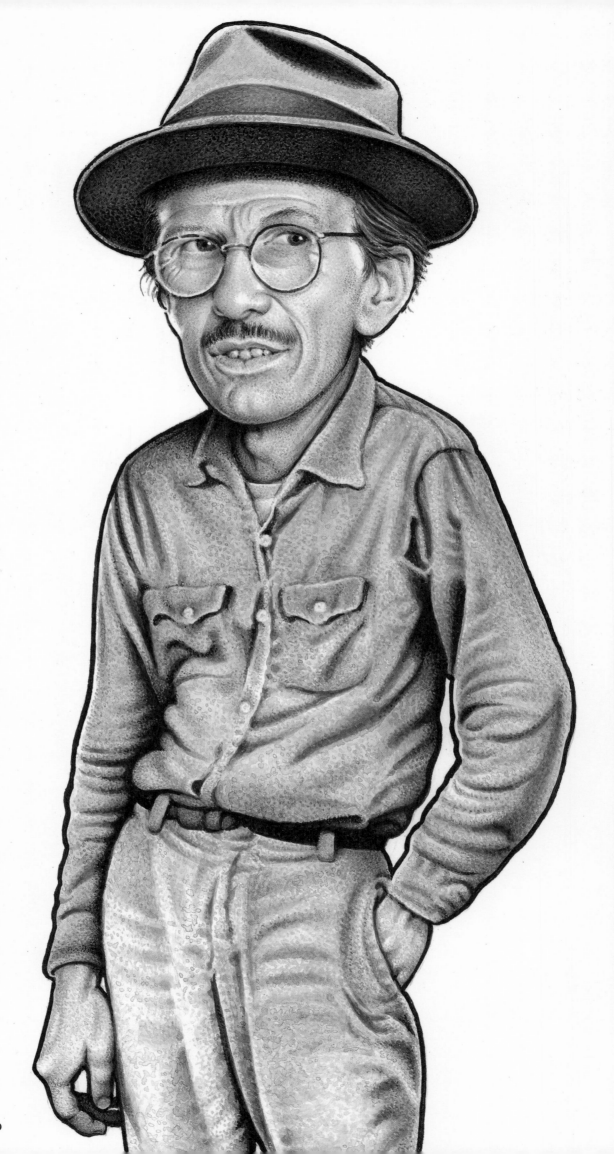

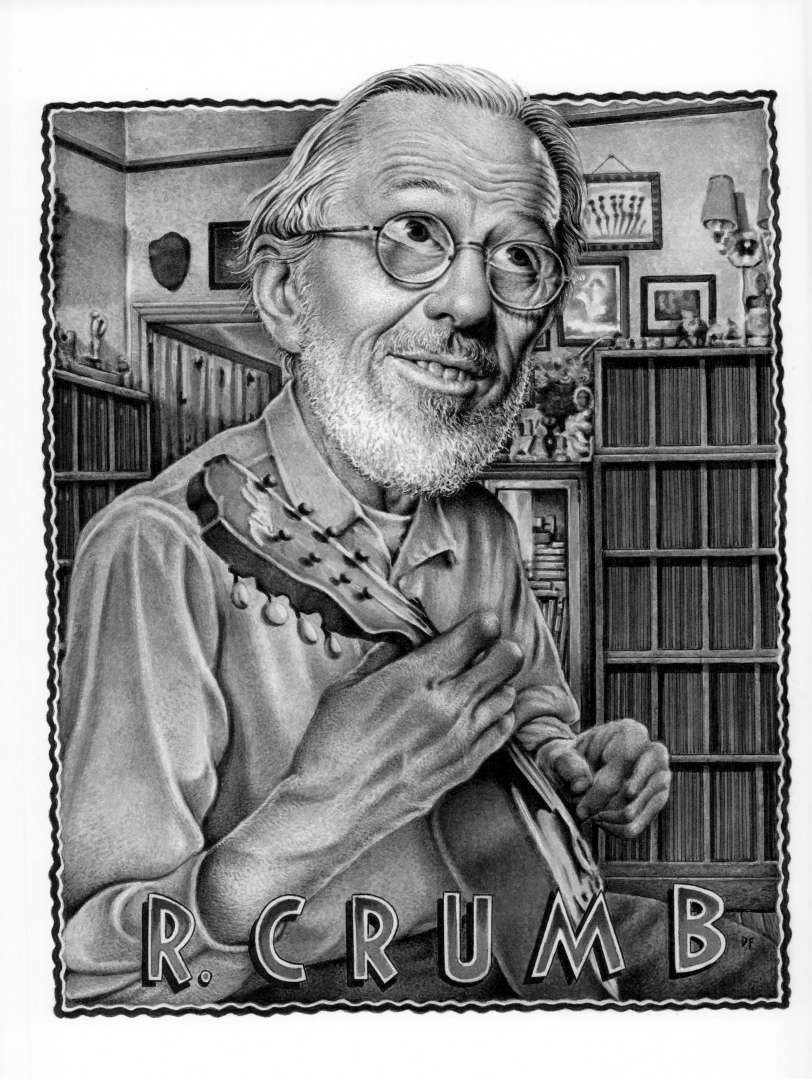

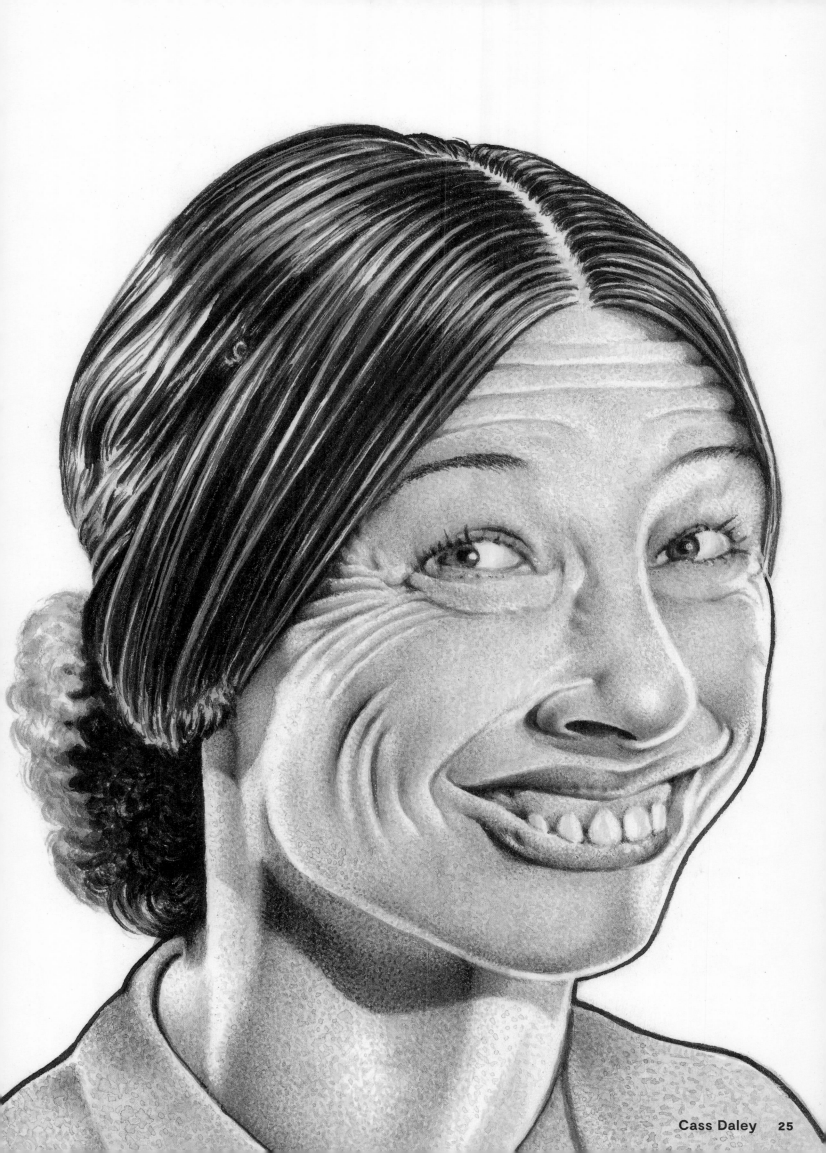

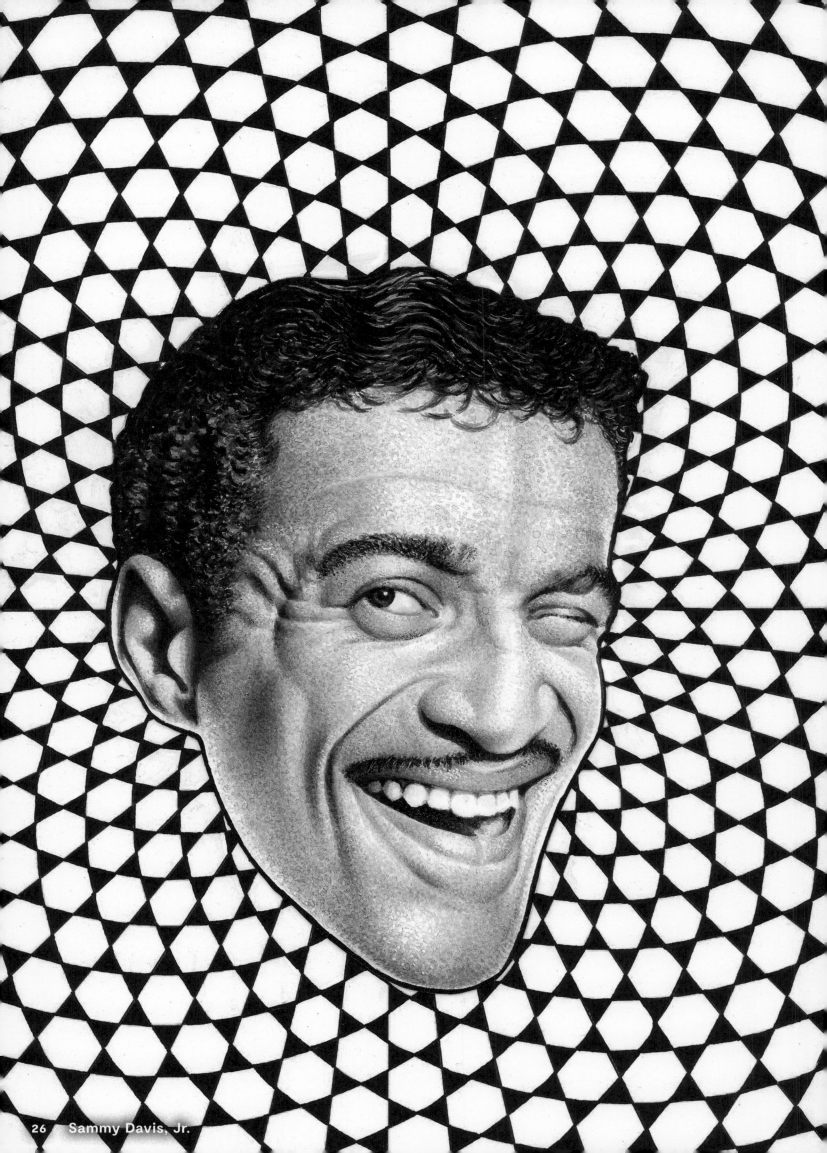

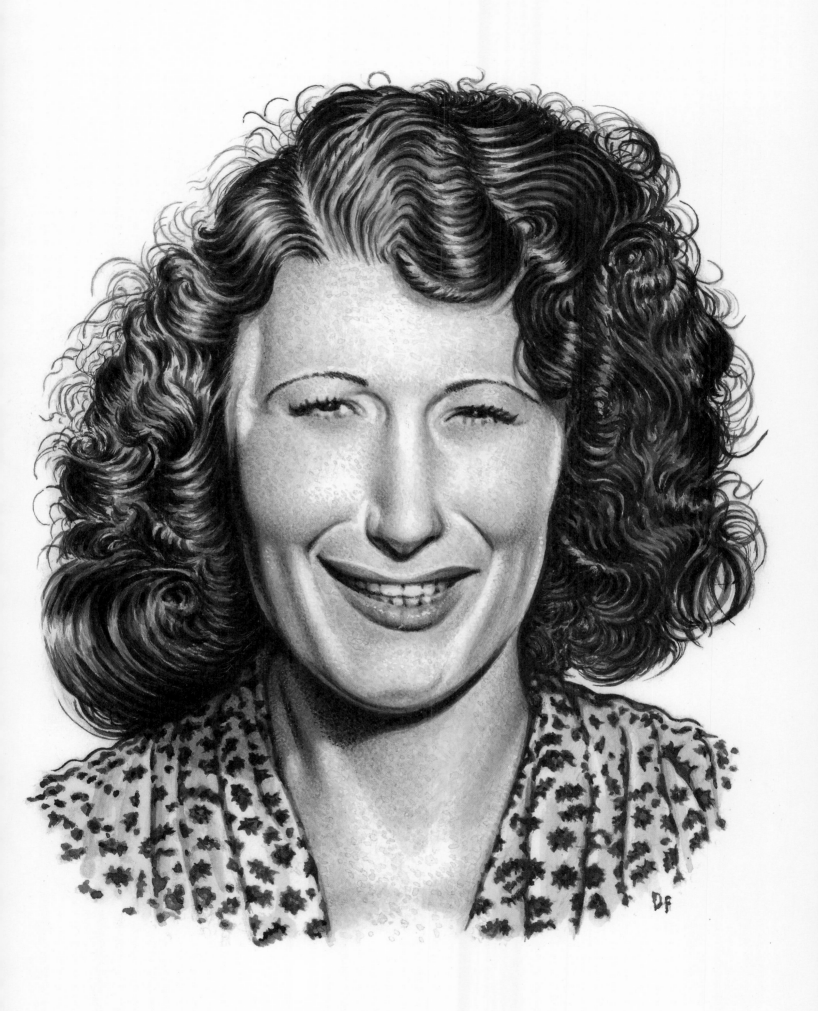

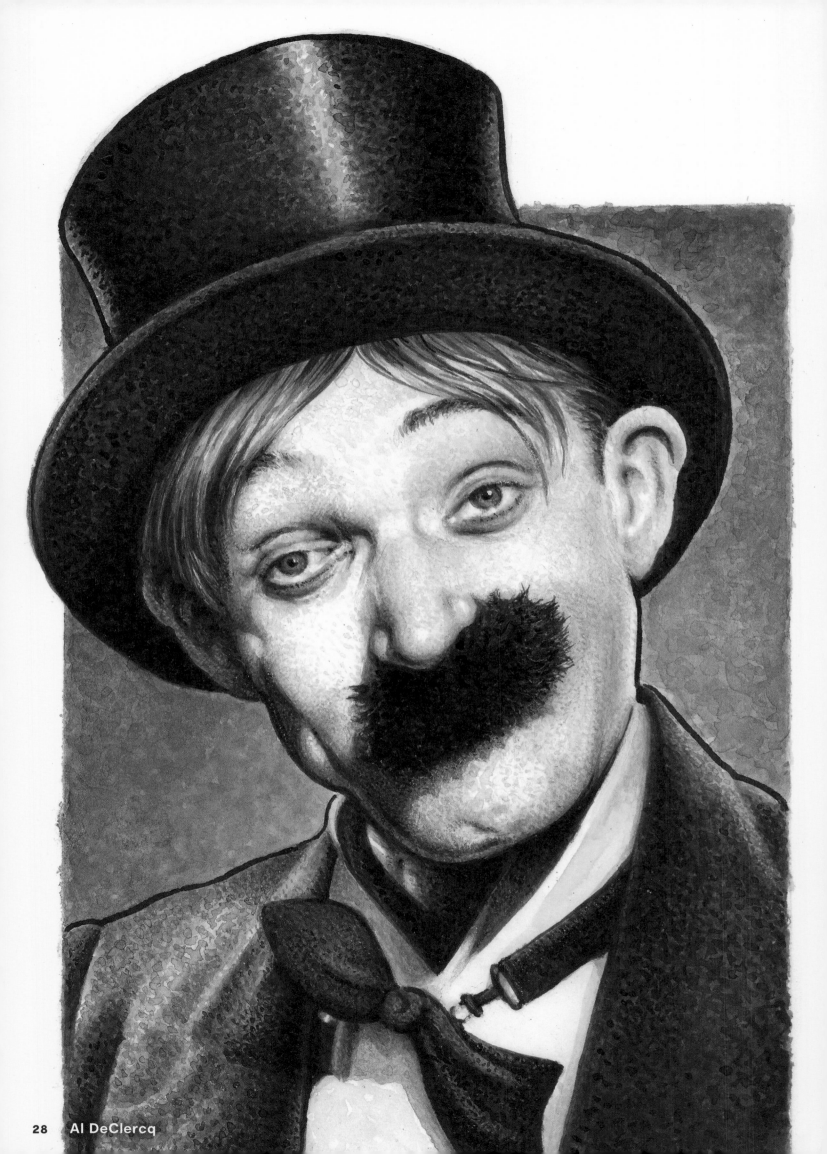

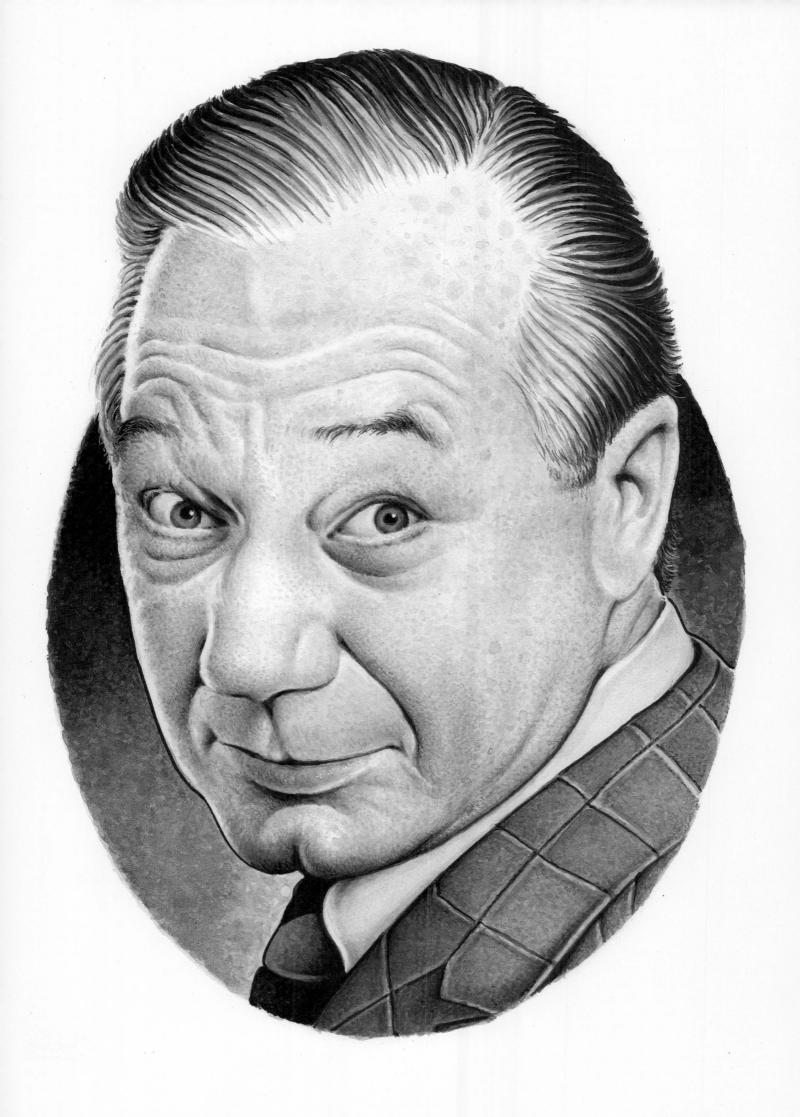

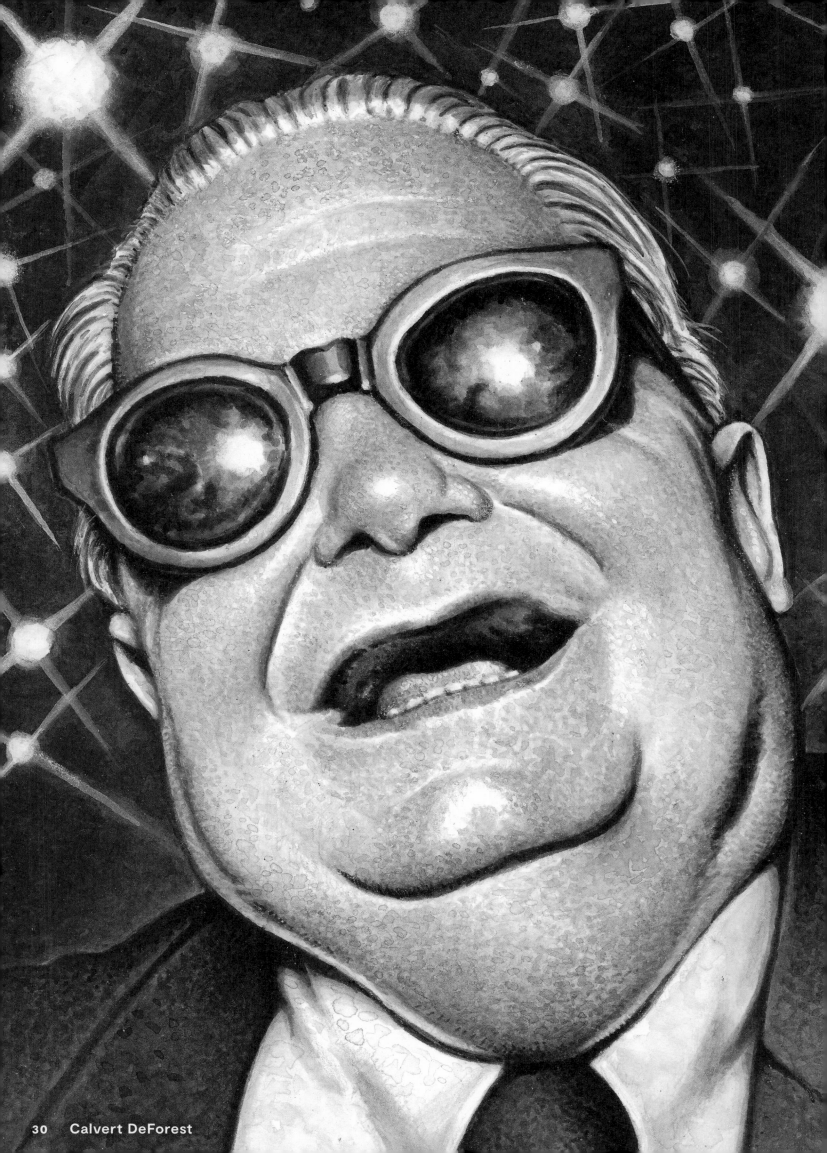

Calvert DeForest

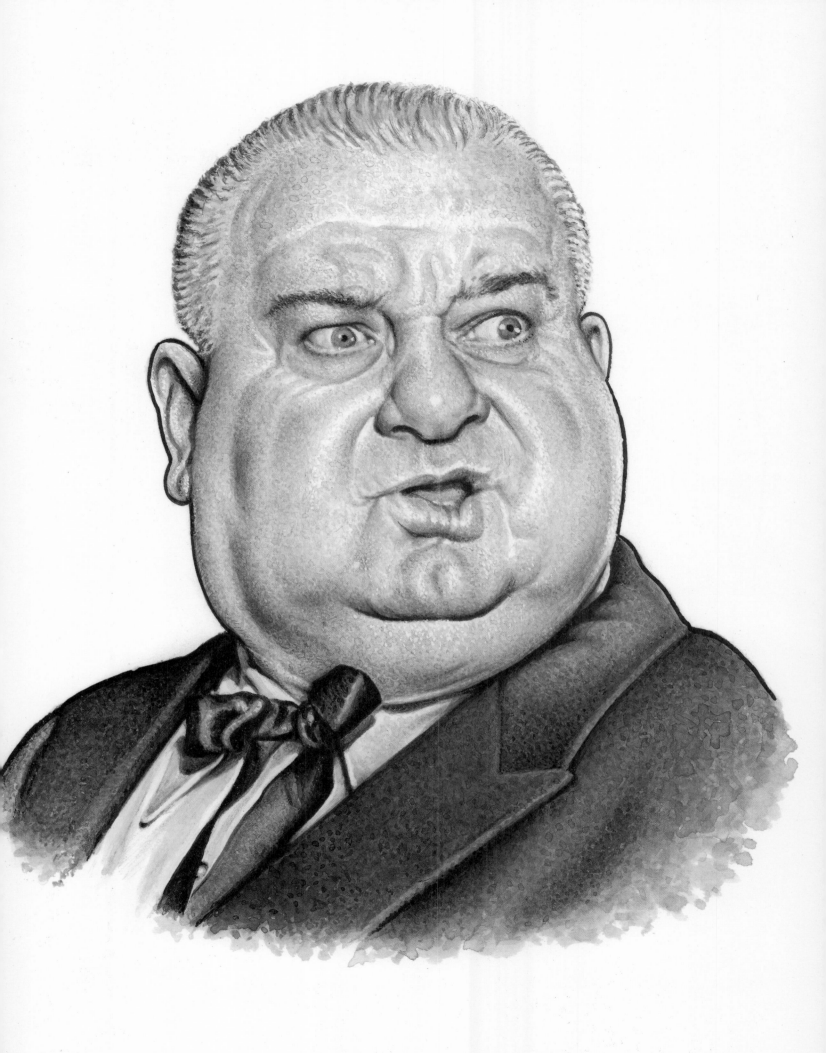

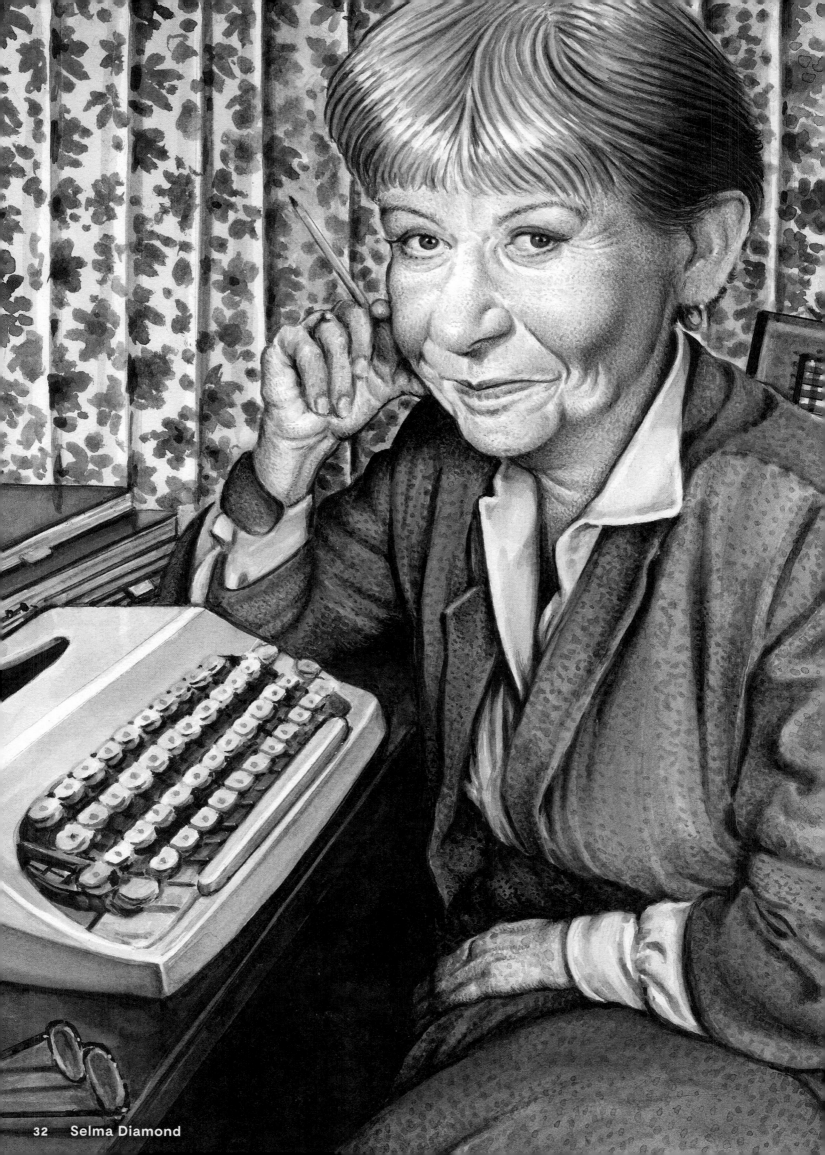

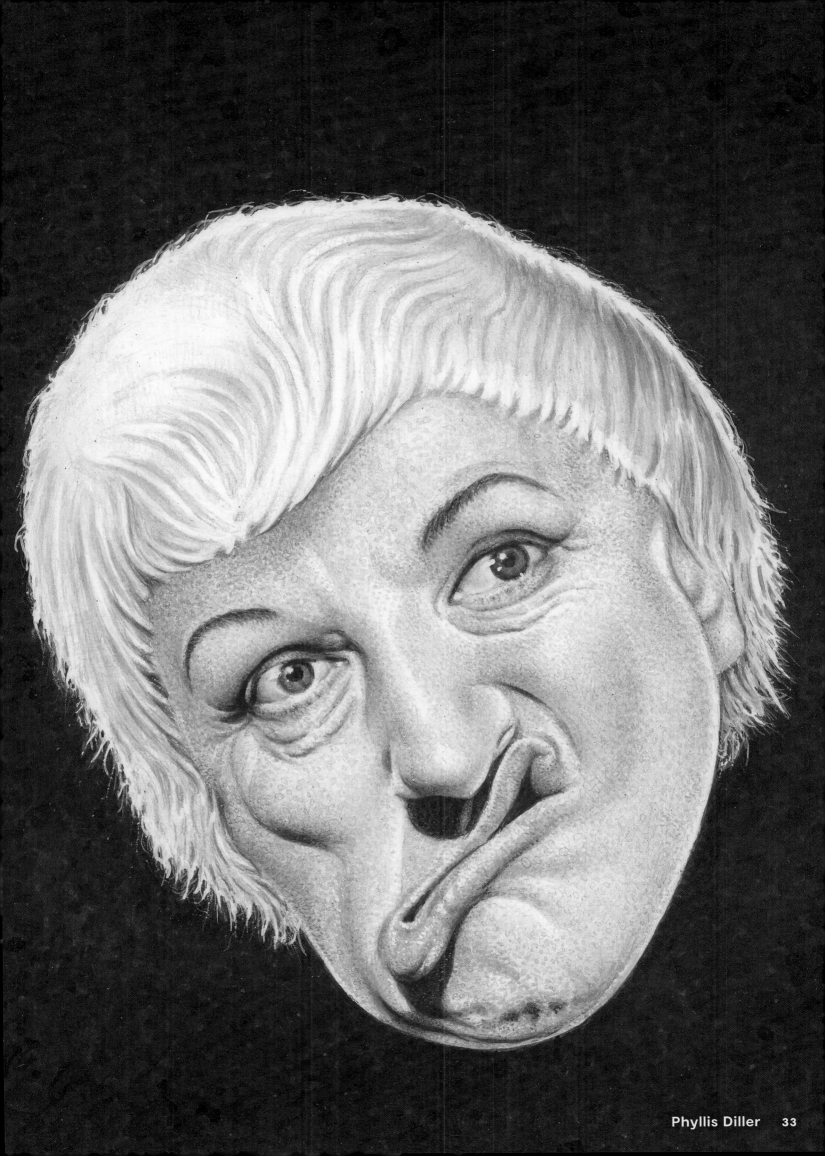

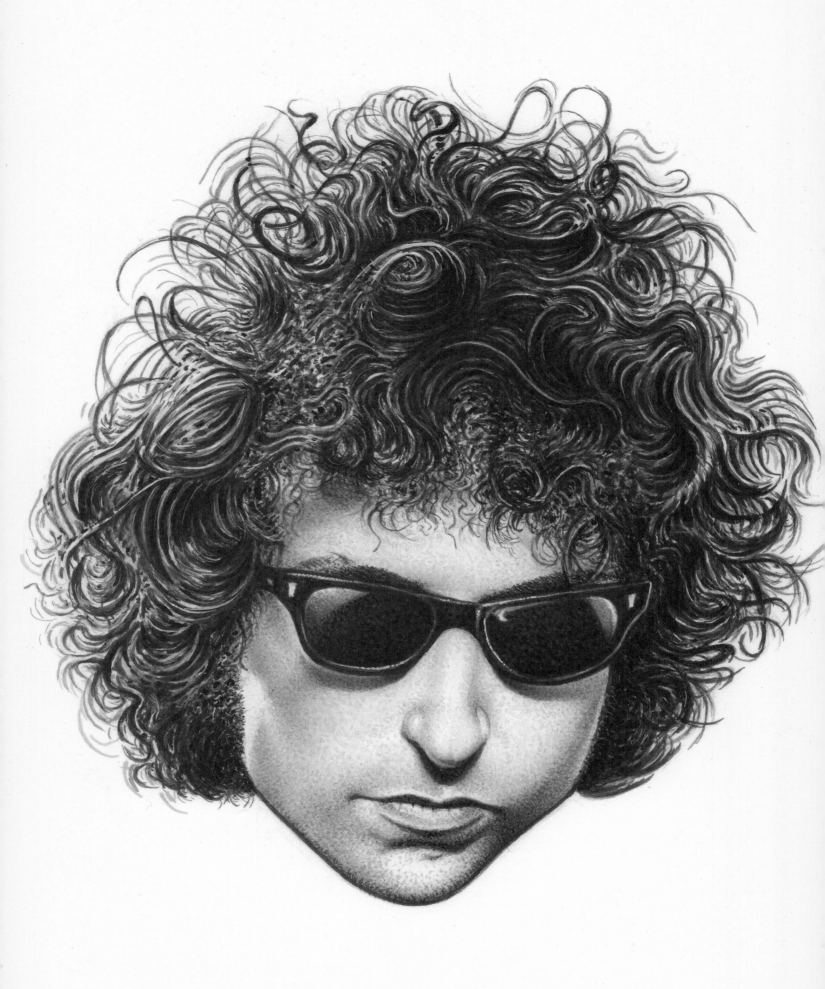

34 Bob Dylan

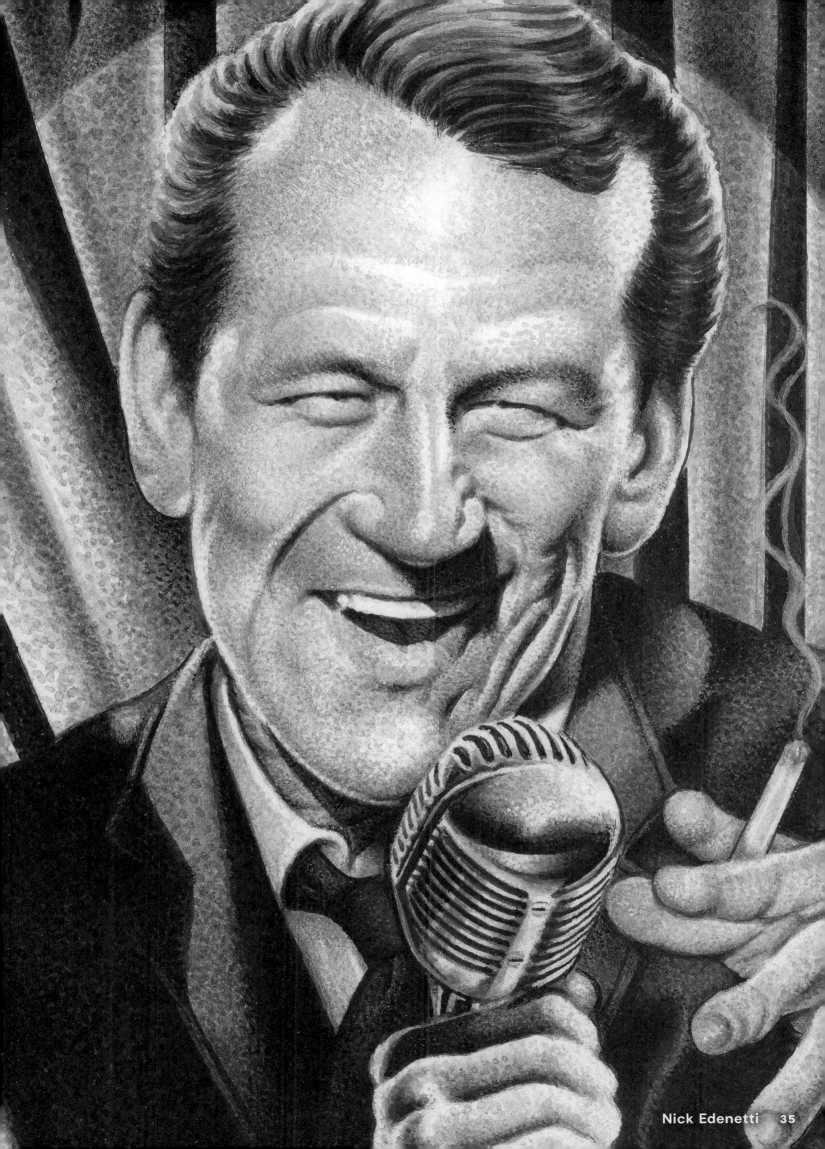

Nick Edenetti 35

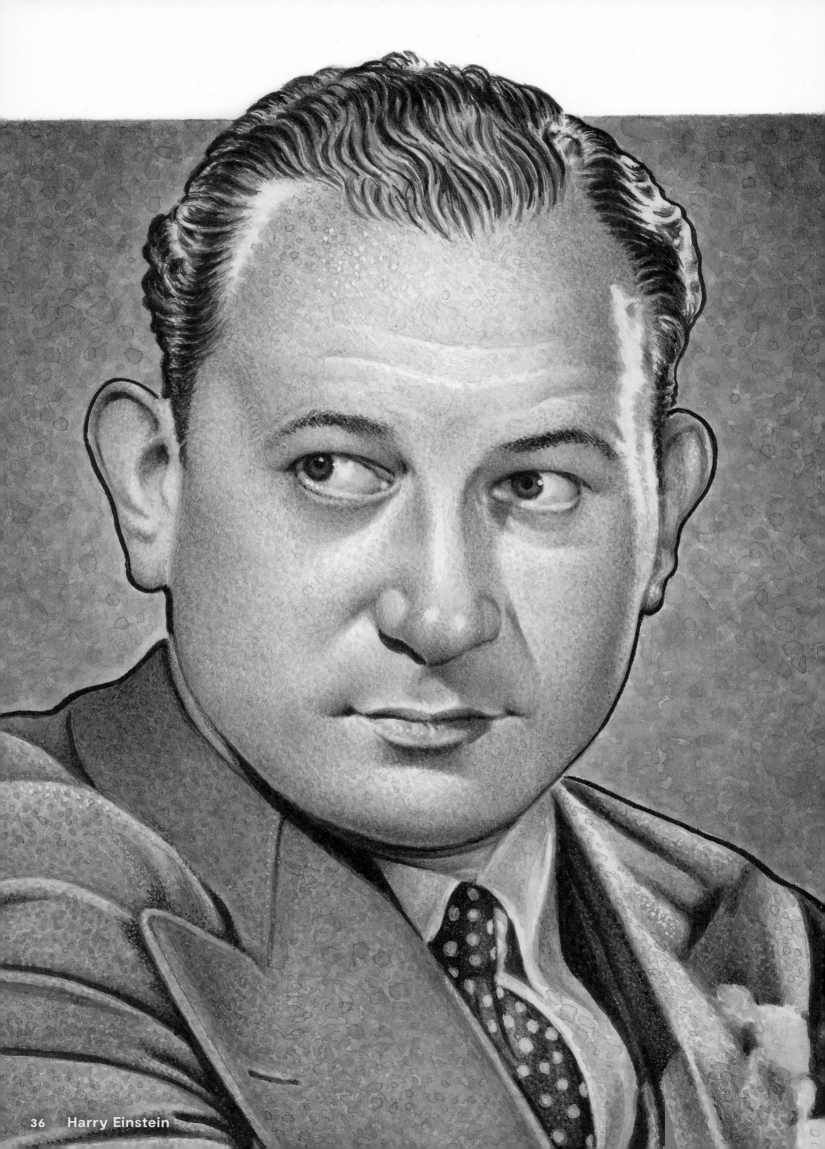

36　Harry Einstein

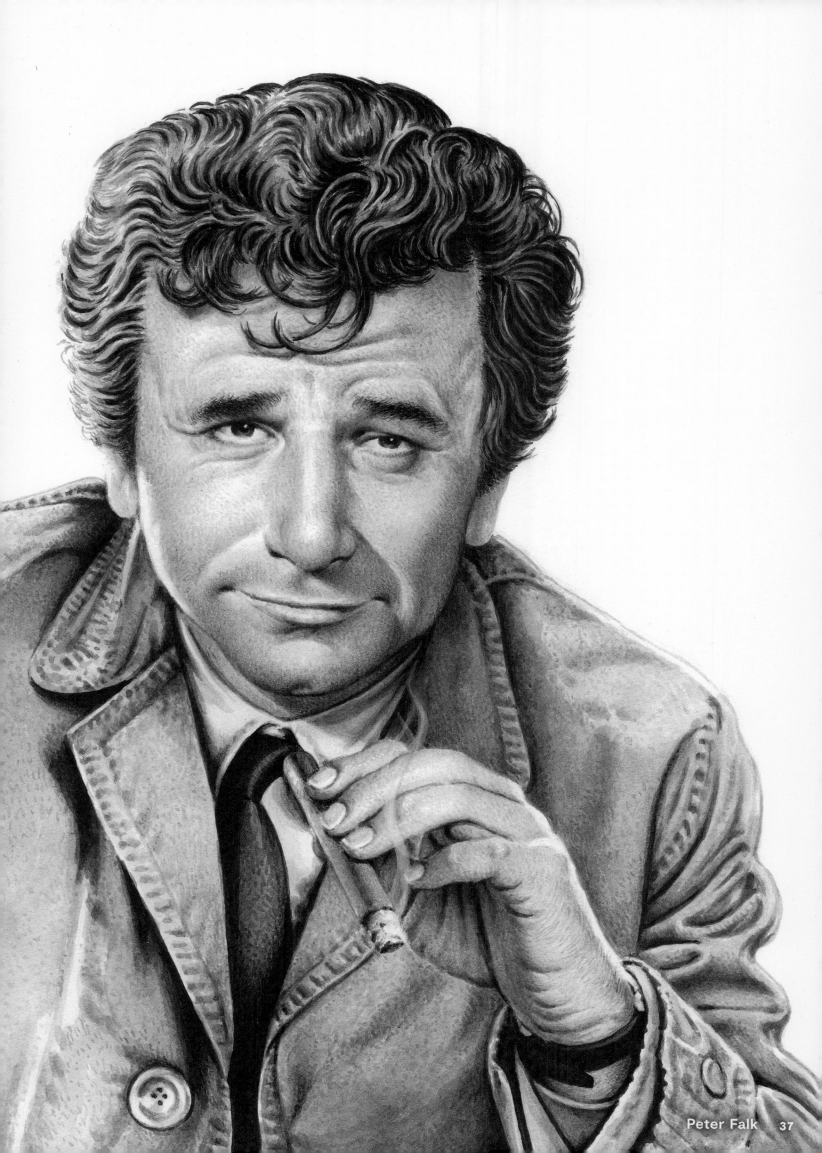

Peter Falk 37

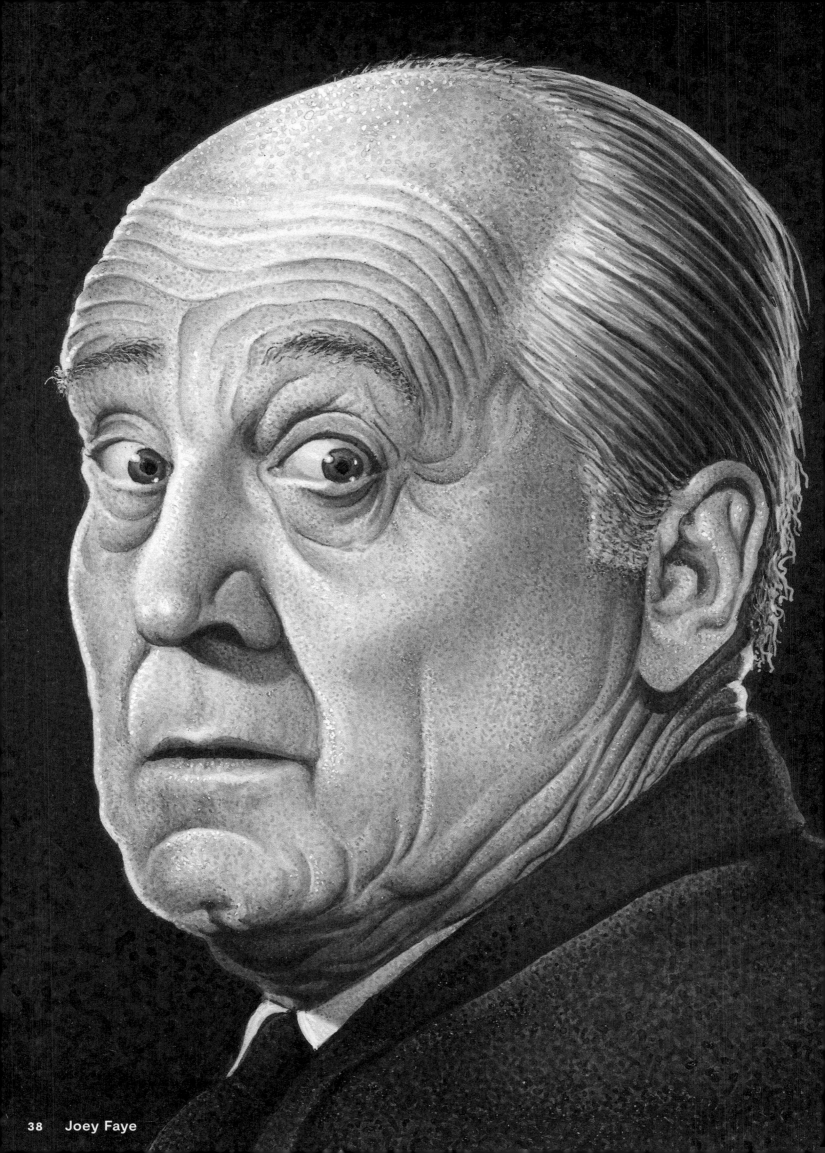

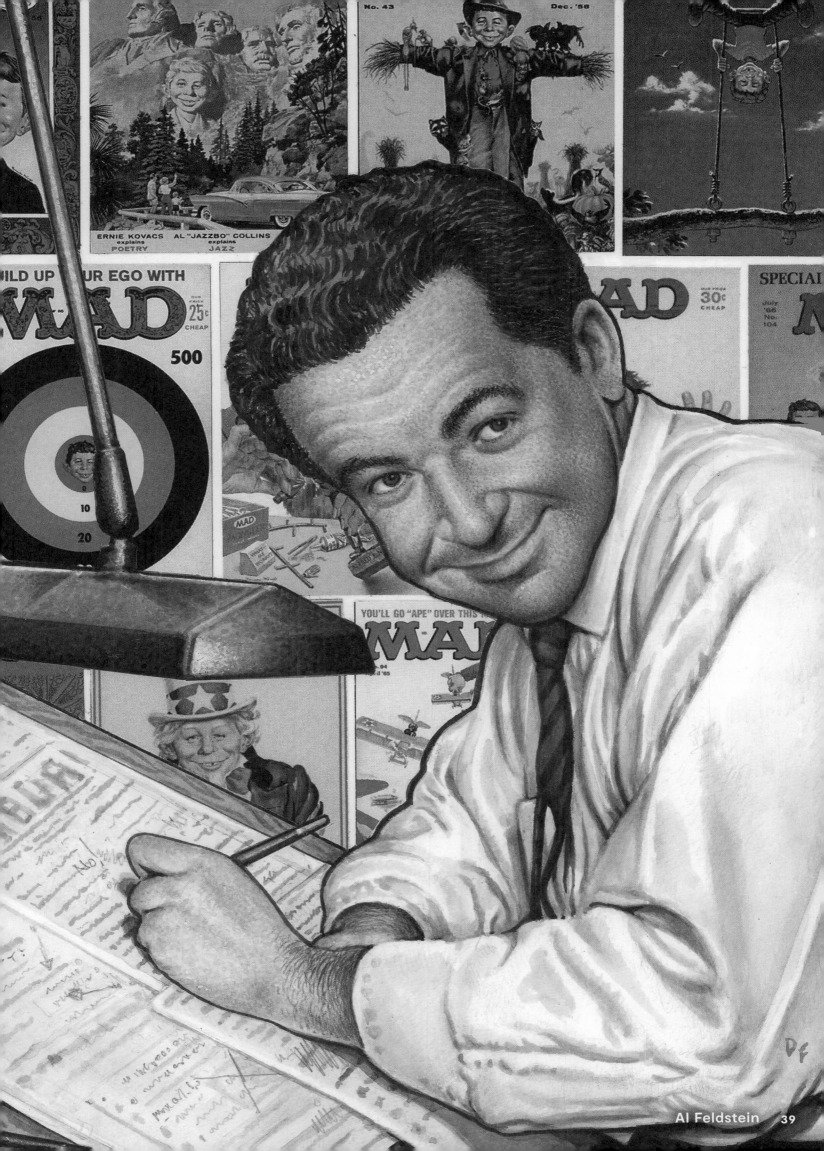

Al Feldstein 39

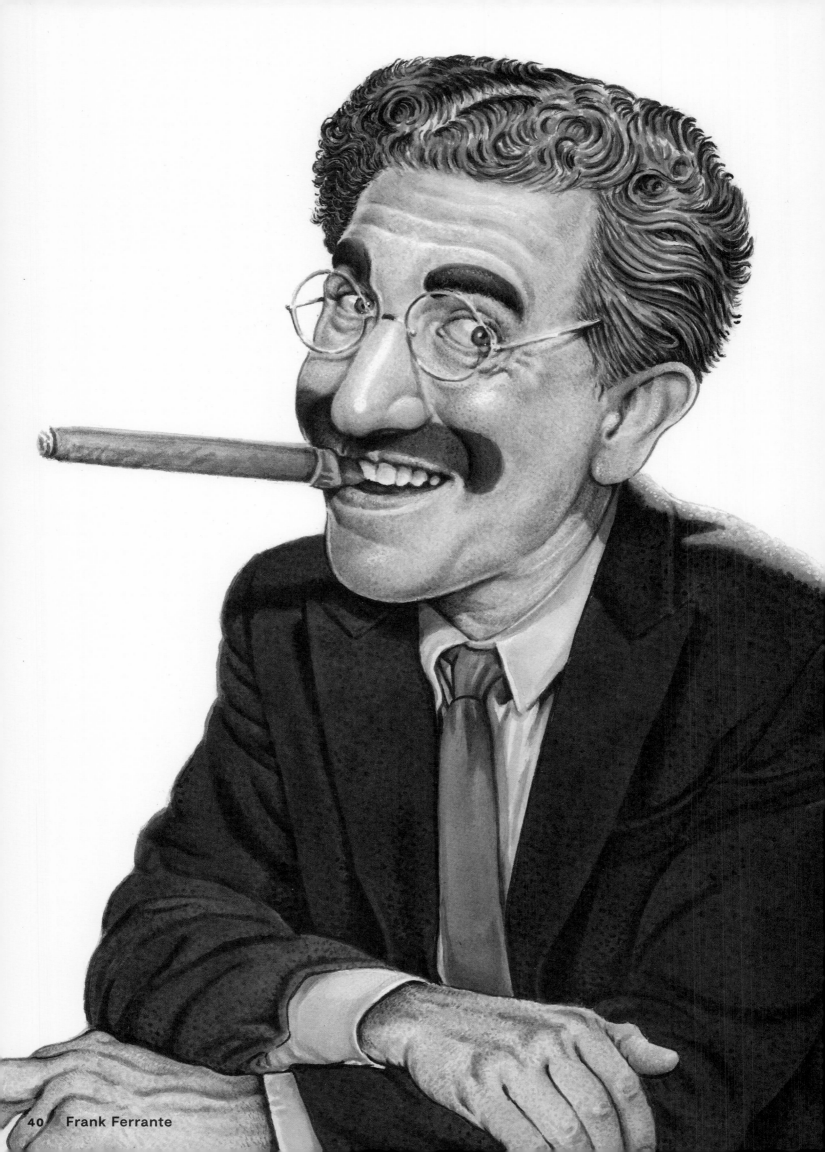

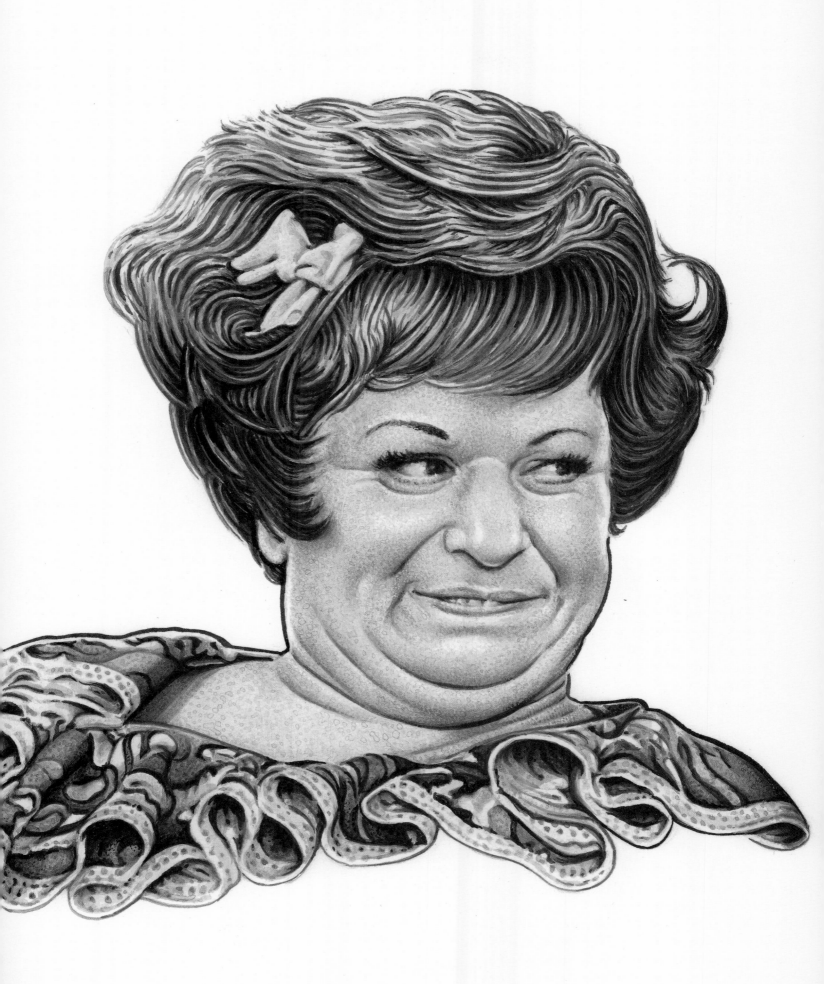

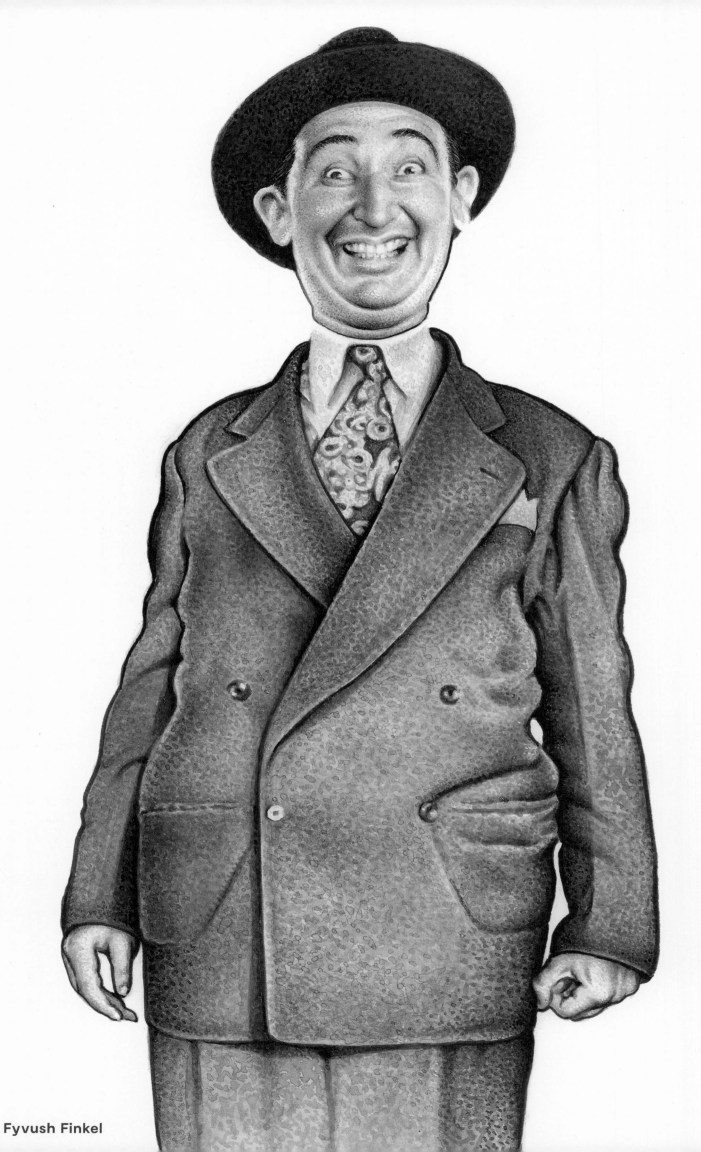

Fyvush Finkel

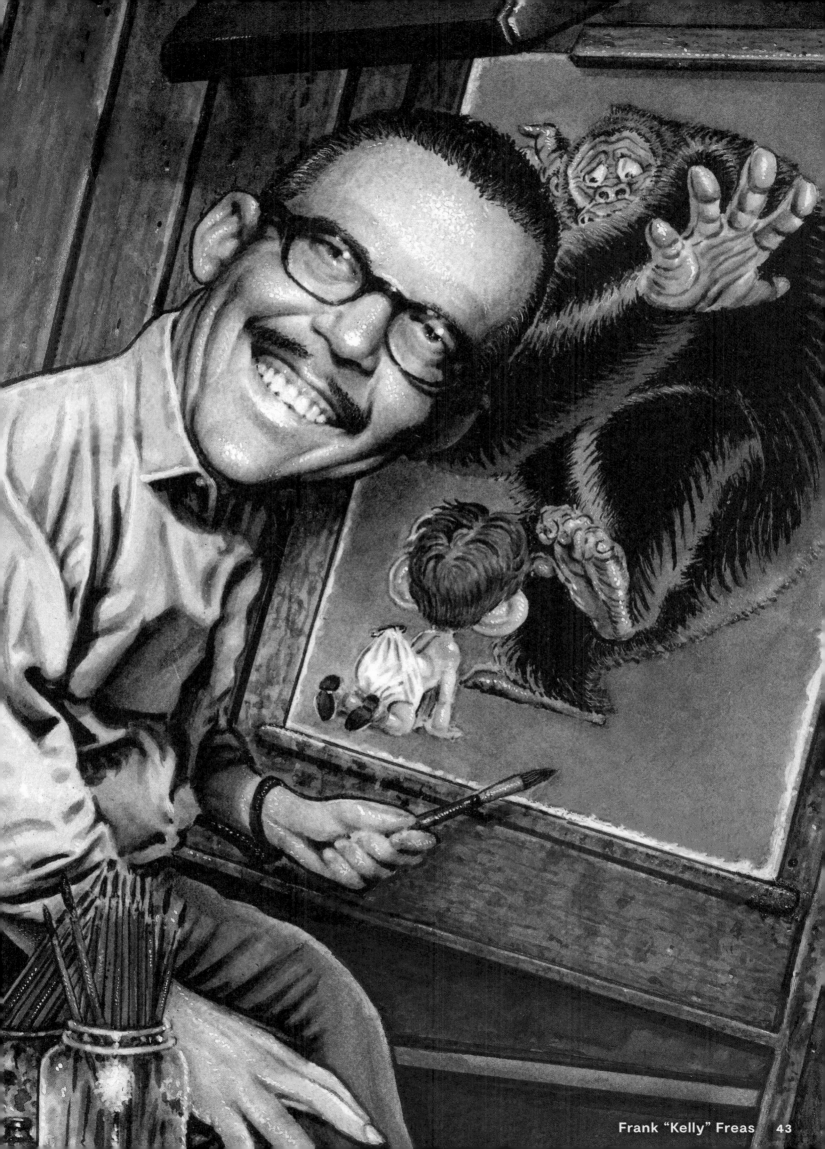

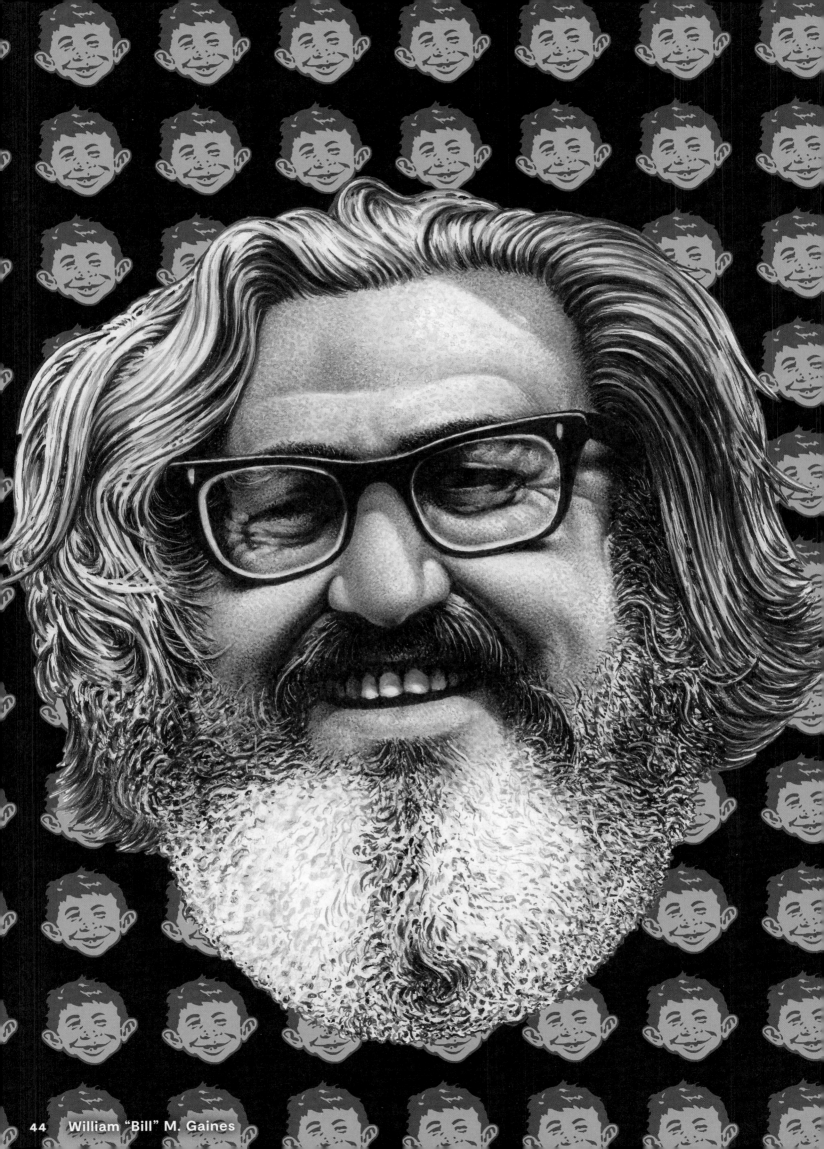

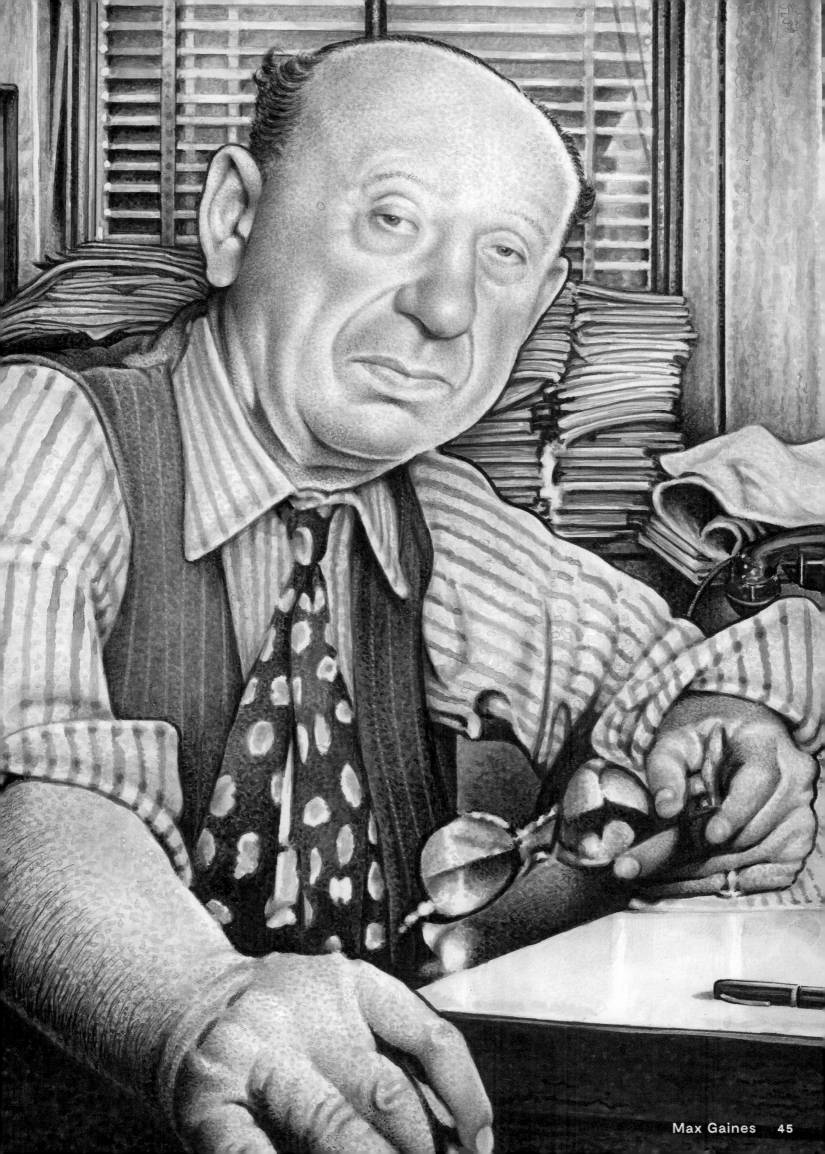

Max Gaines 45

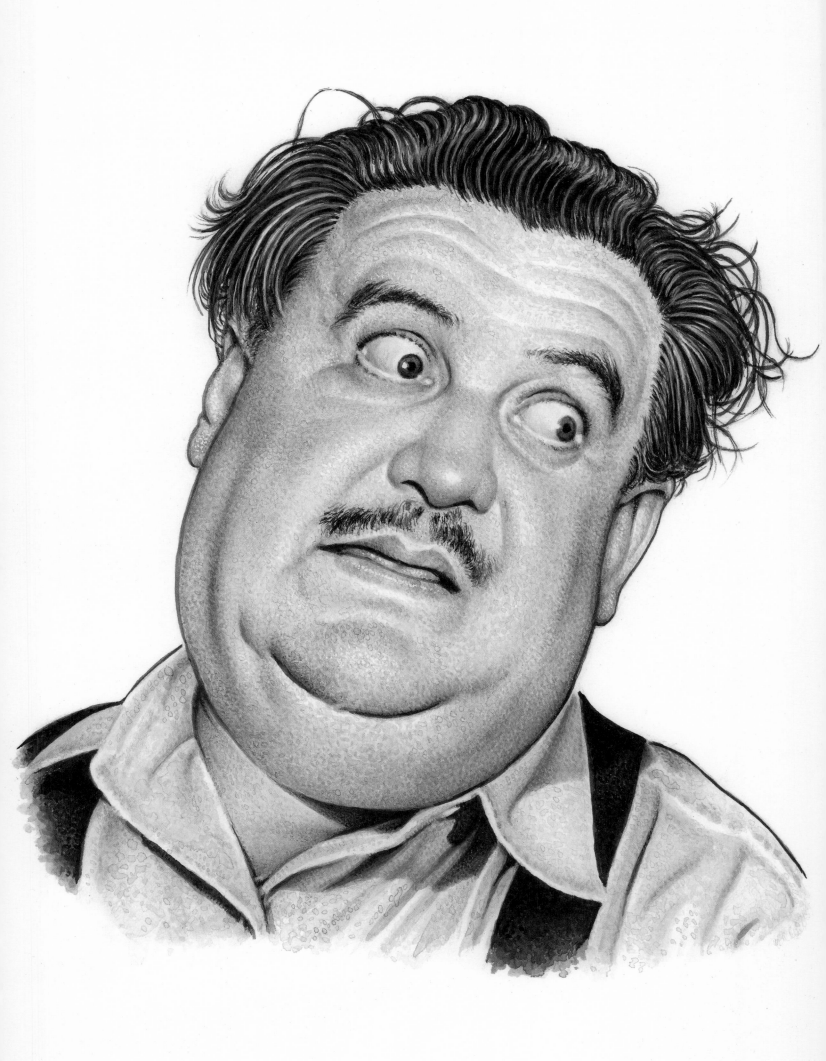

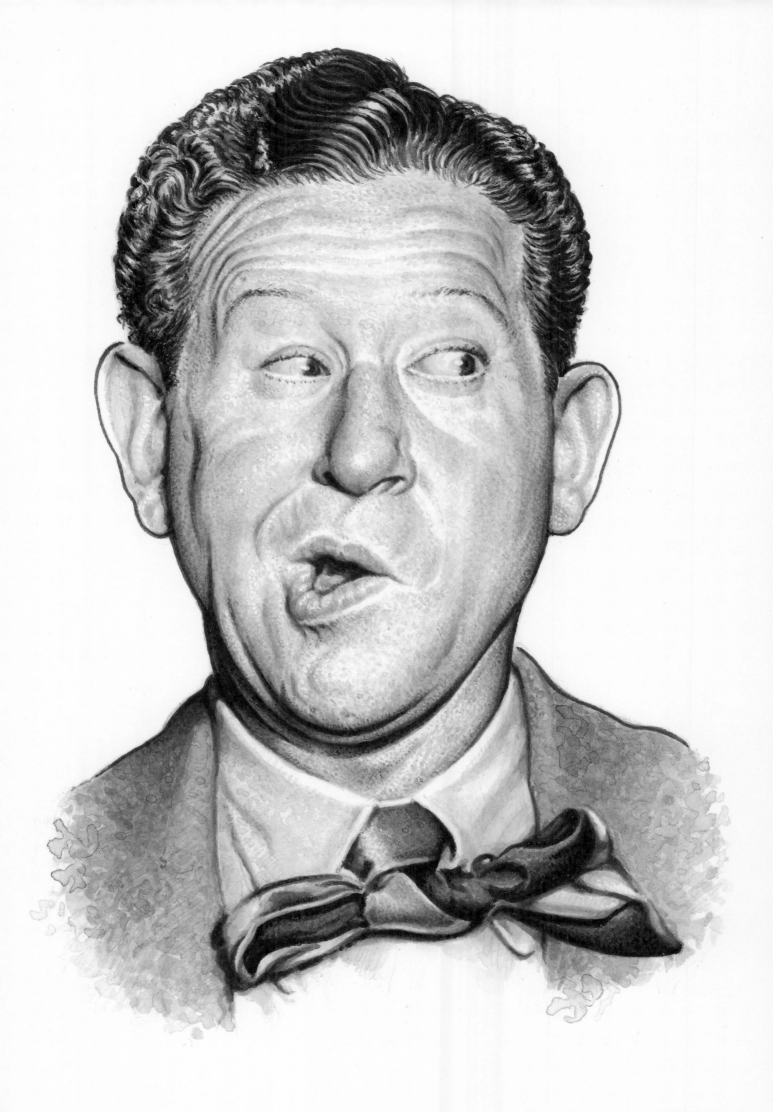

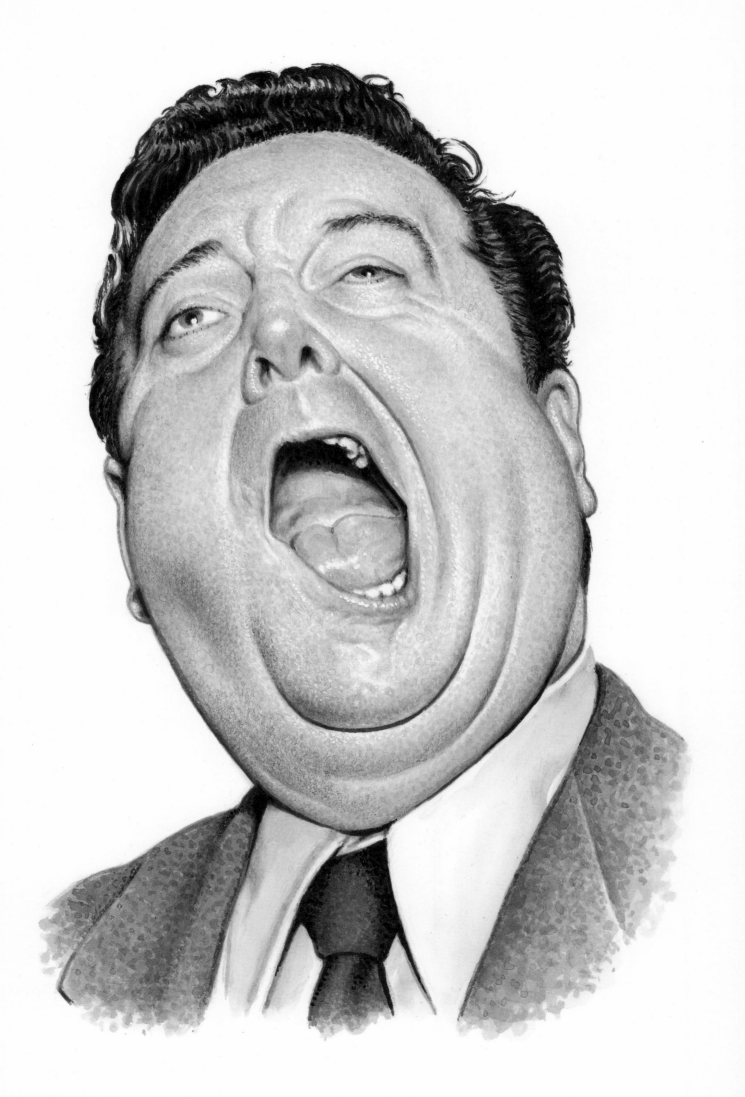

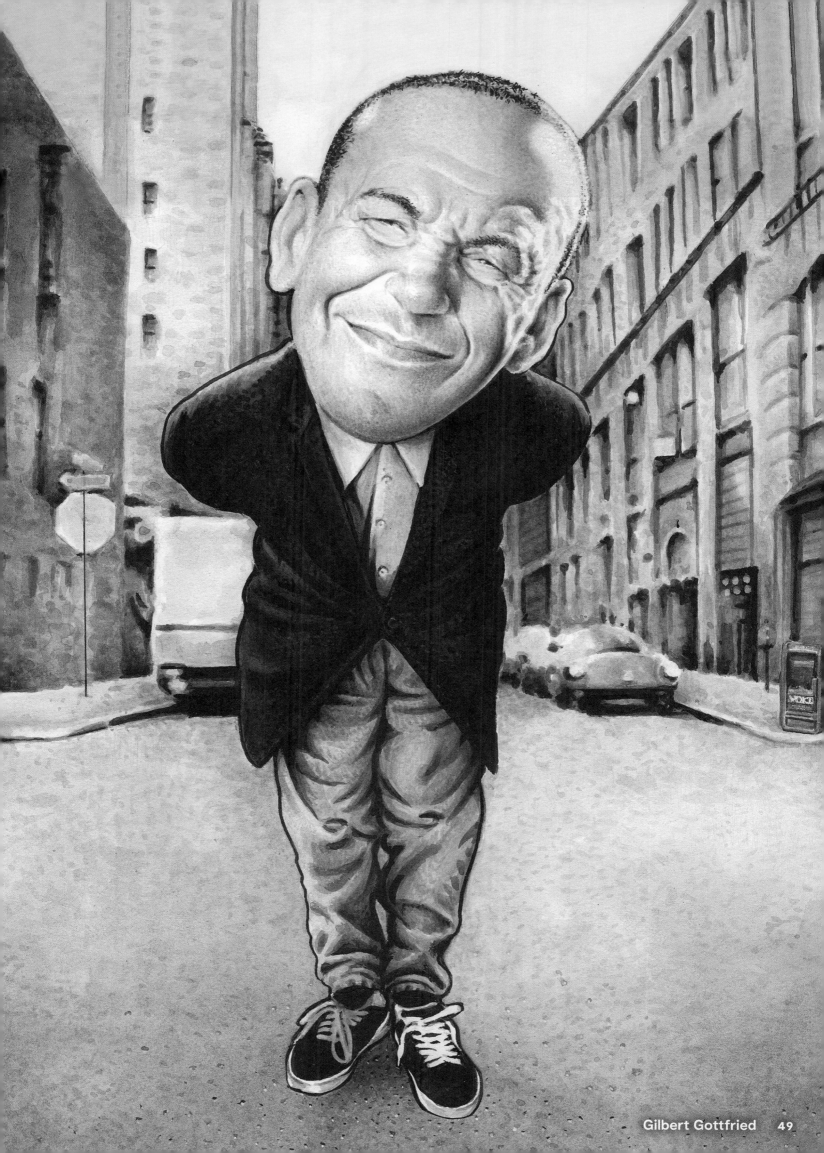

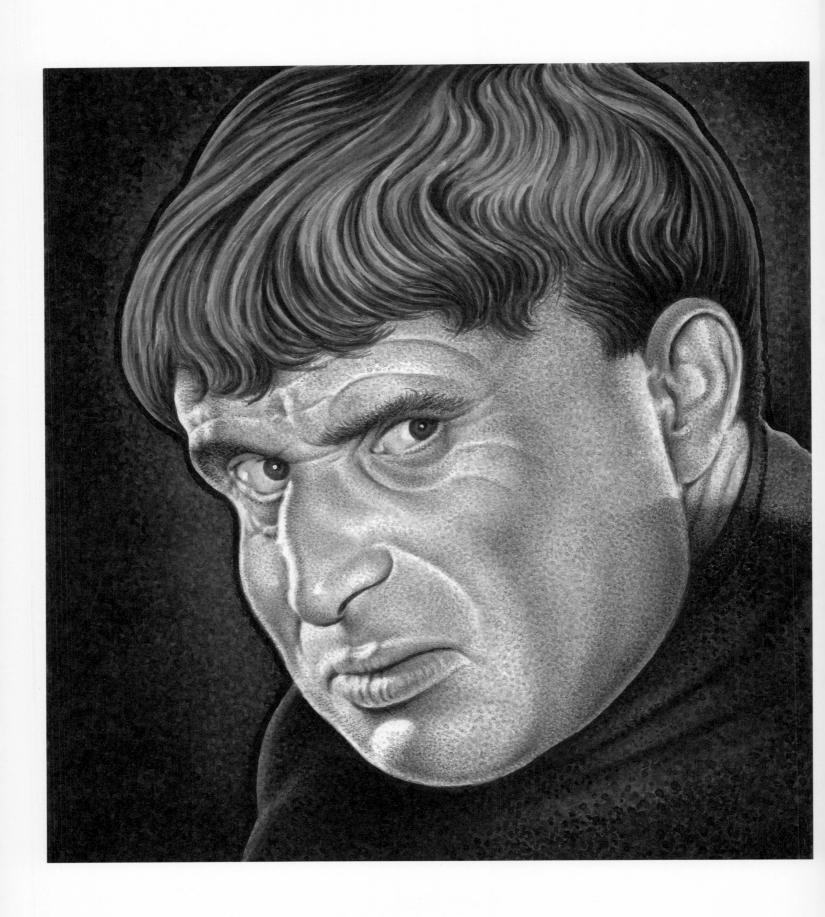

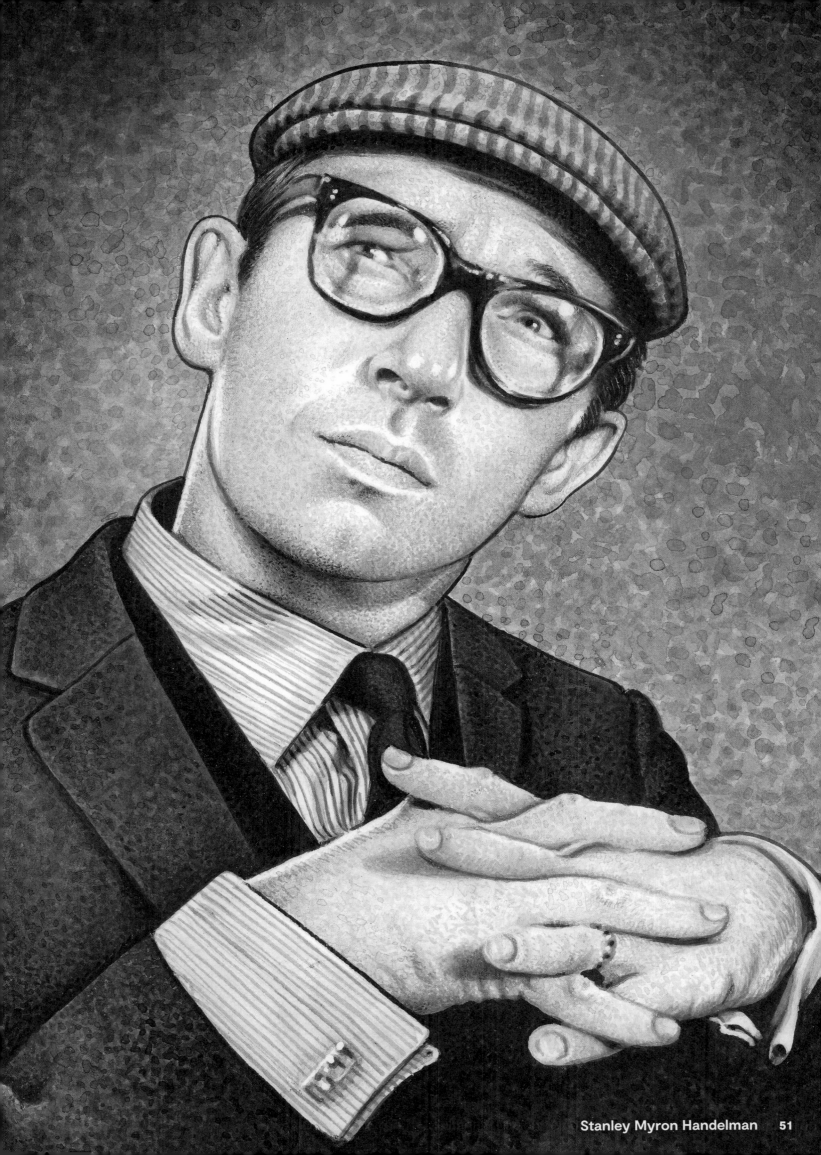

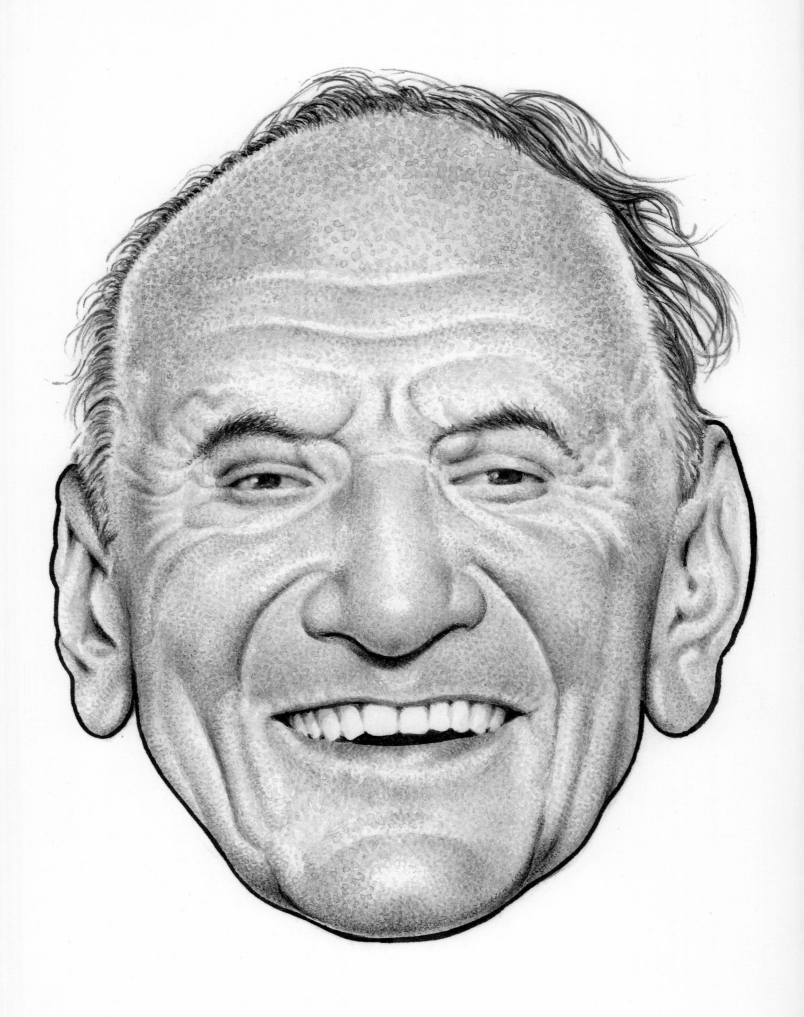

Manuel "Van" Harris

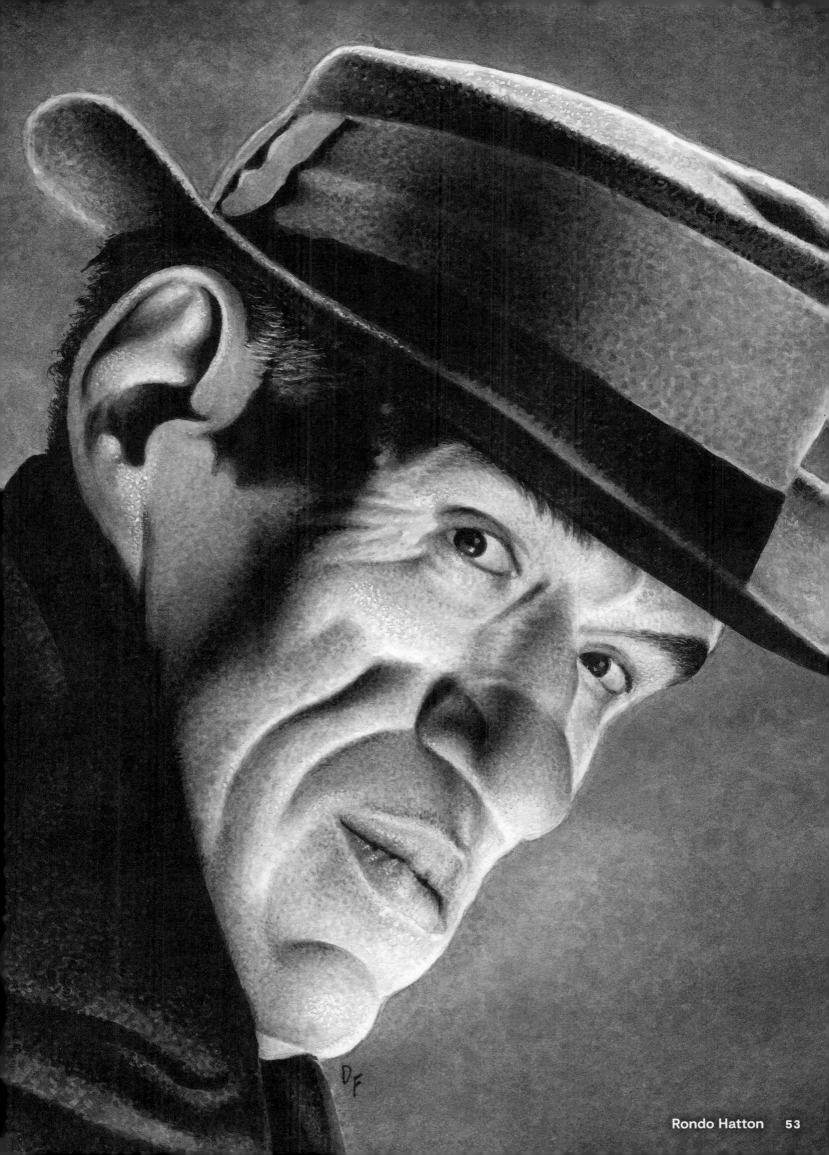

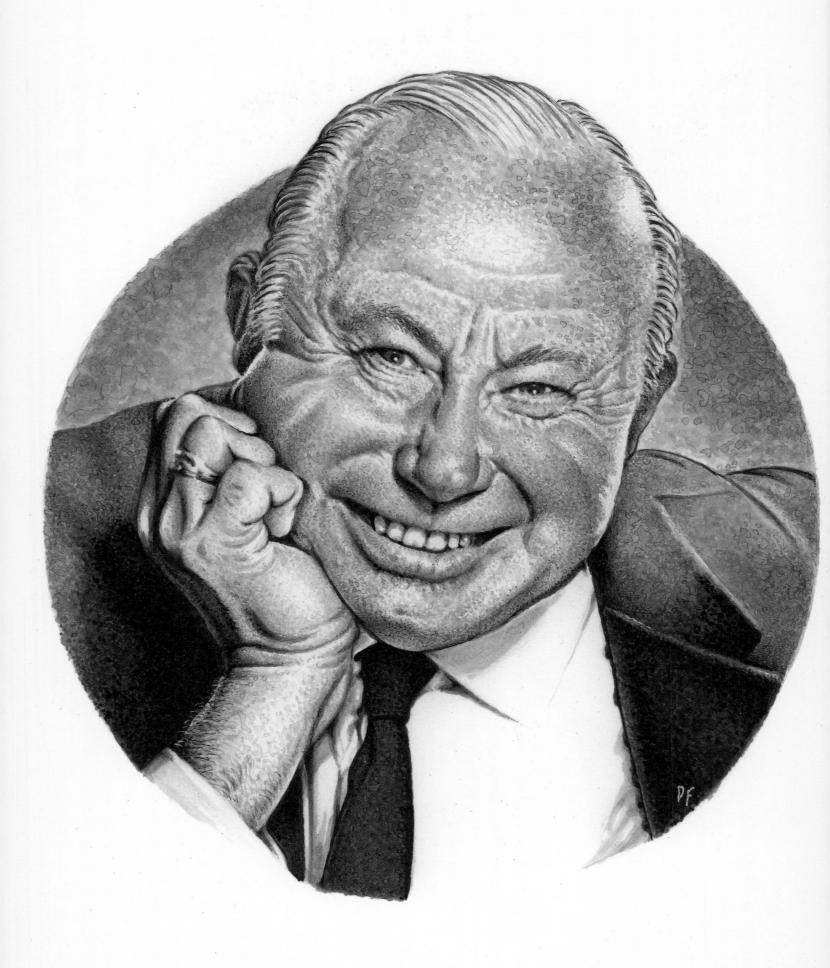

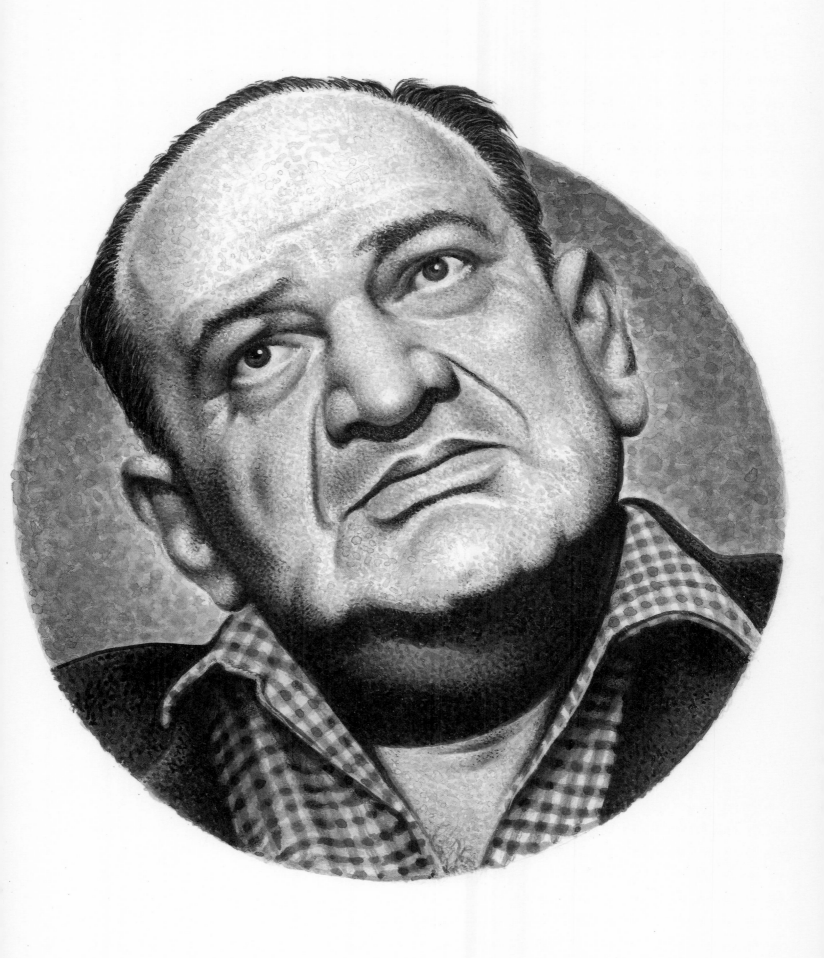

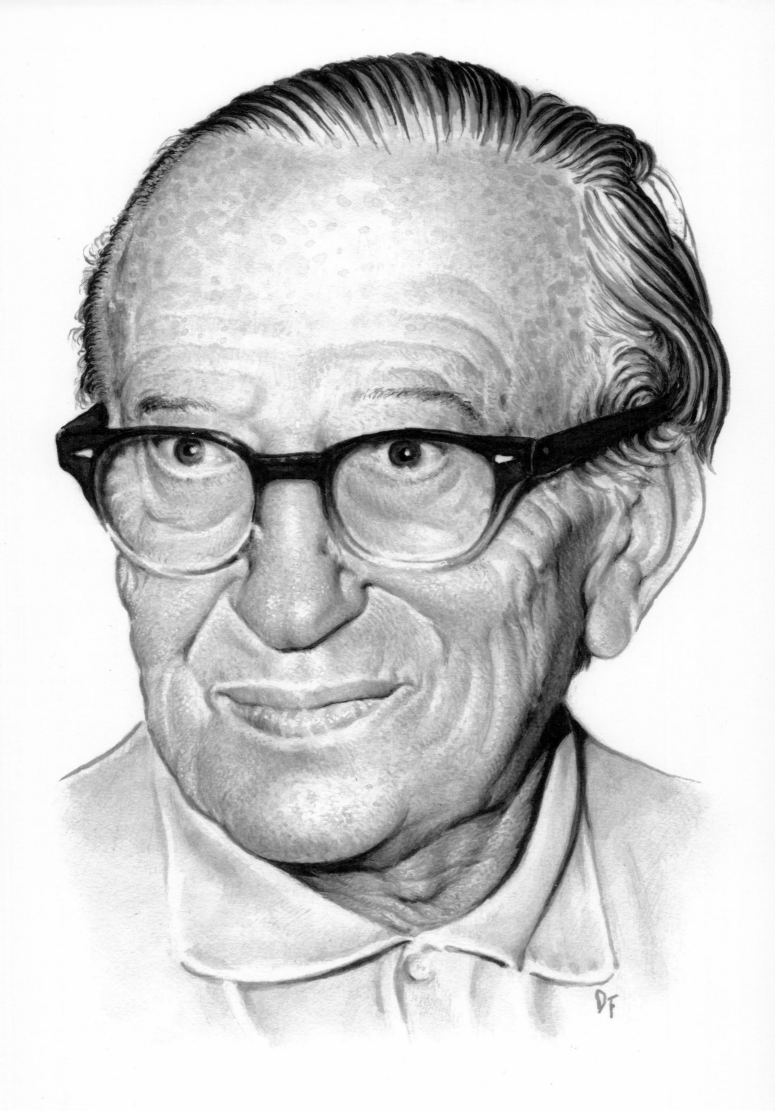

56 Lou Holtz

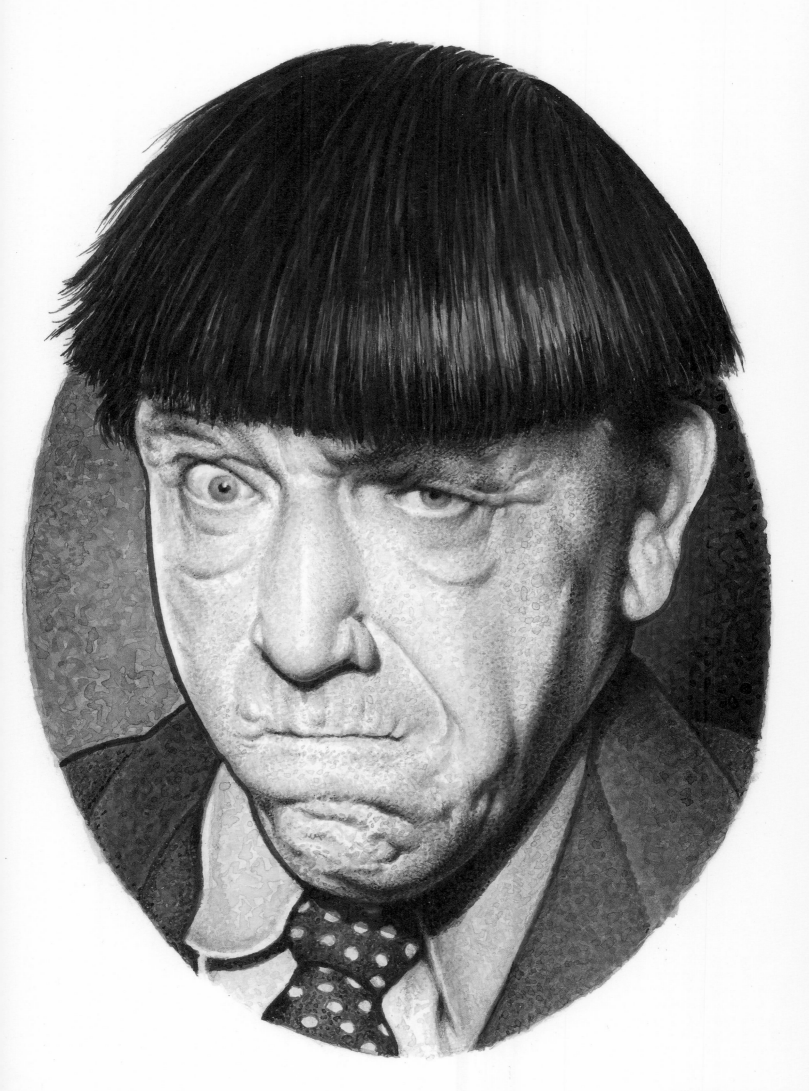

Moe Howard 57

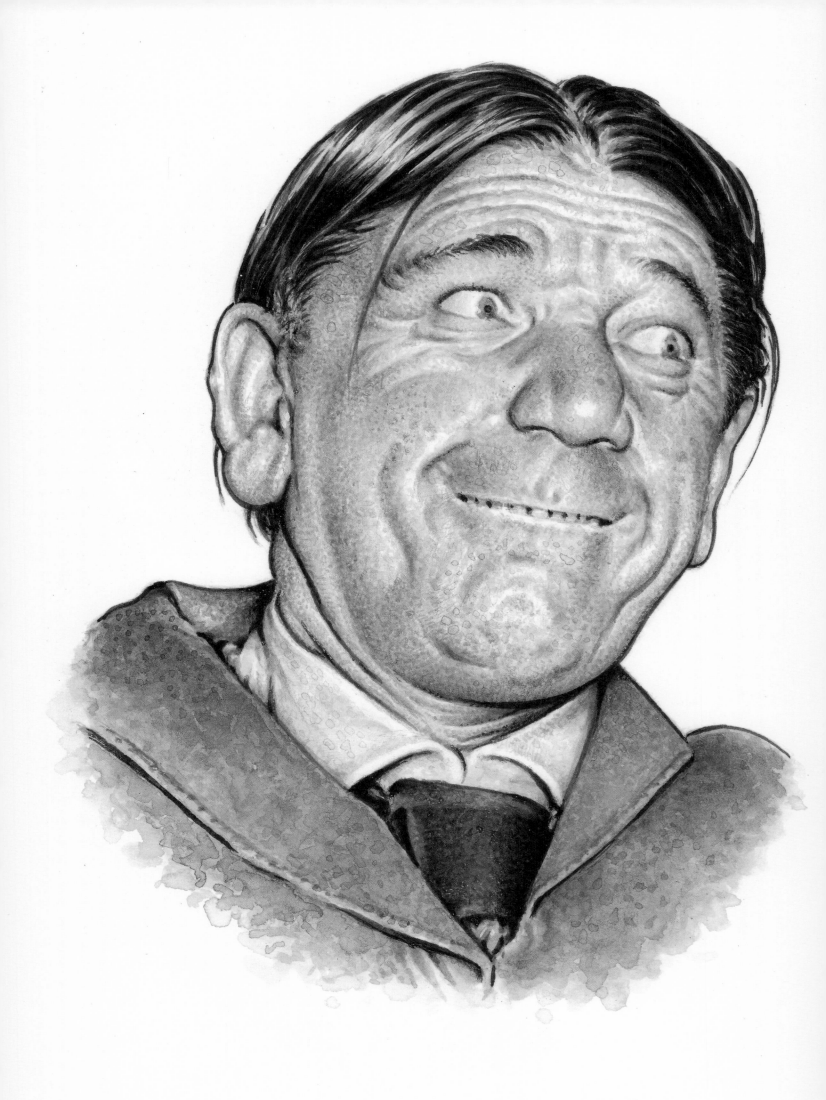

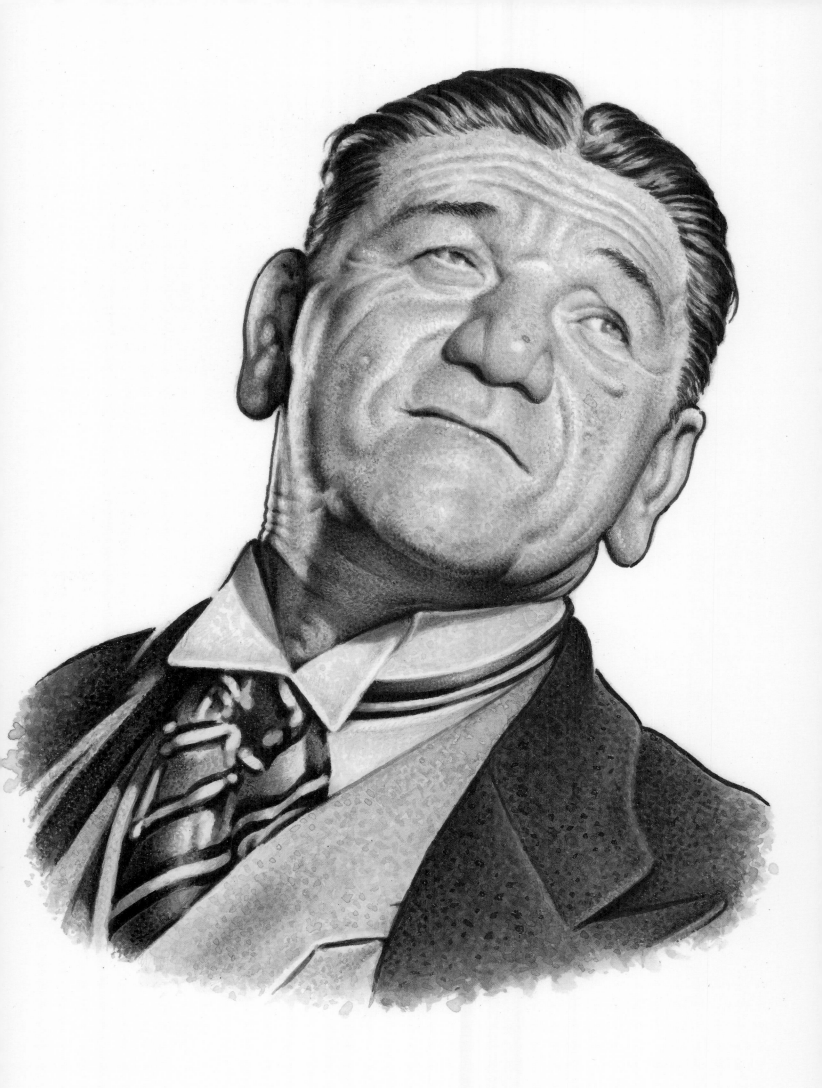

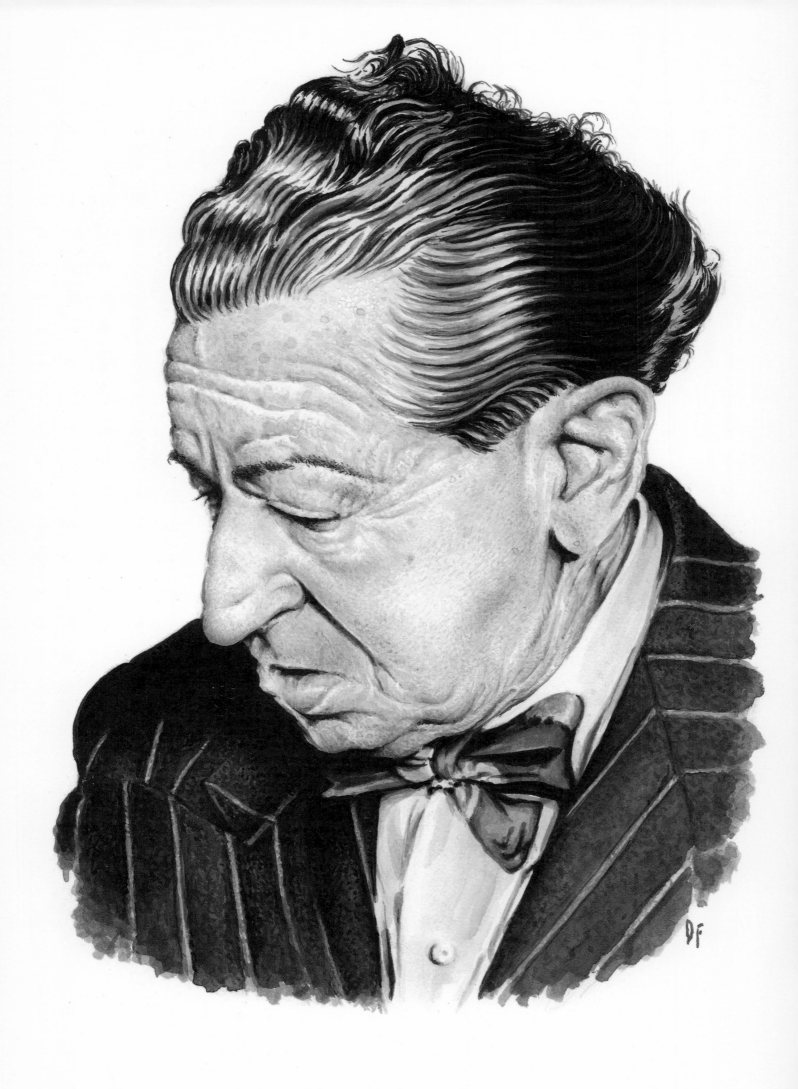

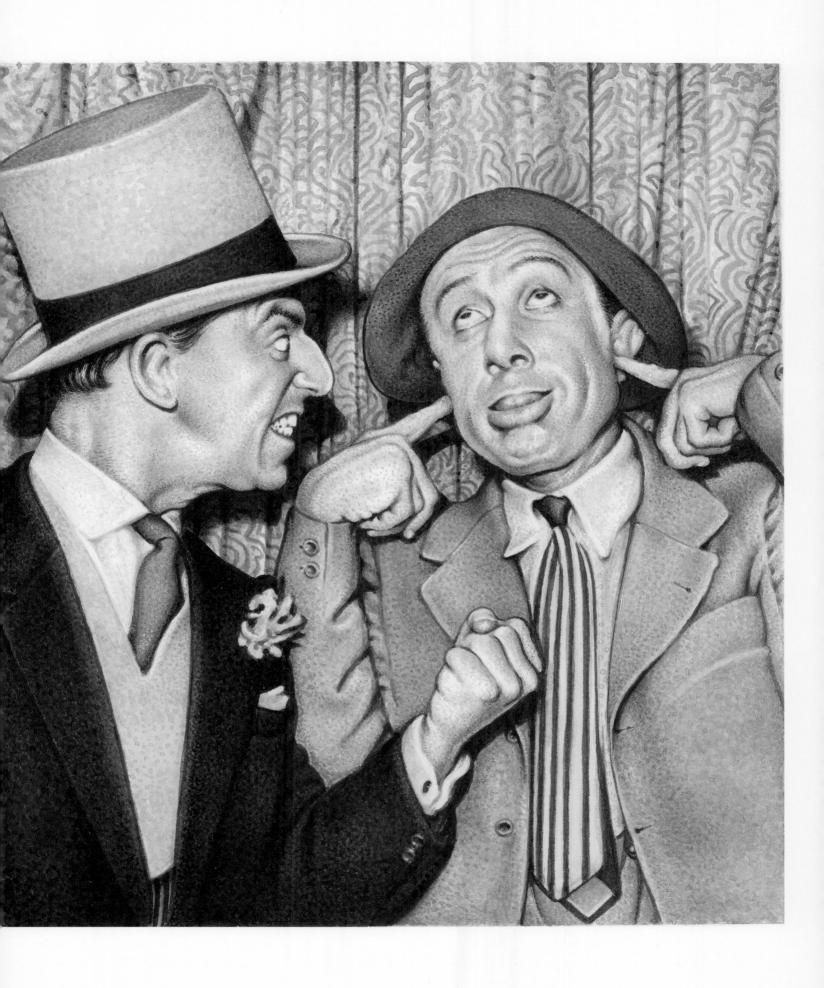

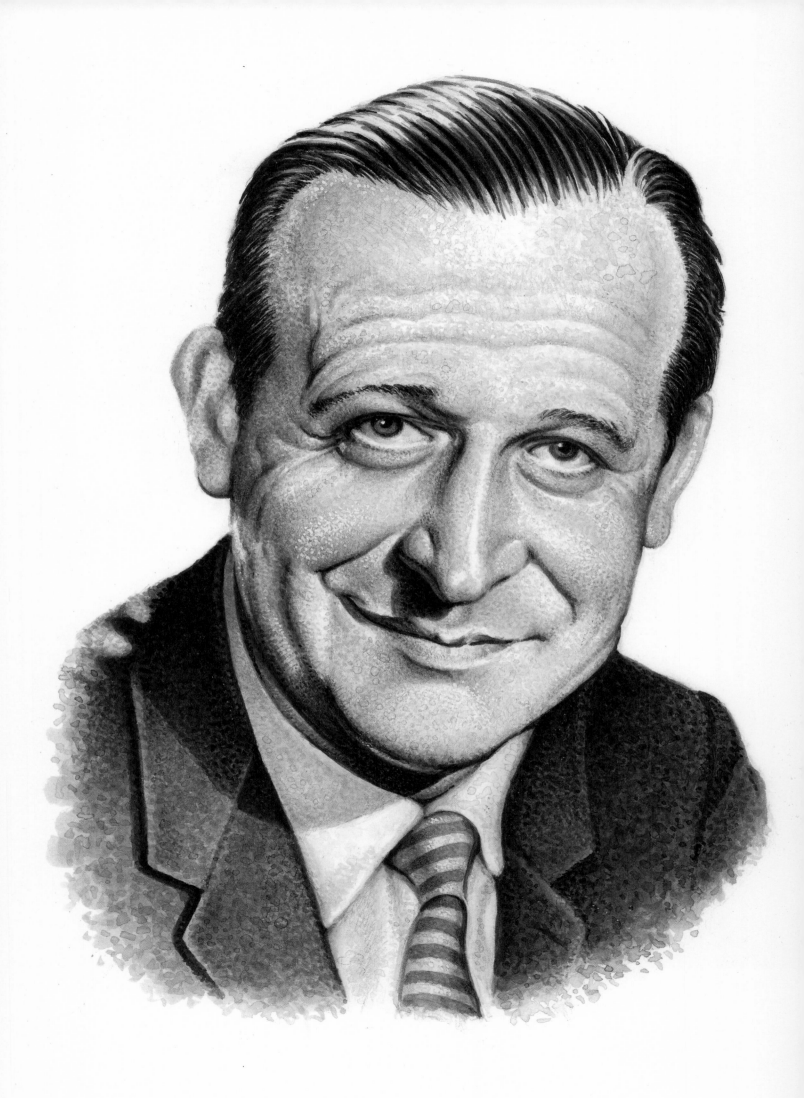

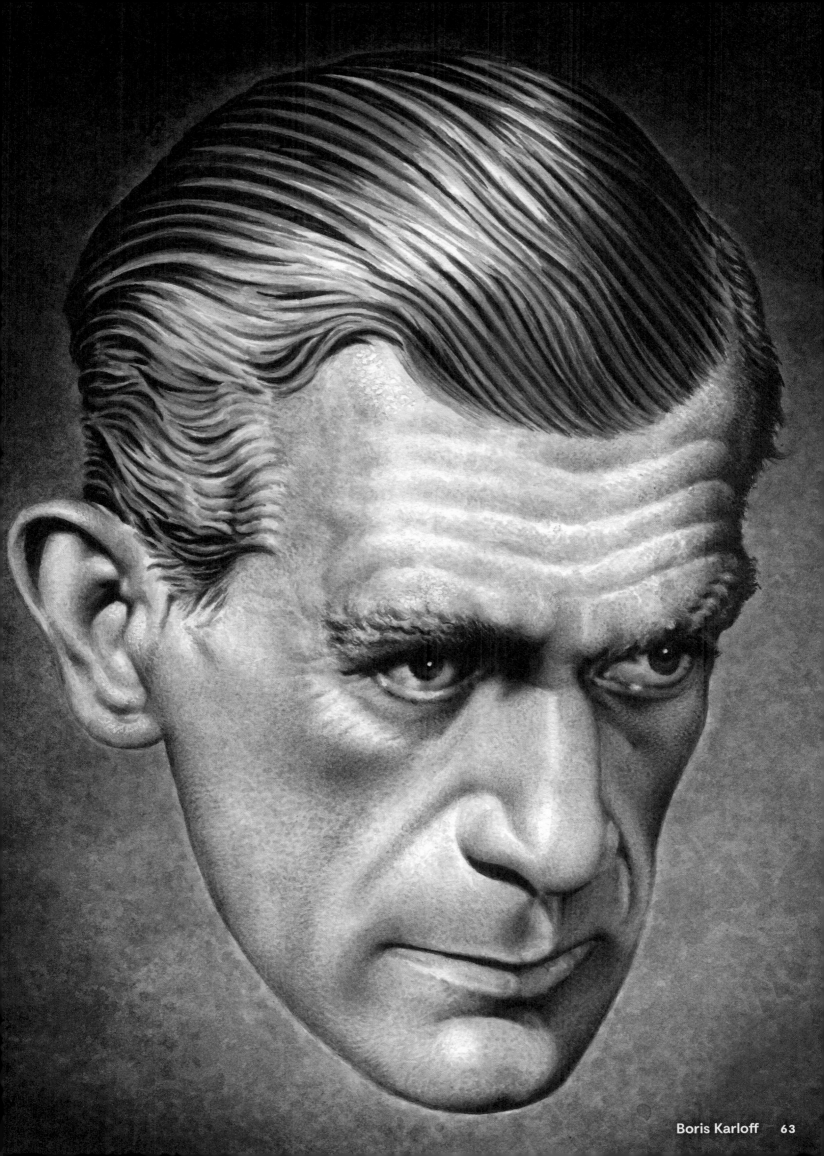

Boris Karloff 63

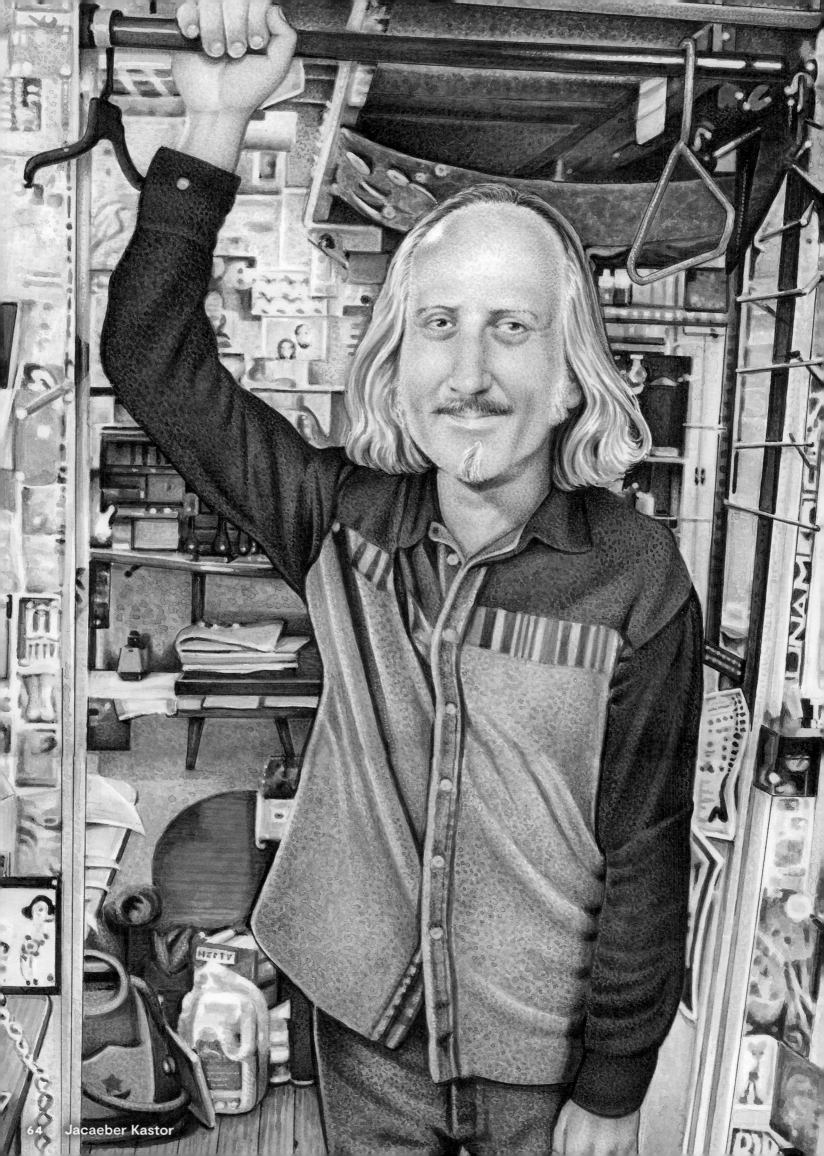

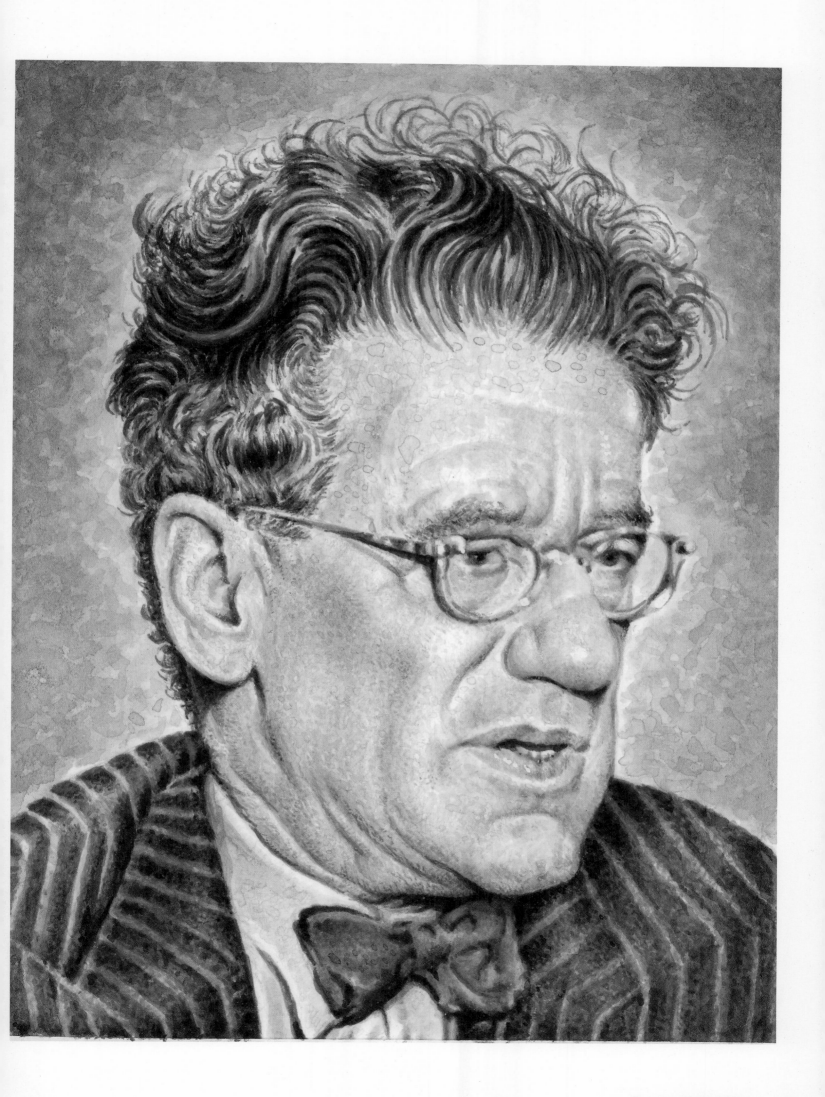

George S. Kaufman **65**

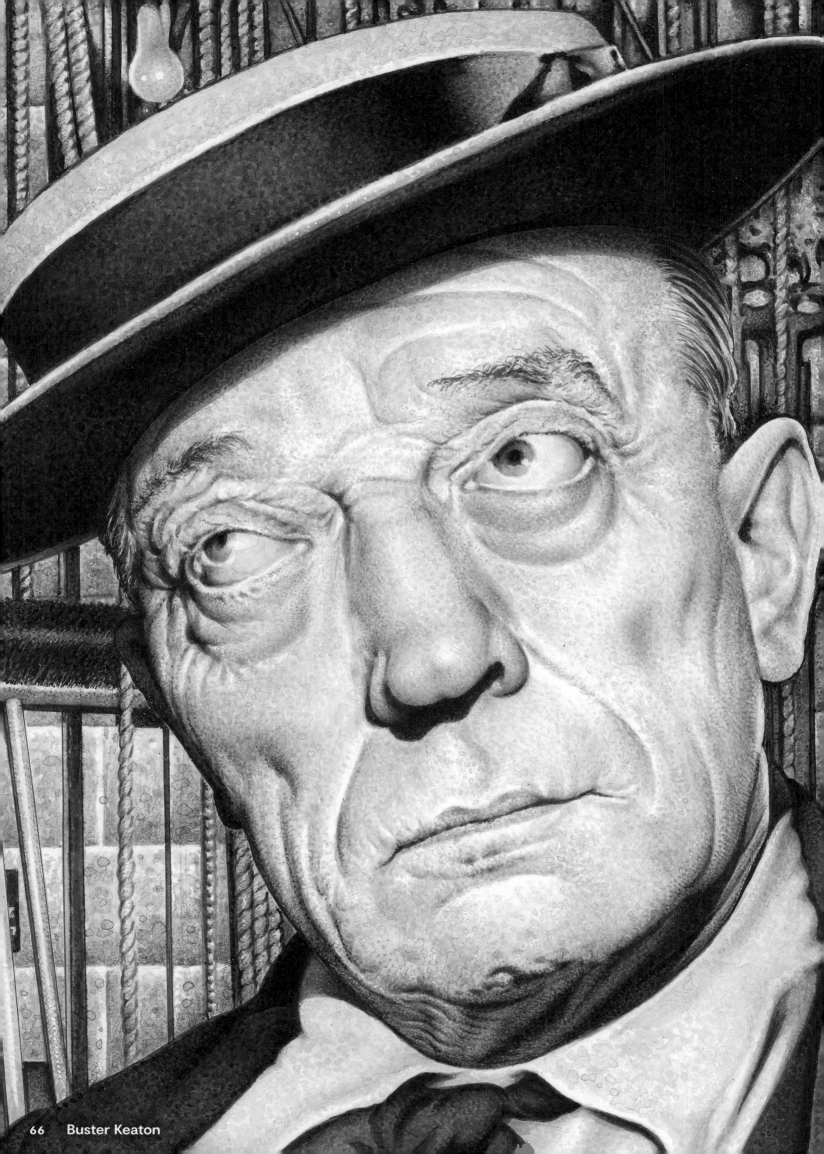

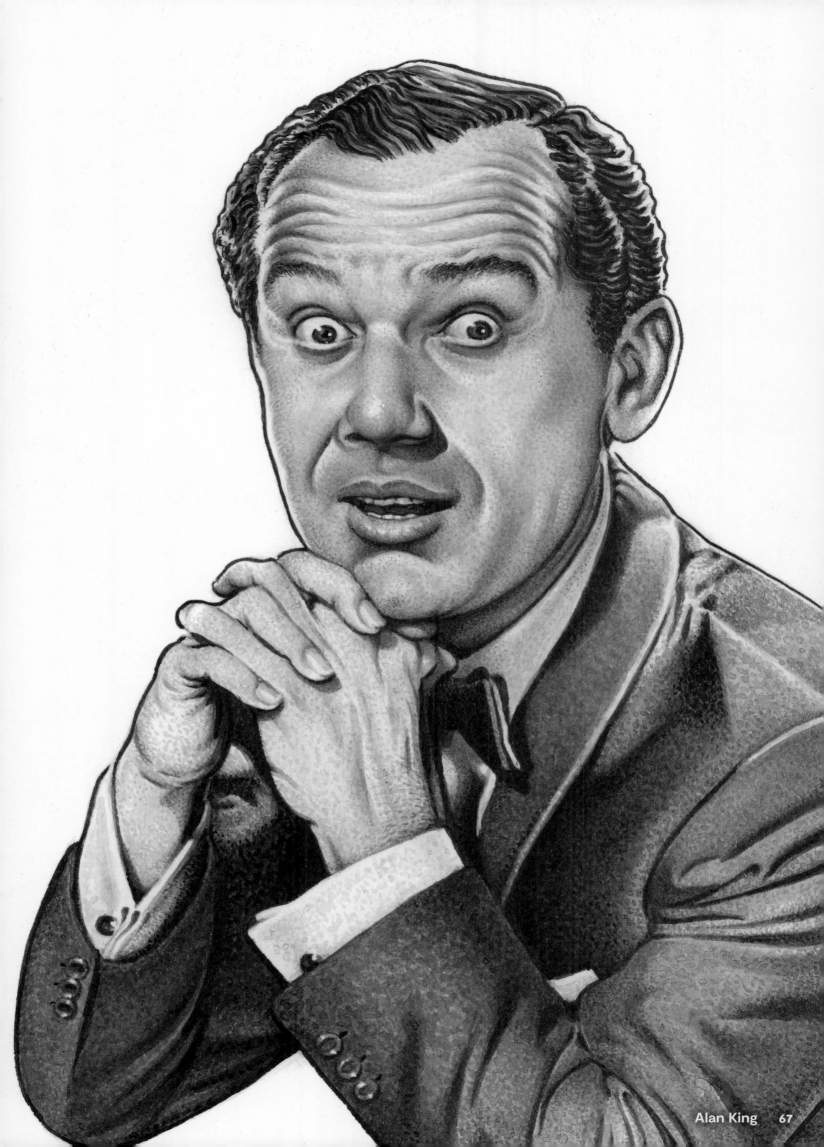

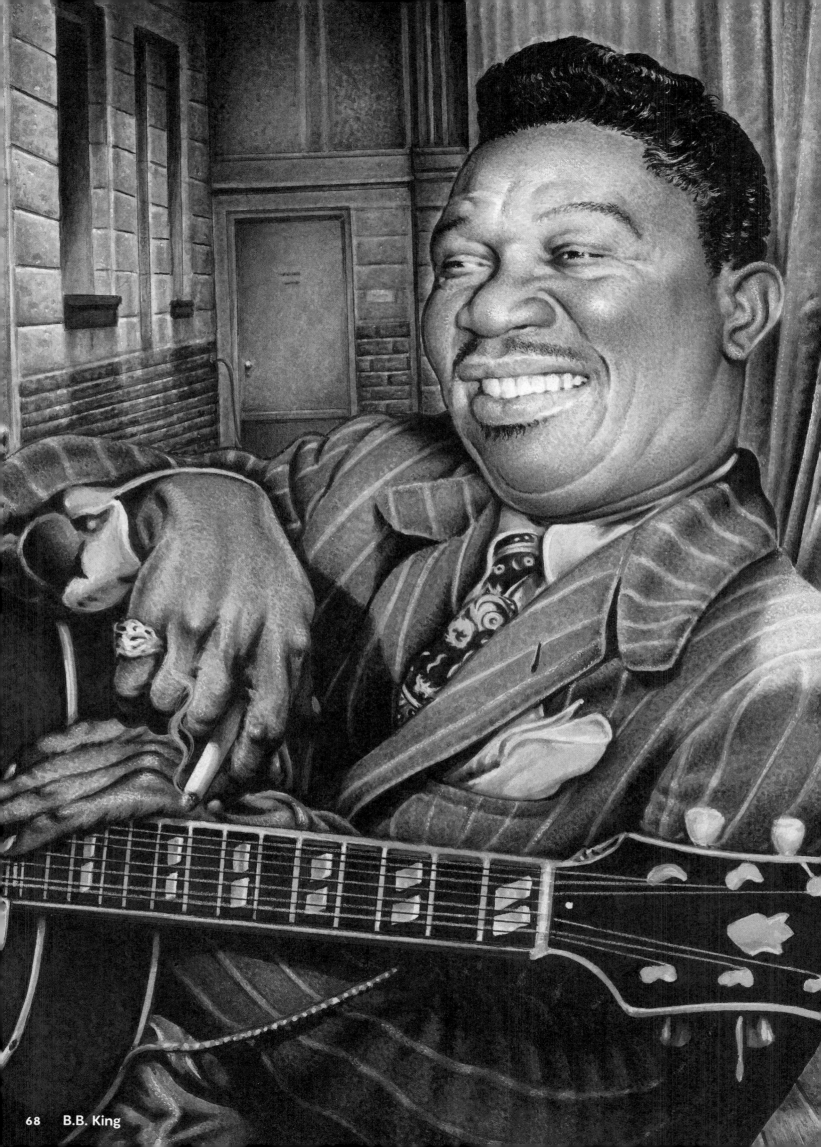

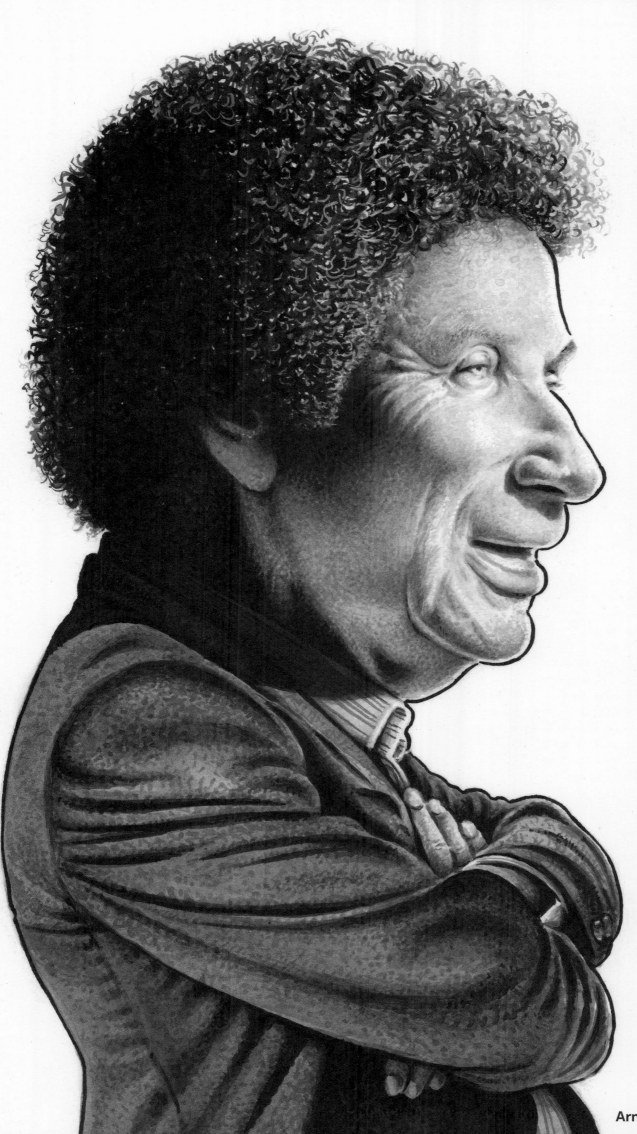

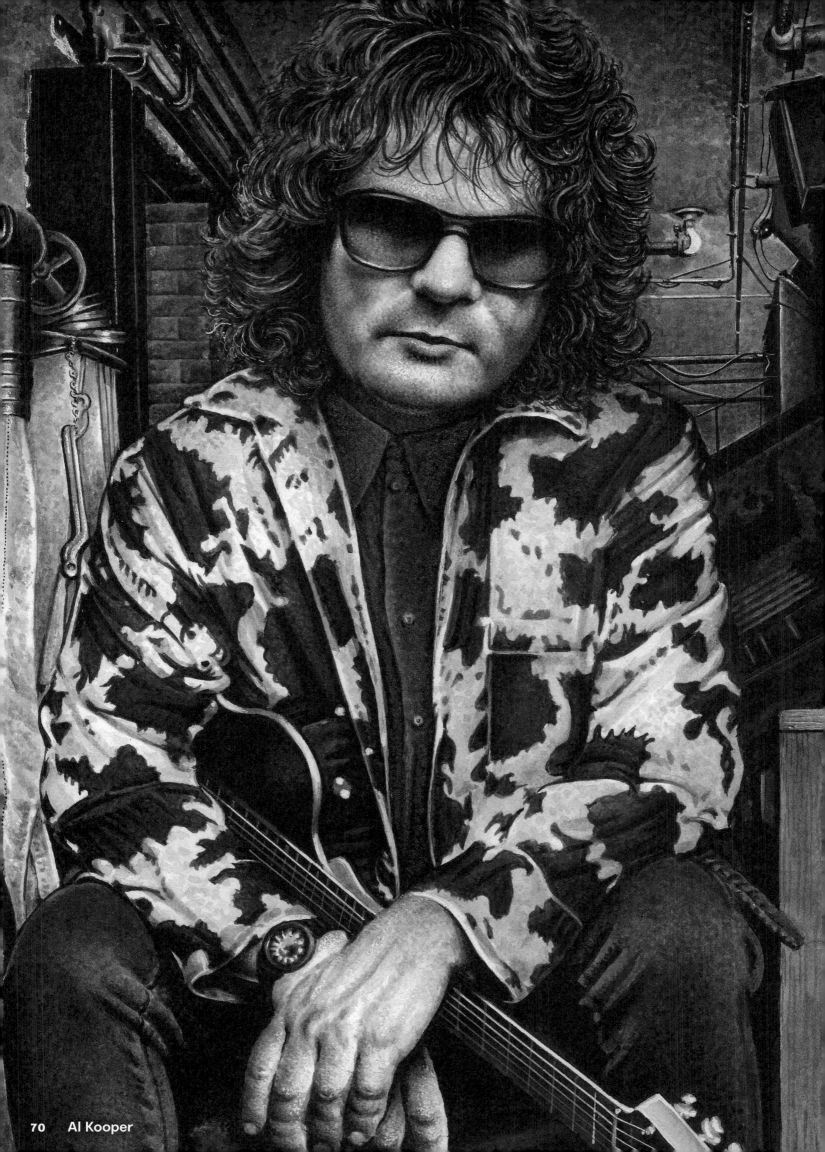

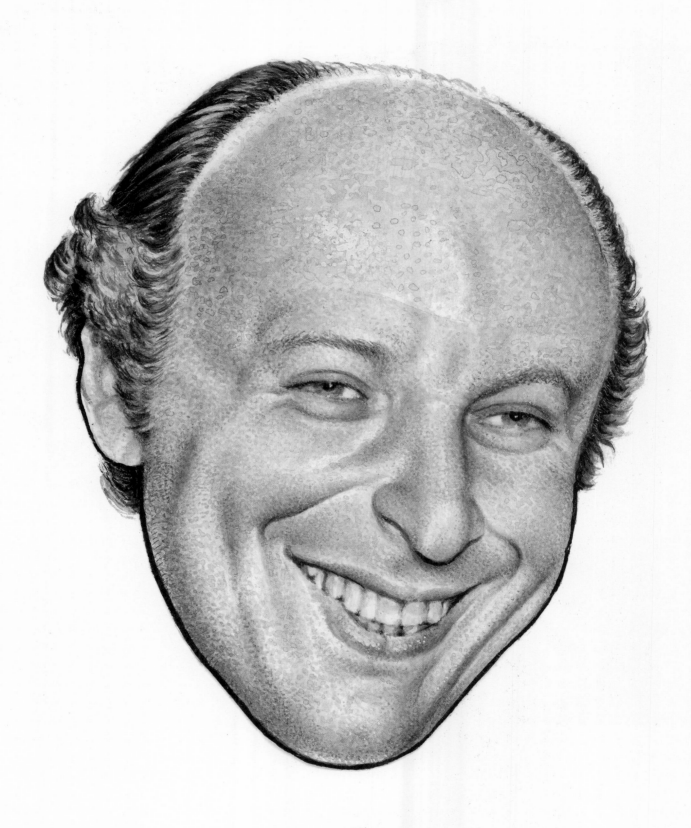

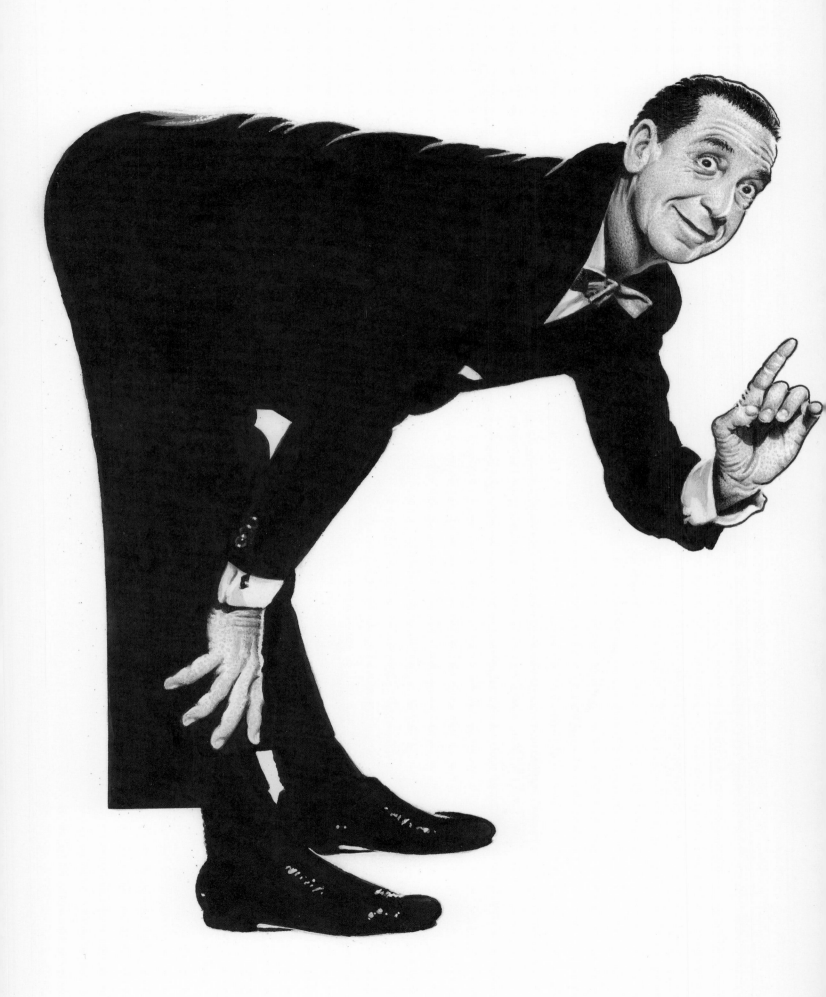

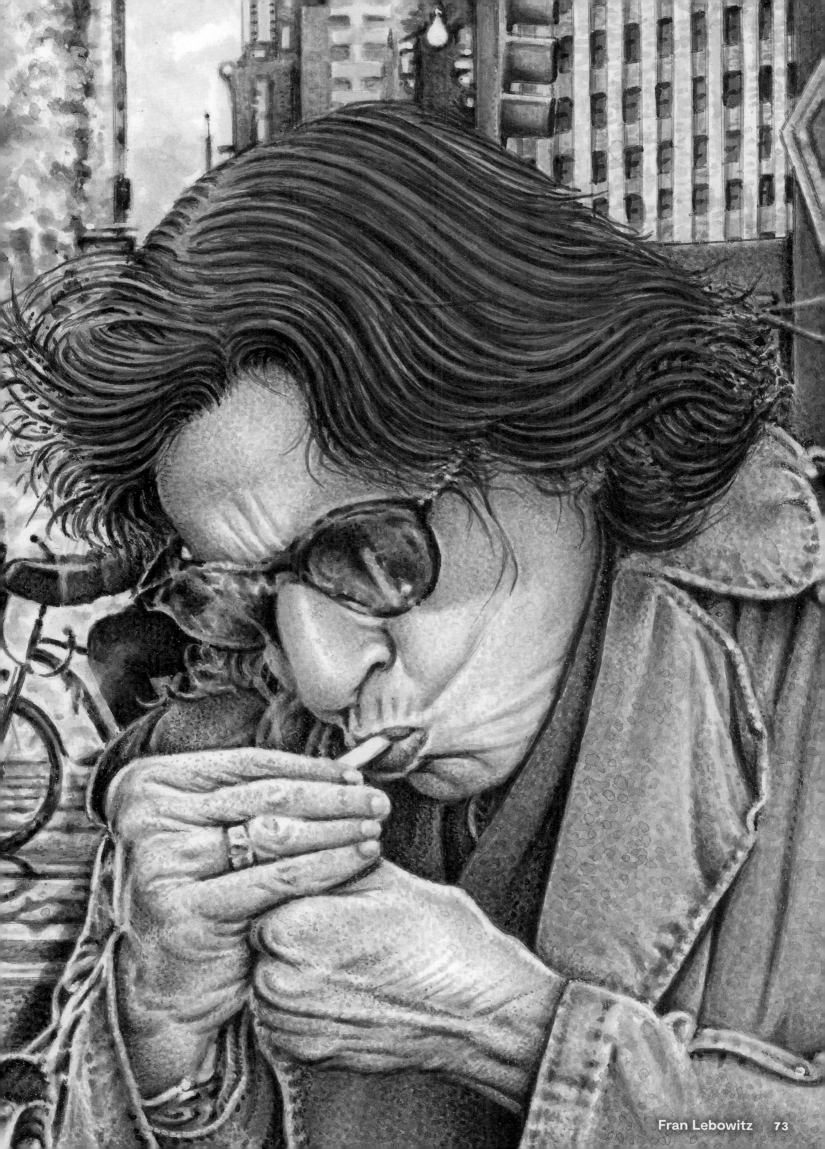

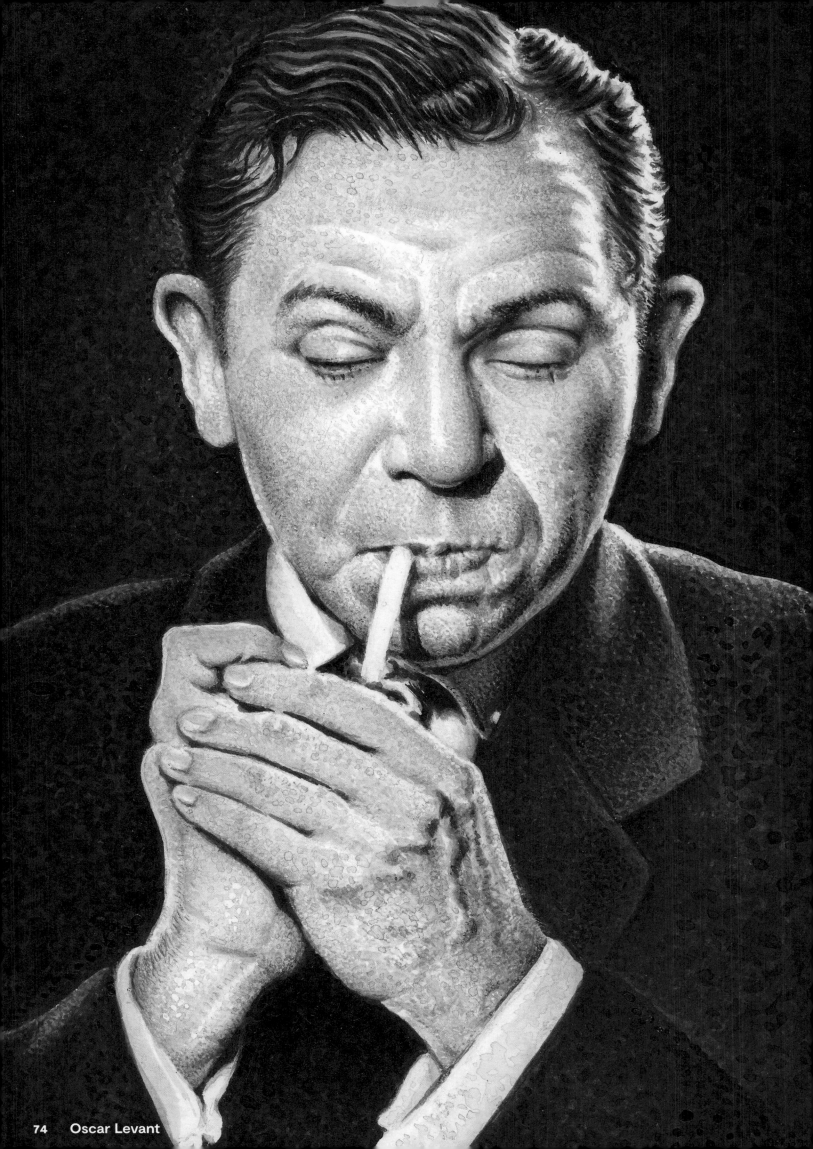

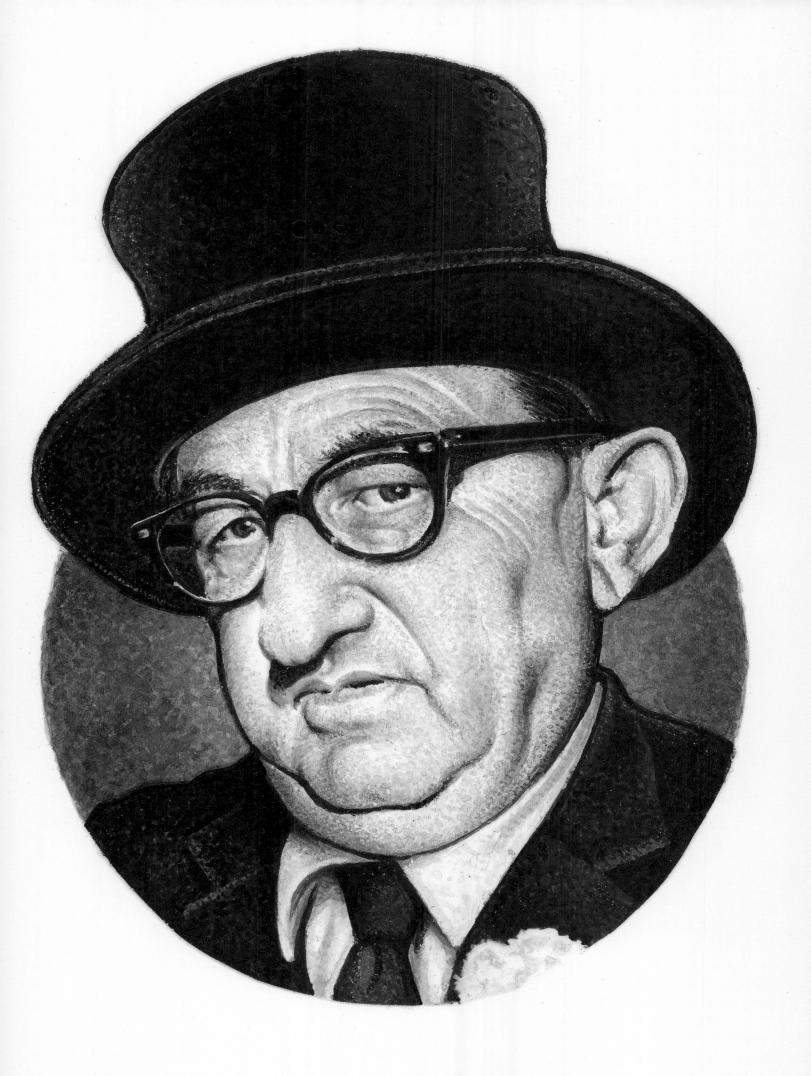

Martin "Blimp" Levy

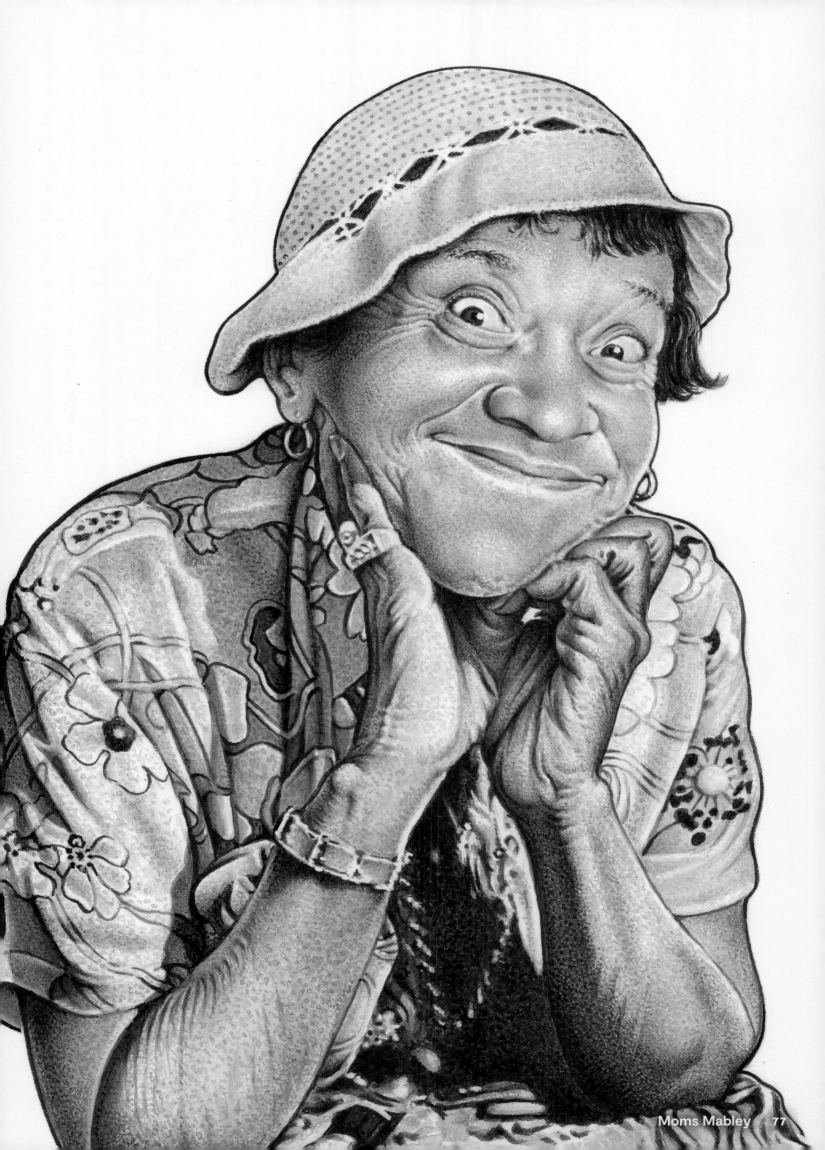

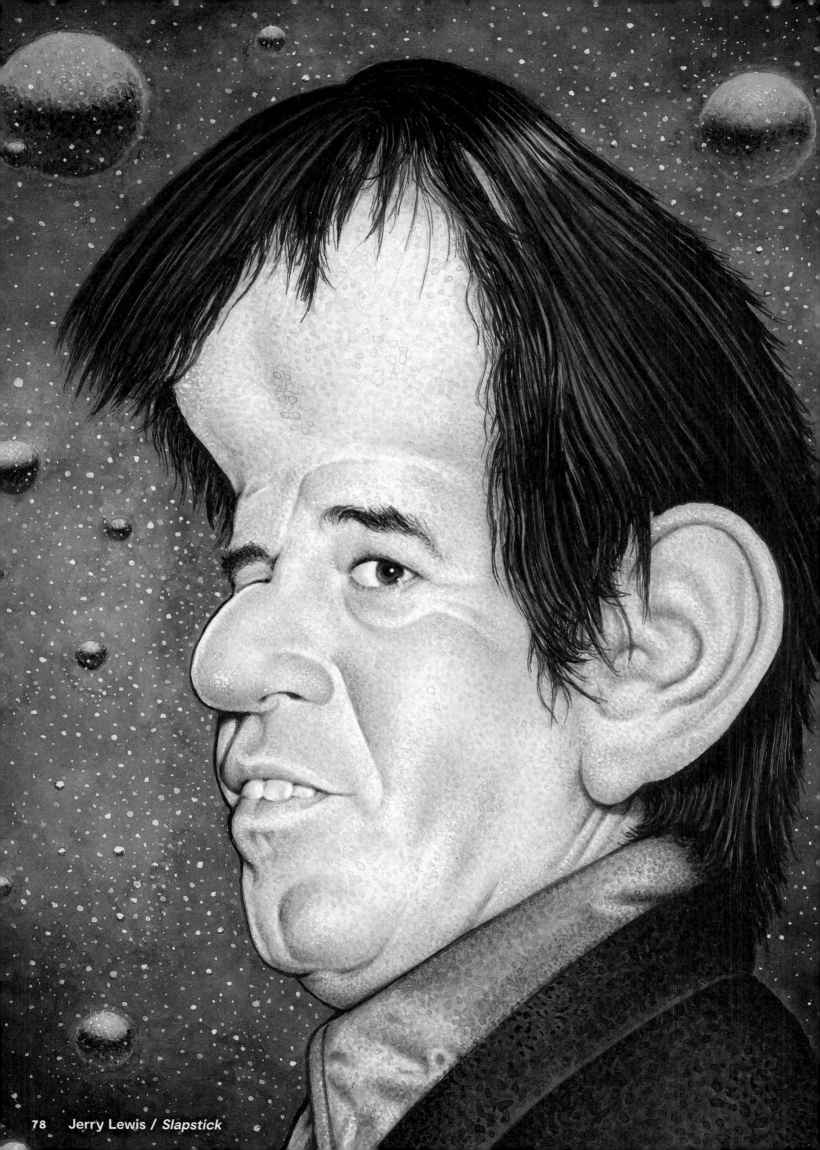

Jerry Lewis / *Slapstick*

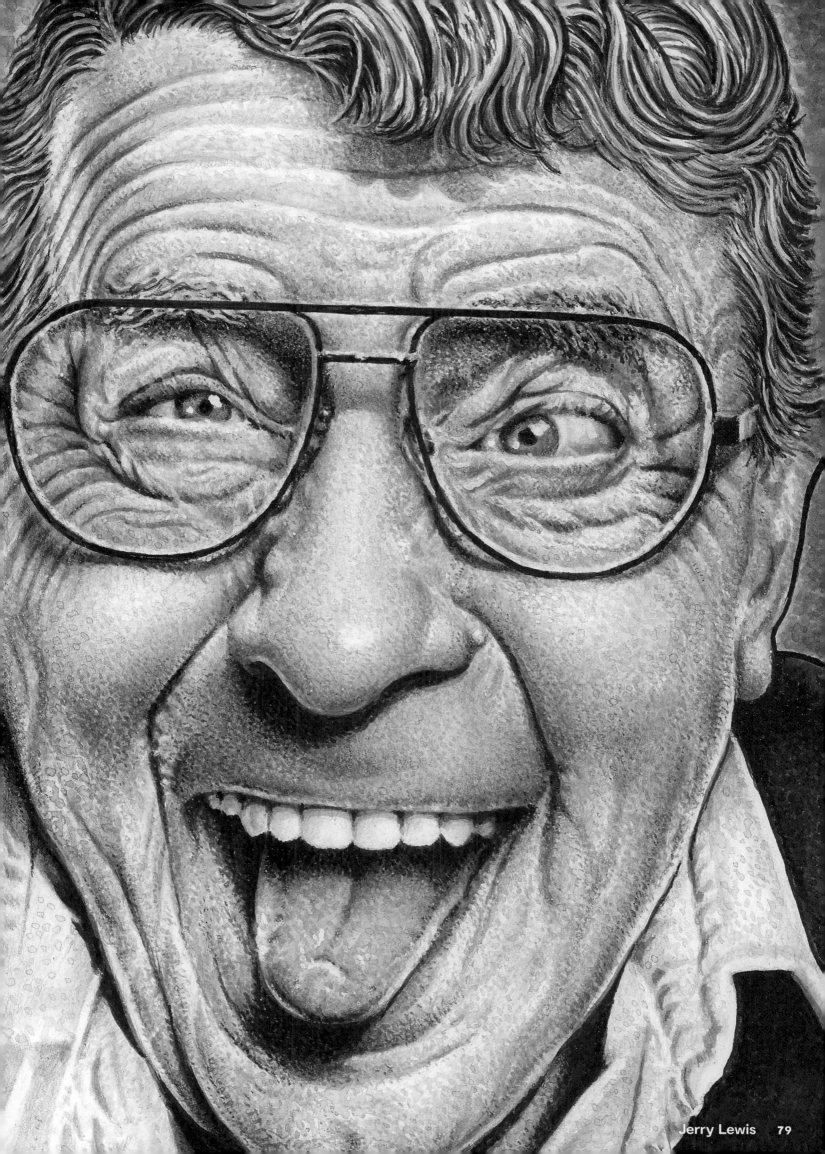

Jerry Lewis 79

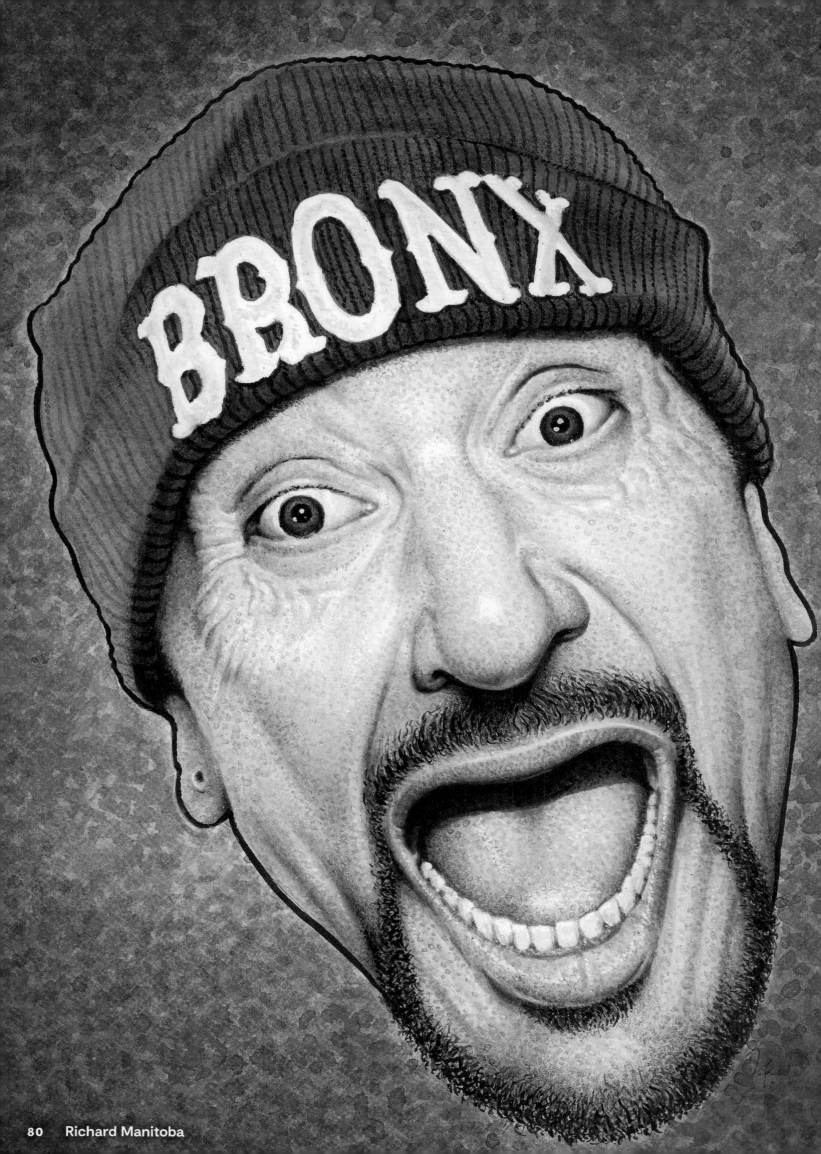

Richard Manitoba

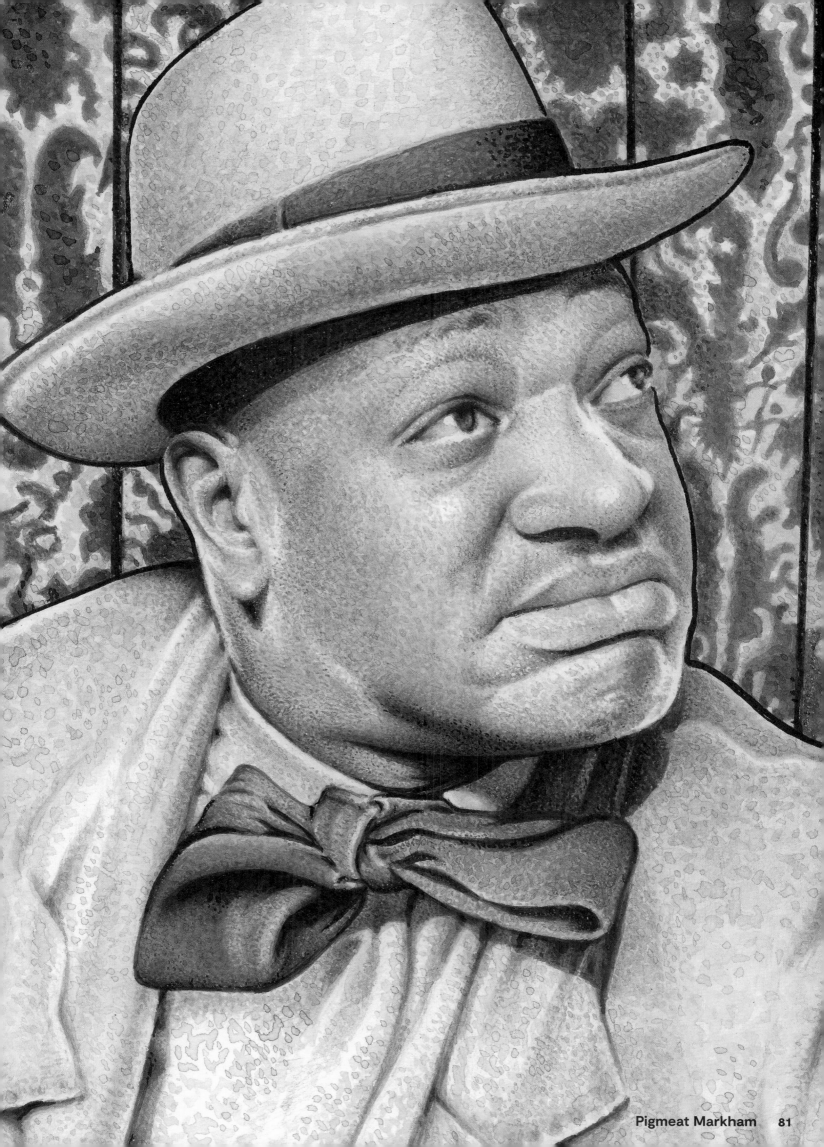

Pigmeat Markham 81

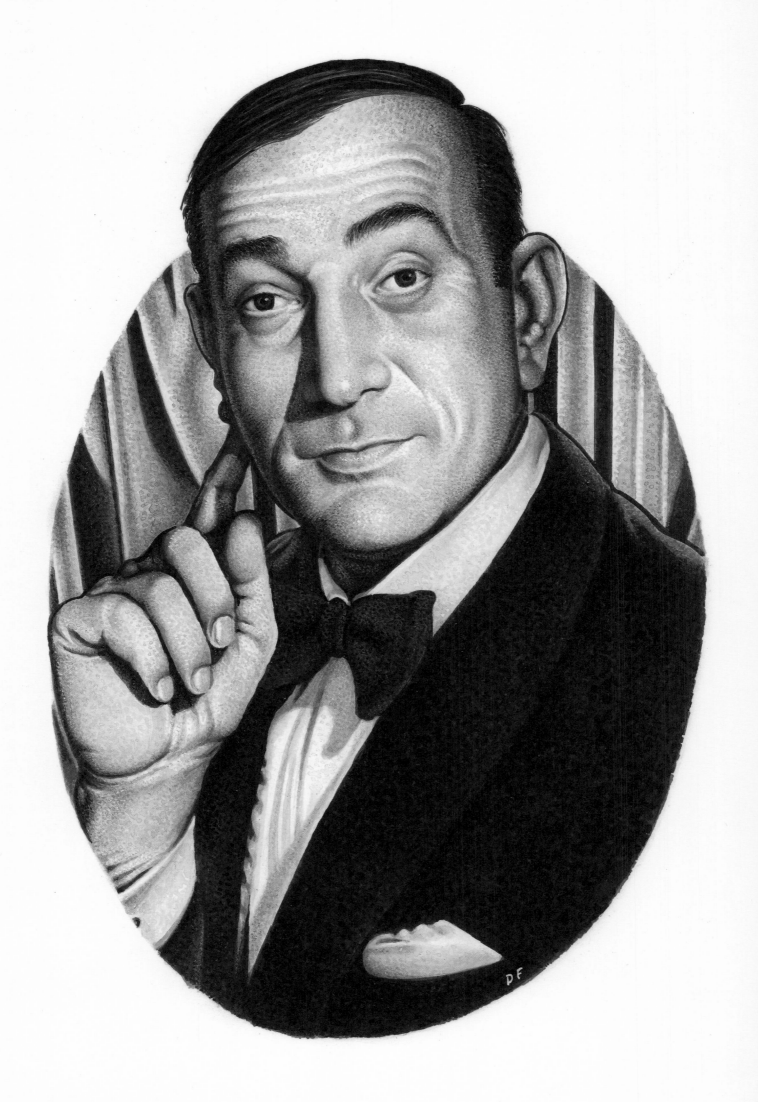

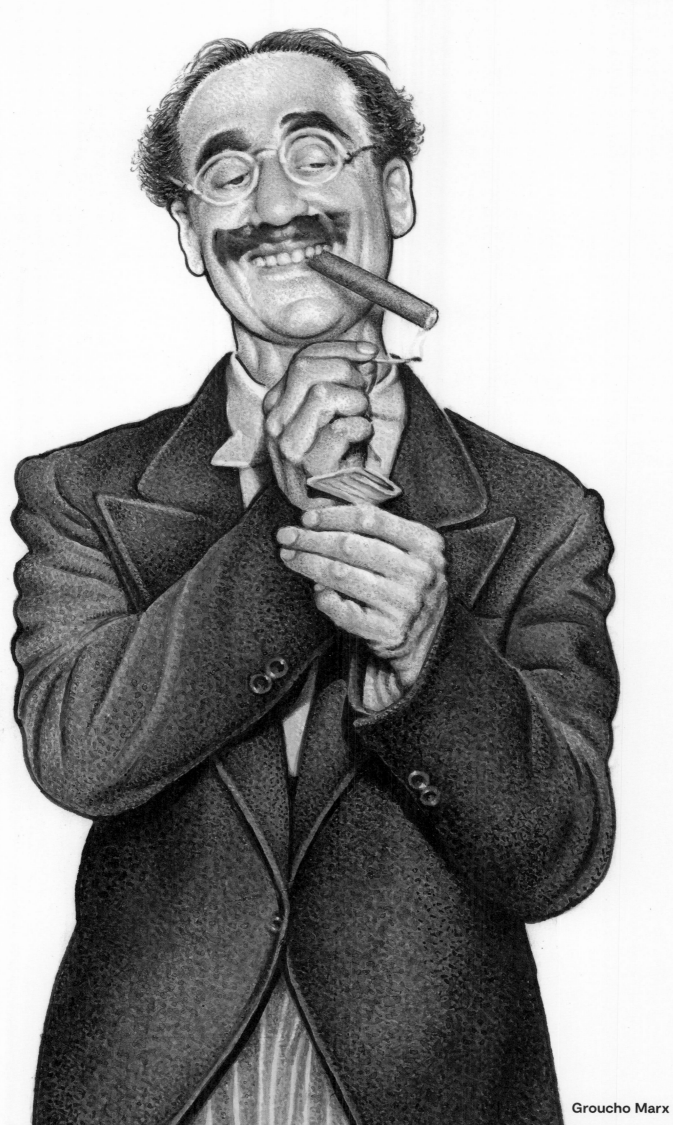

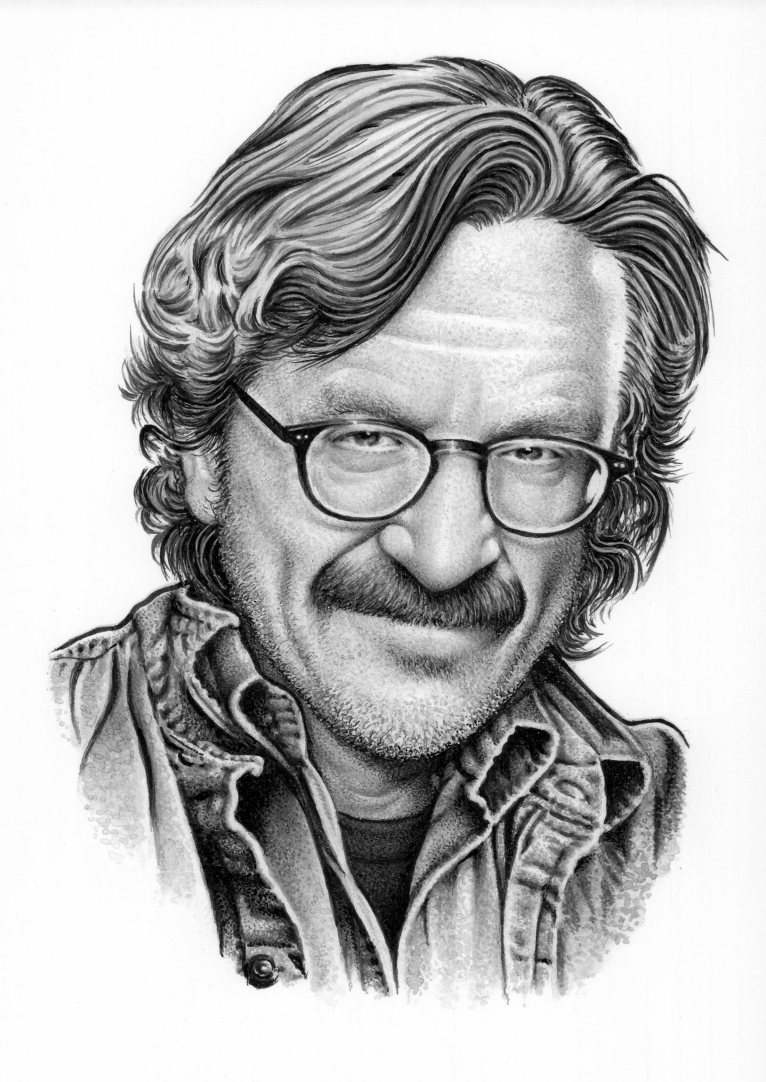

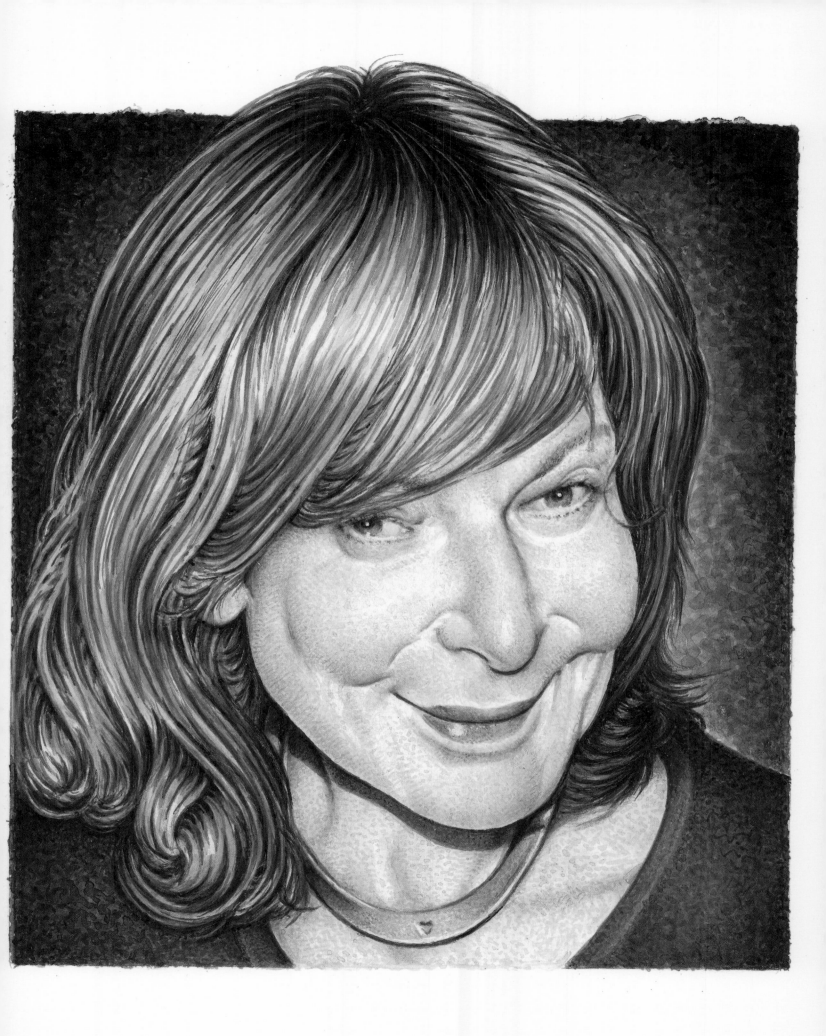

Elaine May 85

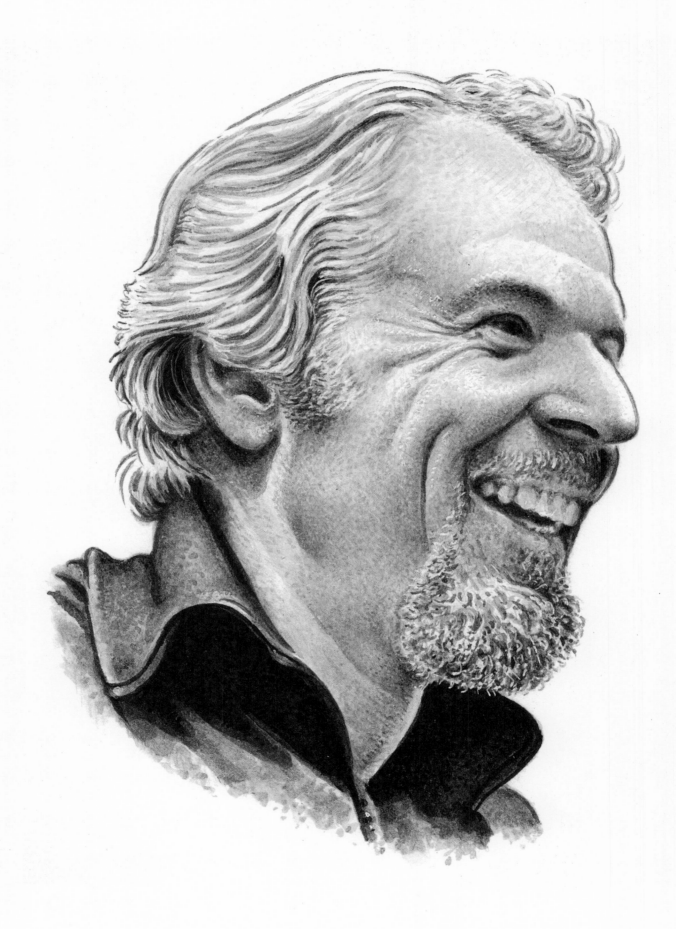

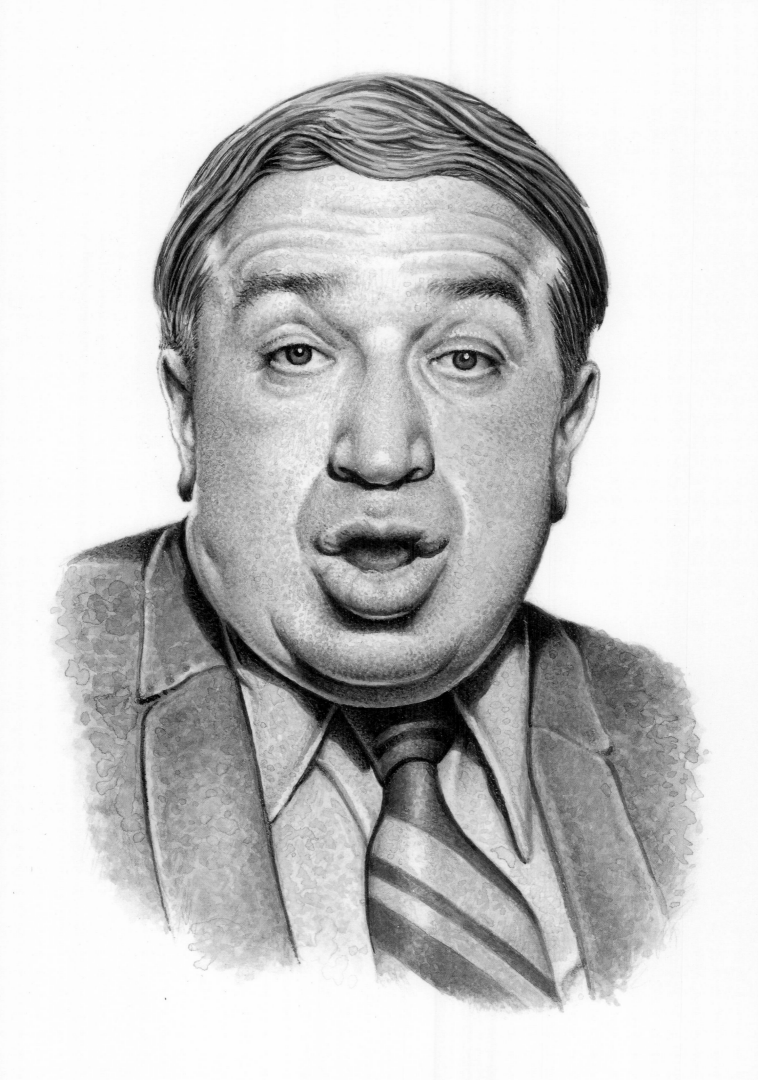

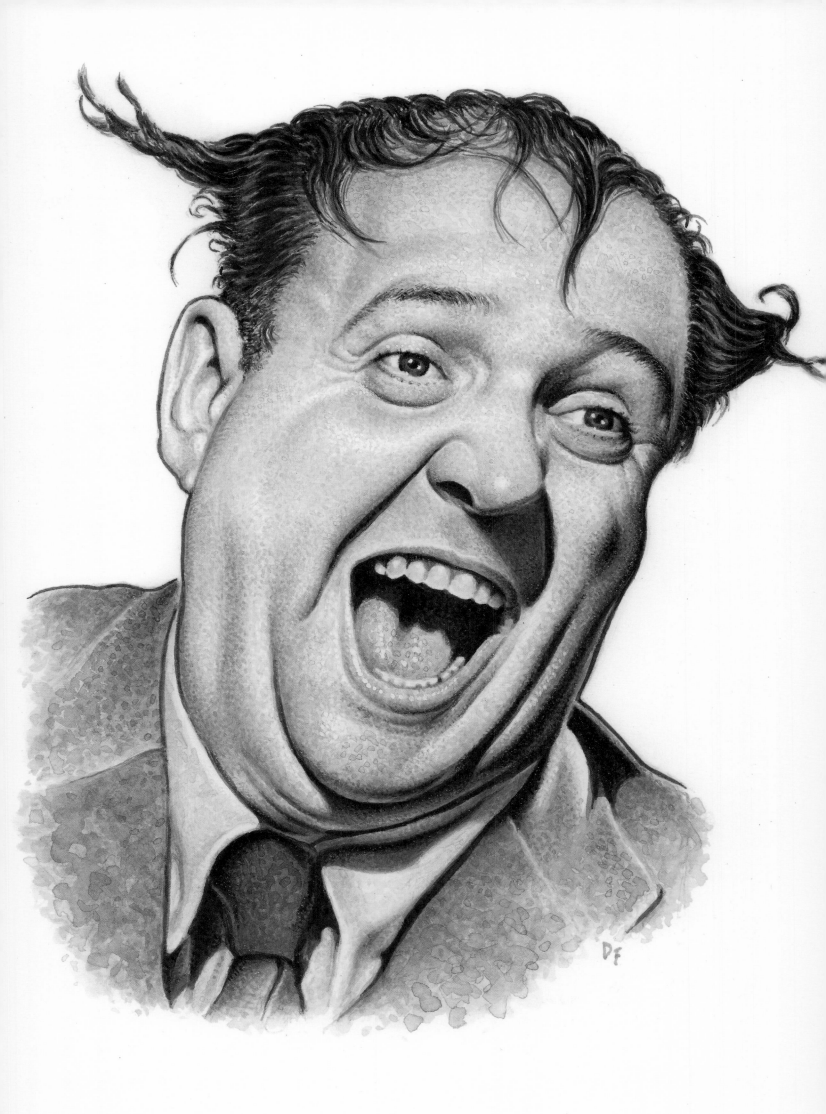

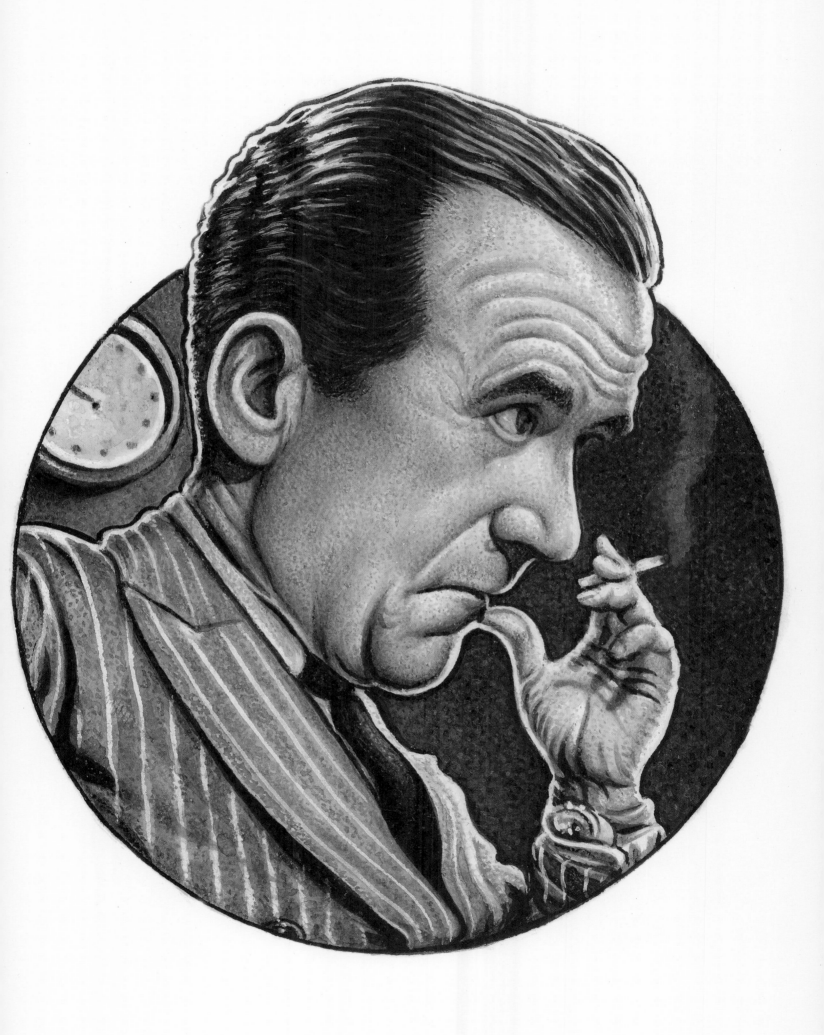

Edward R. Murrow

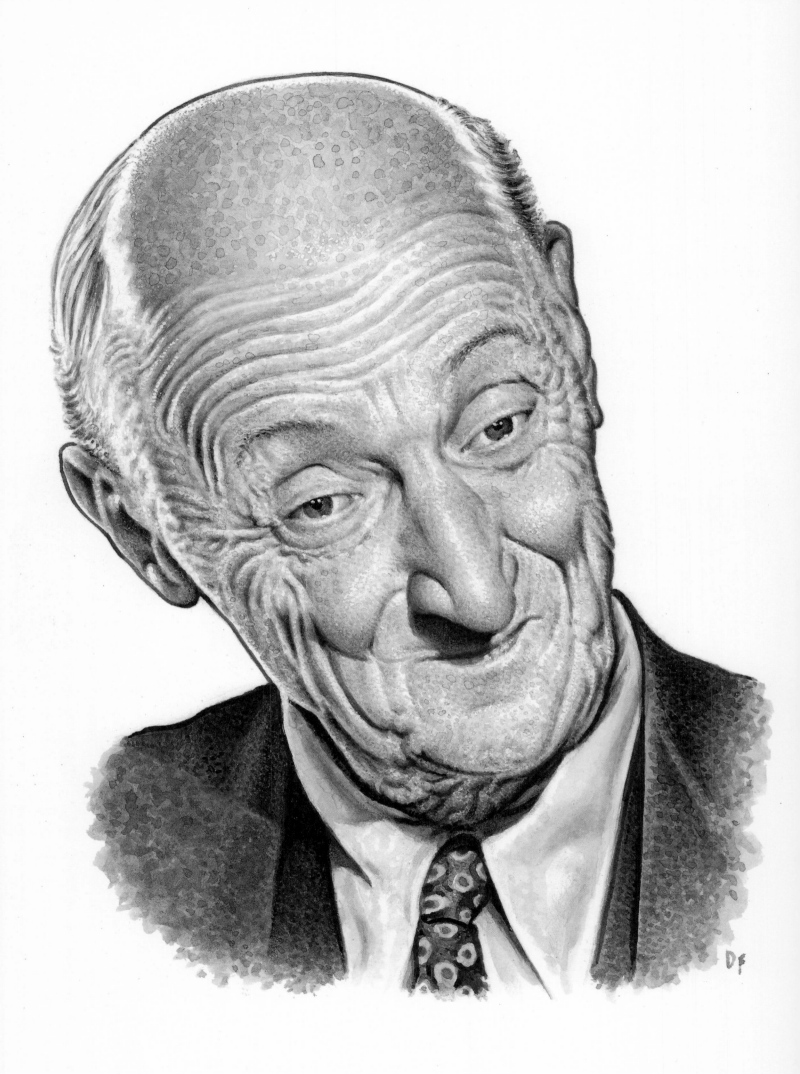

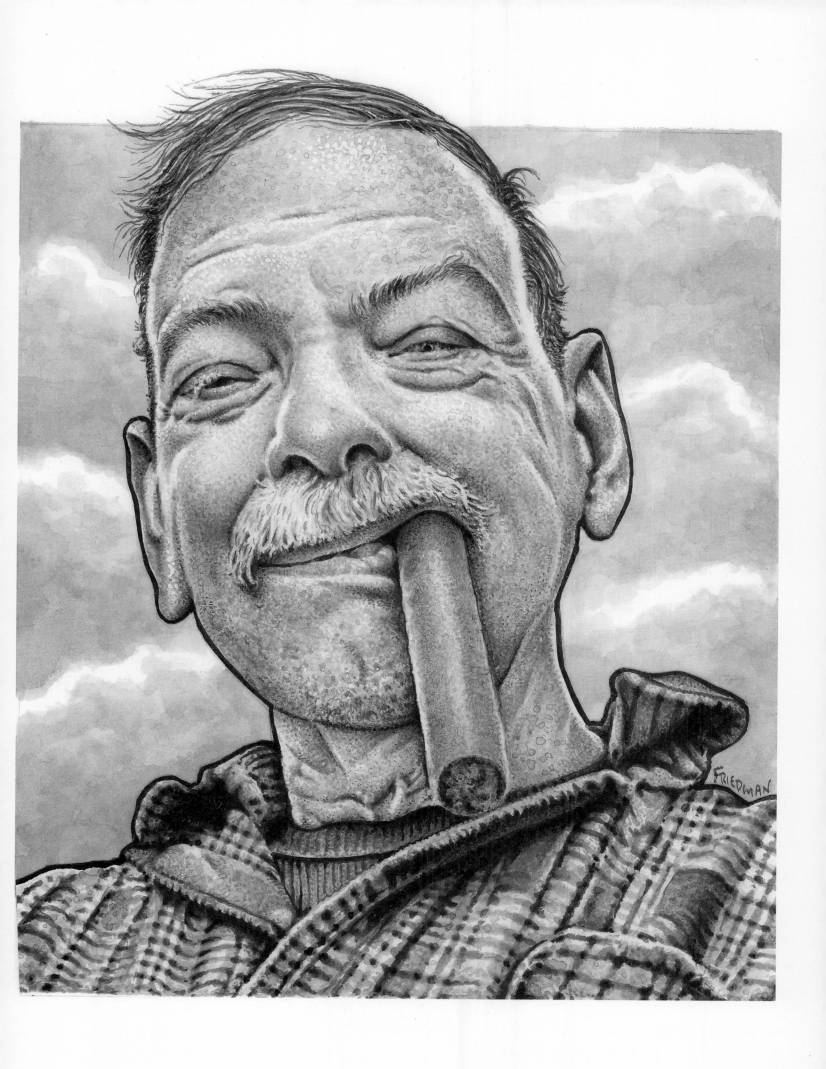

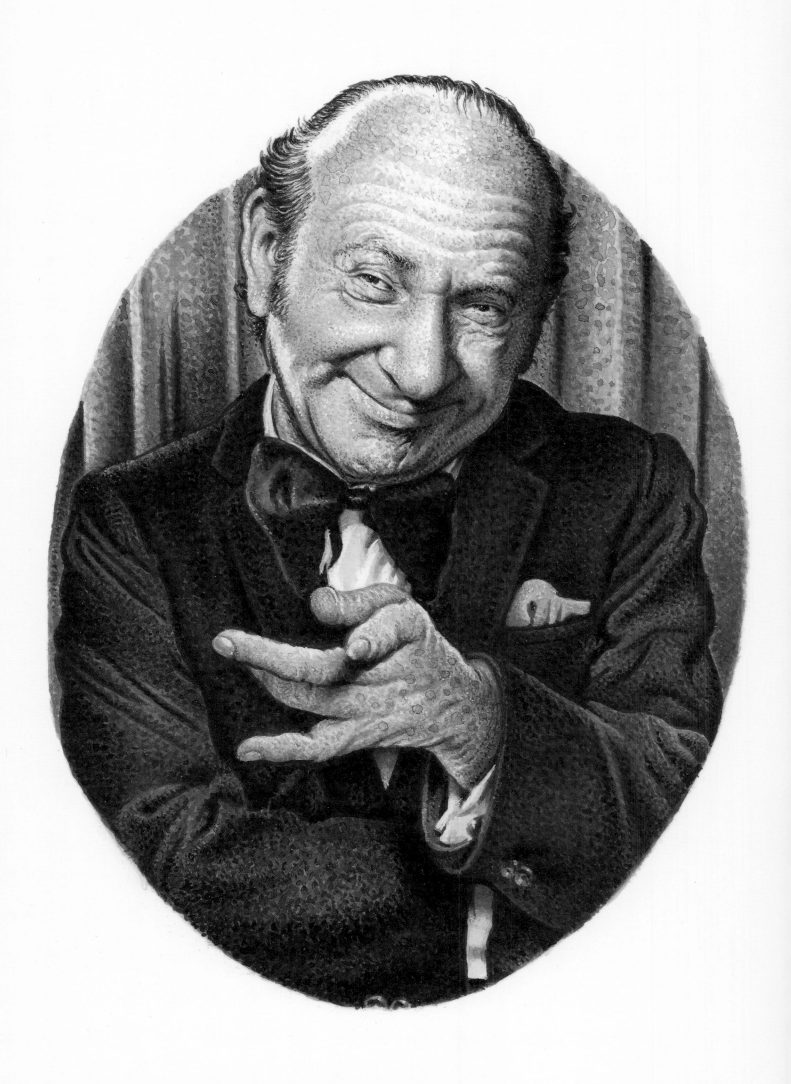

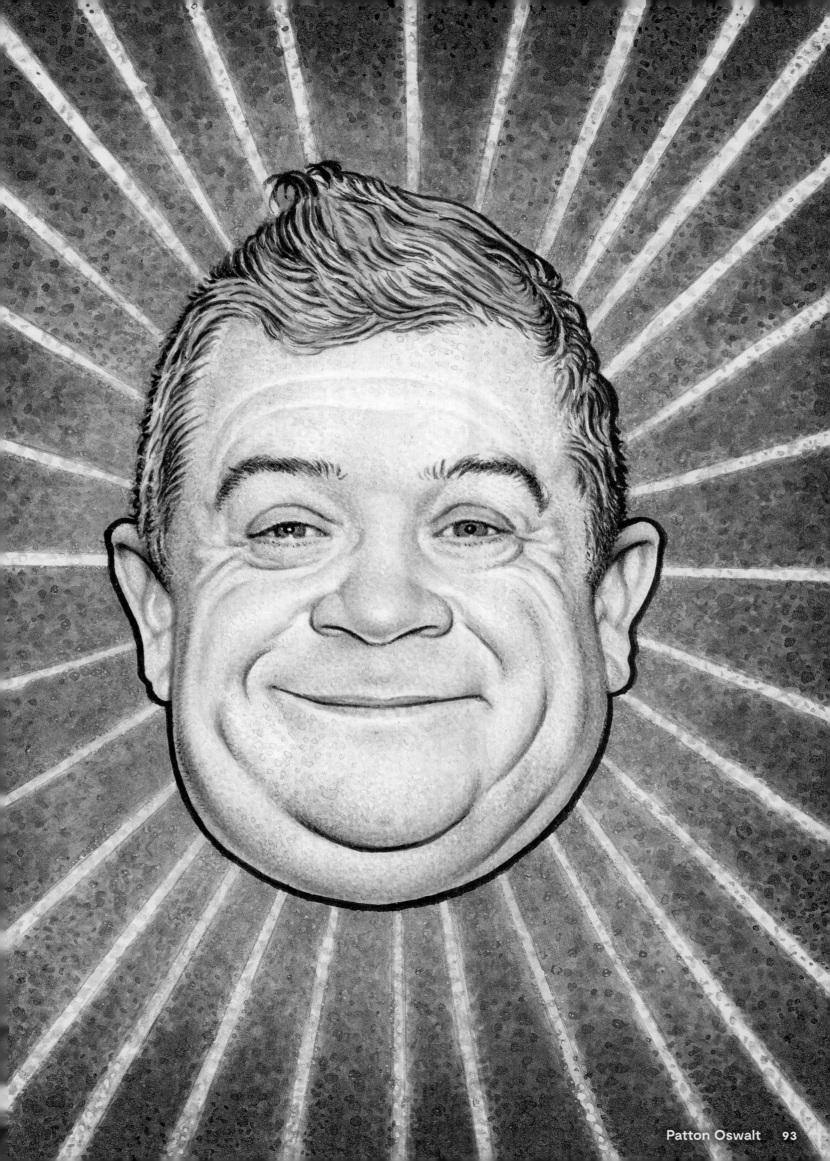

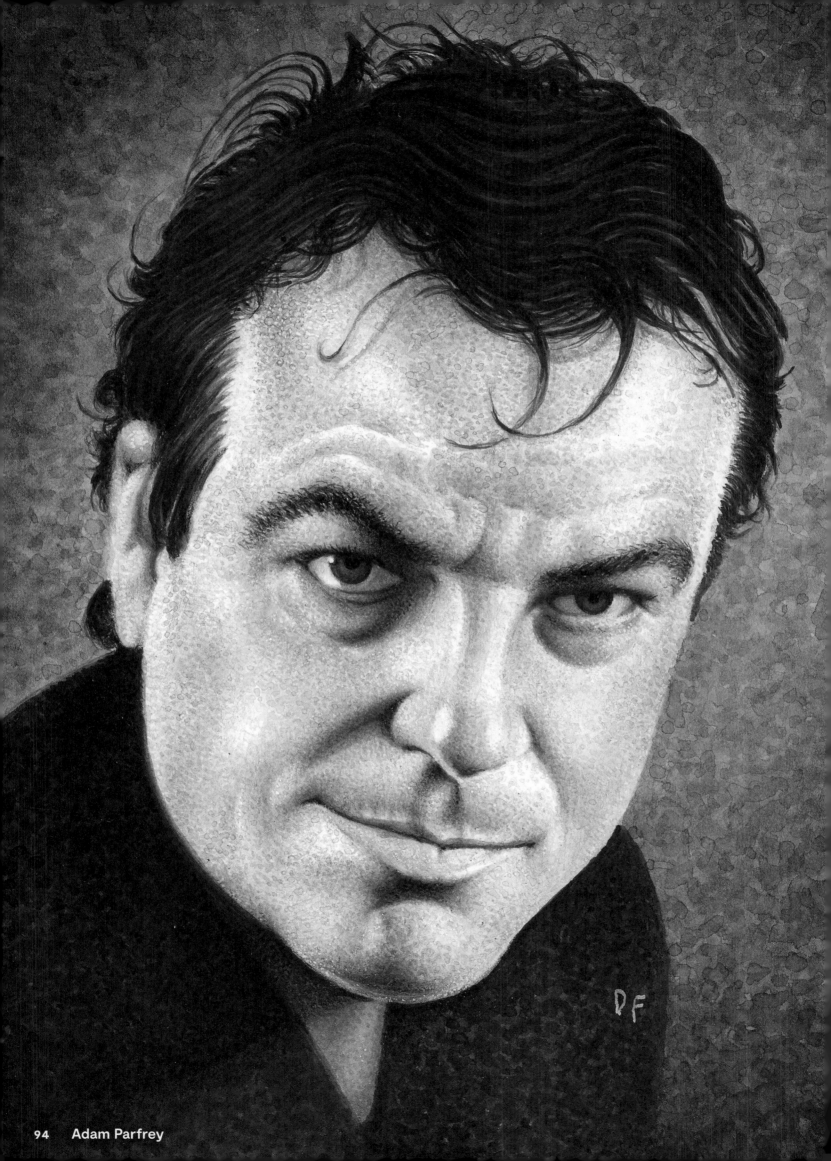

Adam Parfrey

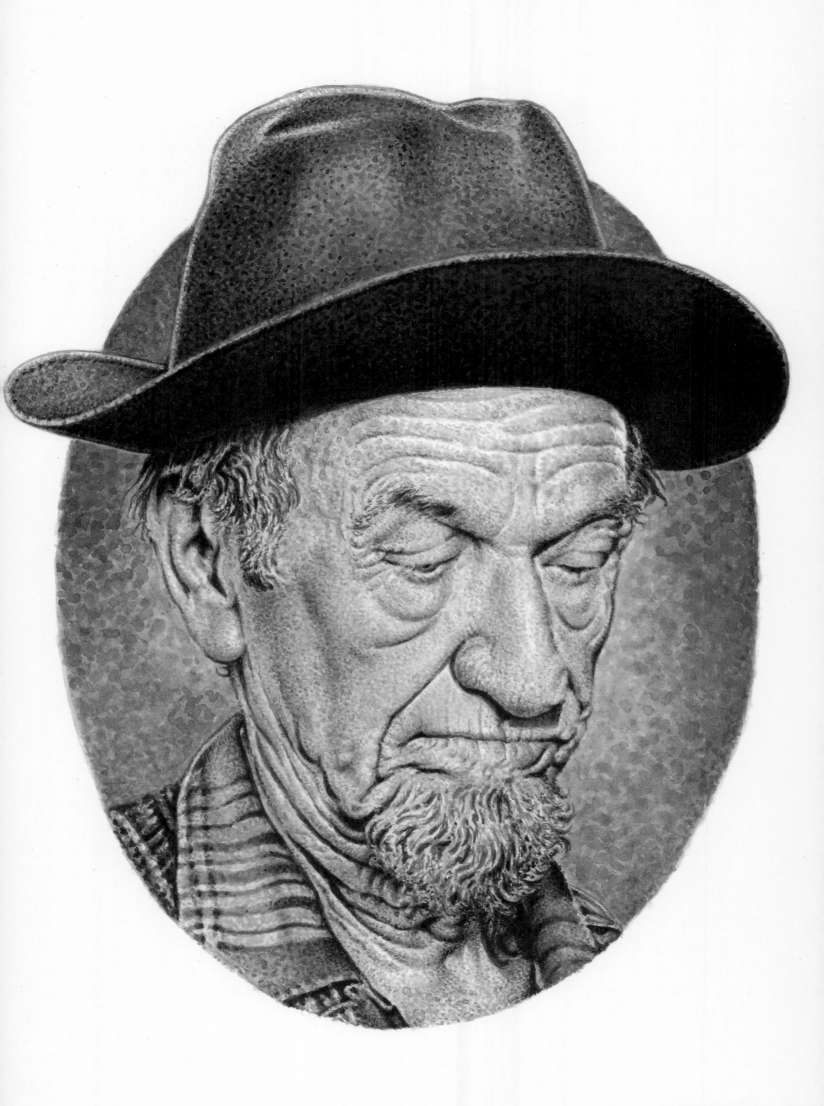

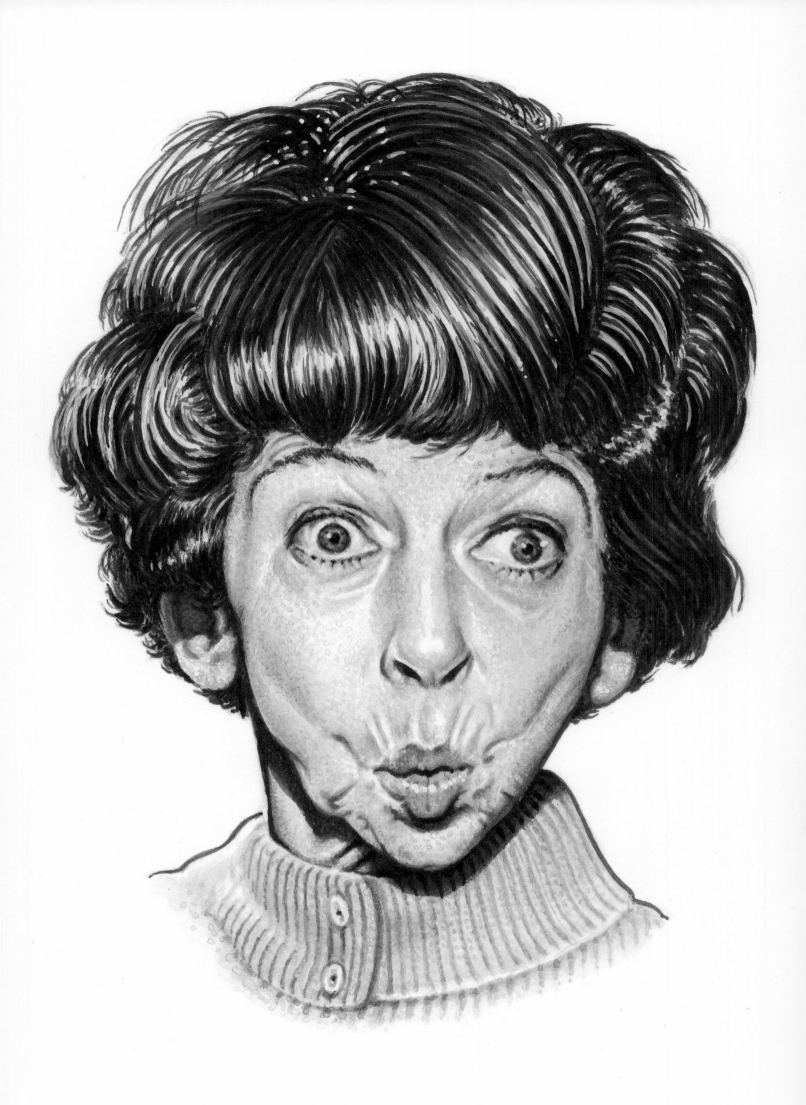

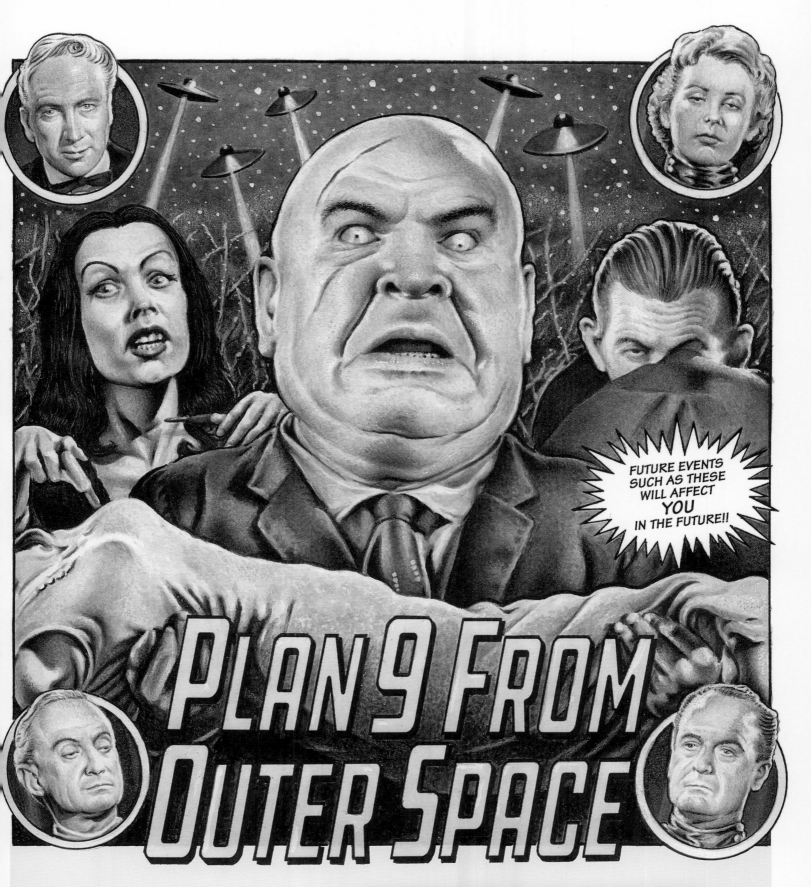

FUTURE EVENTS SUCH AS THESE WILL AFFECT **YOU** IN THE FUTURE!!

PLAN 9 FROM Outer Space

Written—Produced—Directed by **EDWARD D. WOOD**, Jr.

Martha Raye

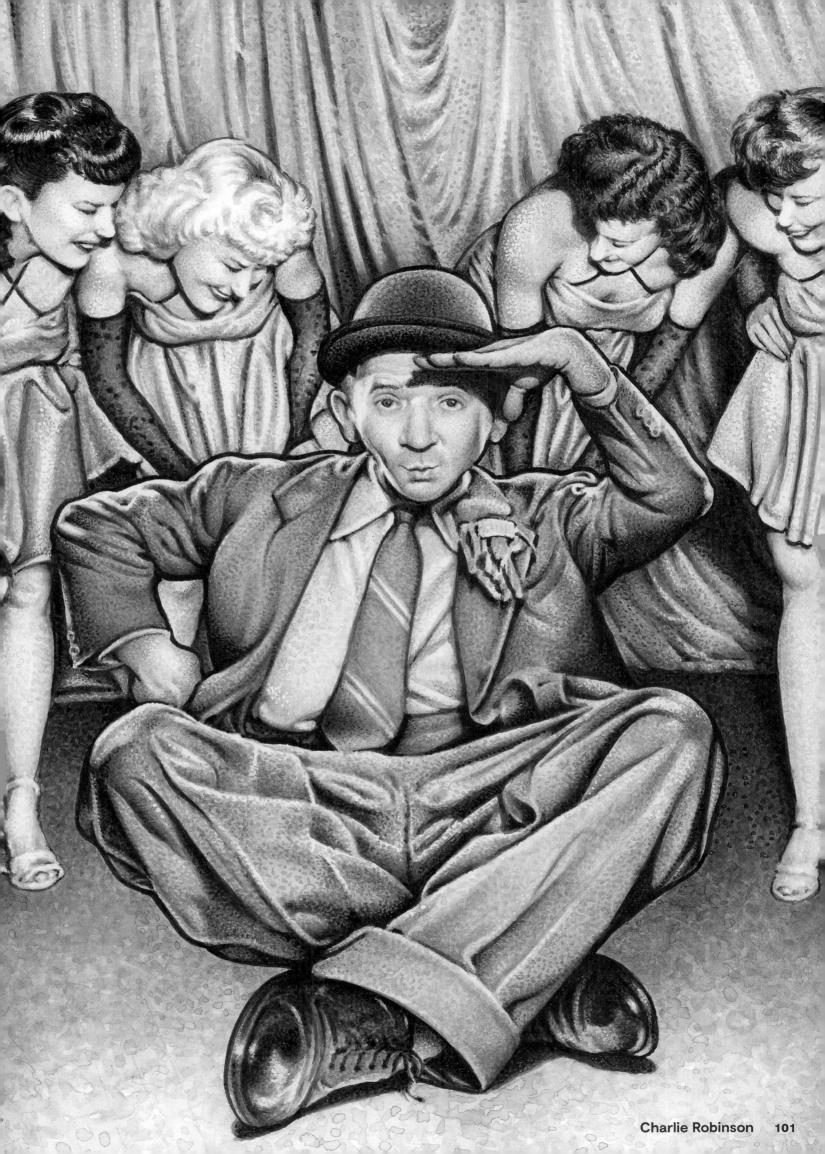

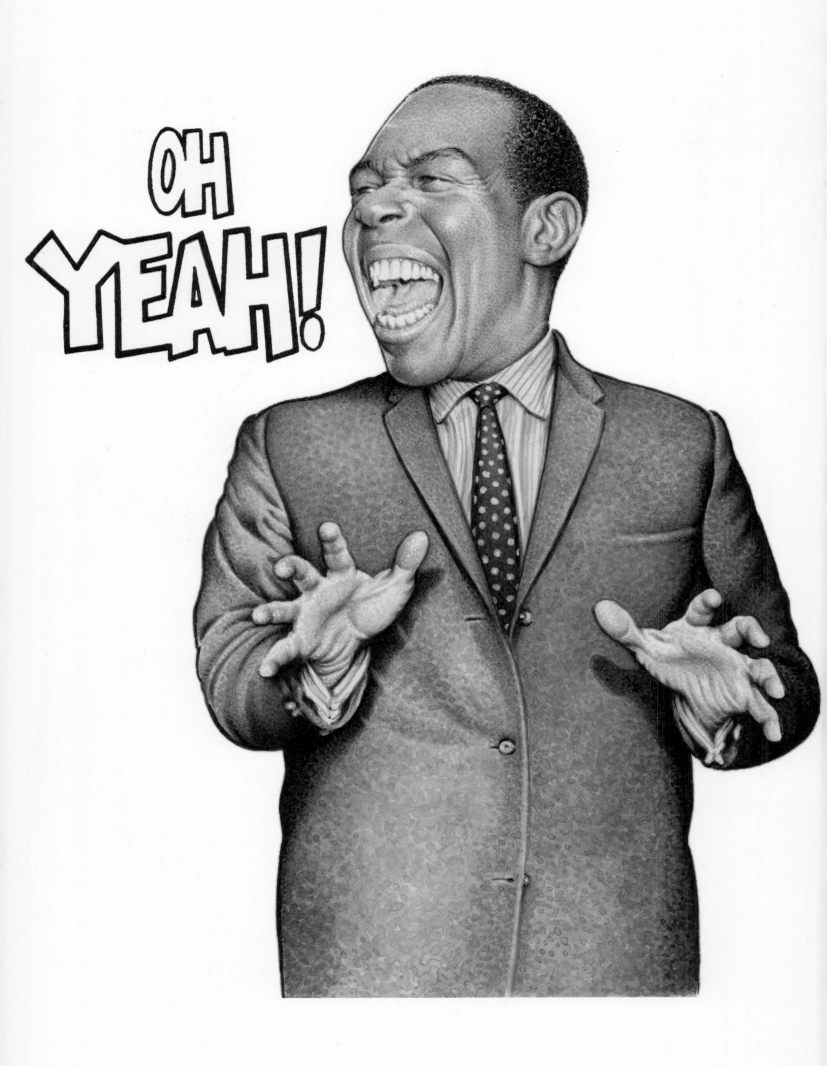

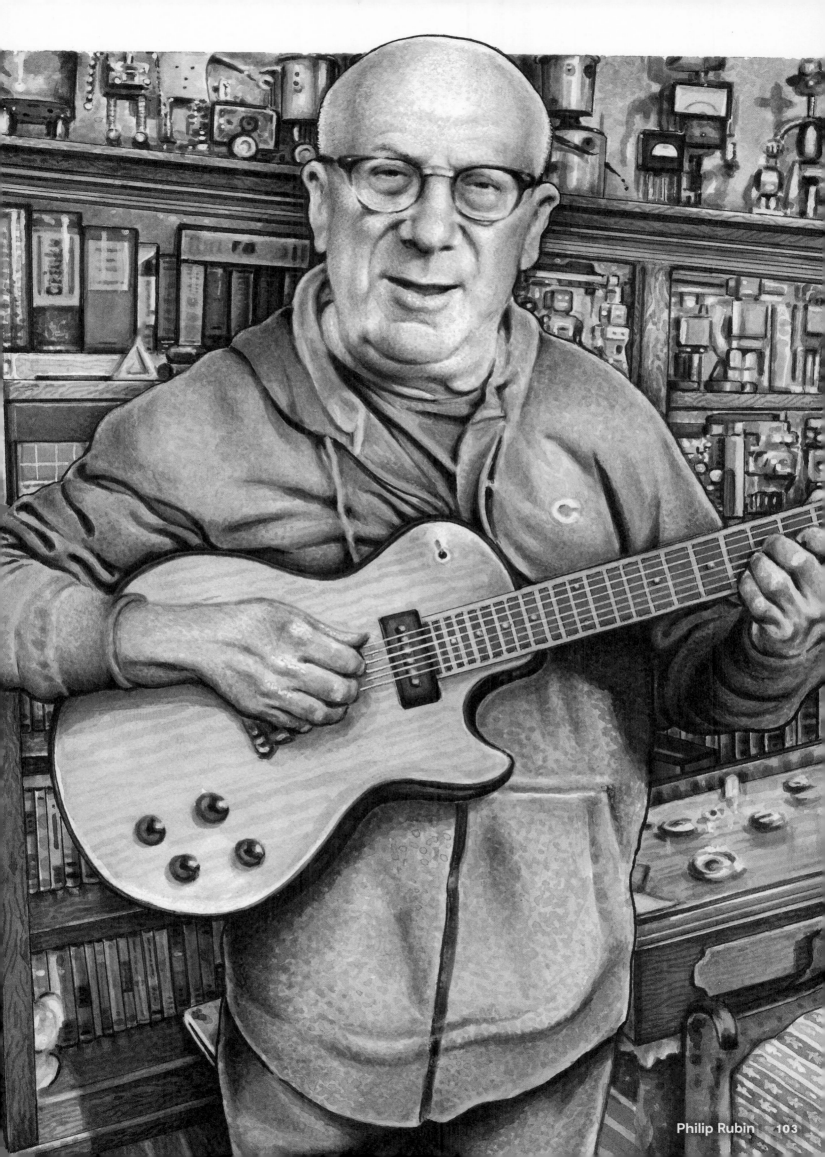

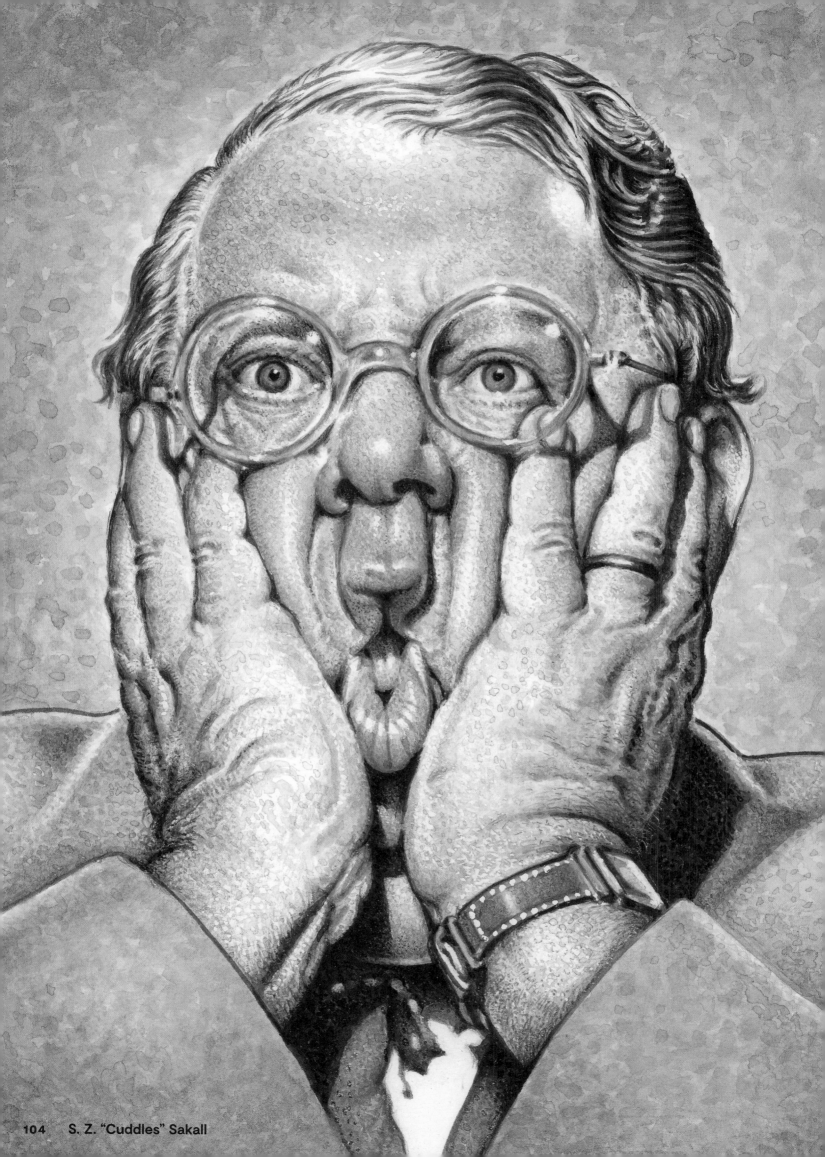

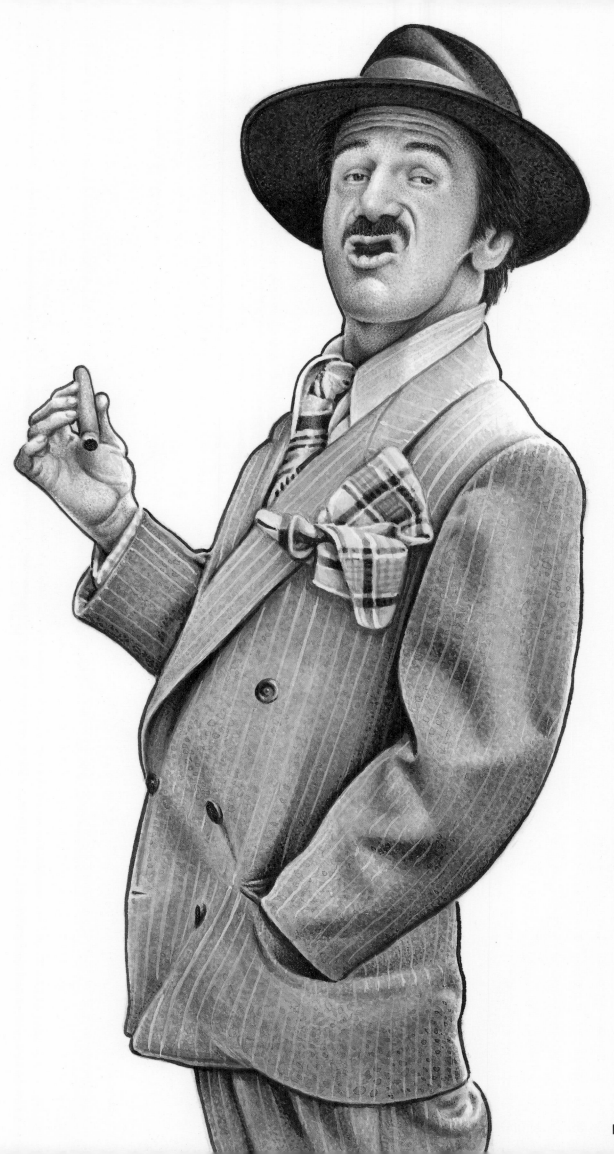

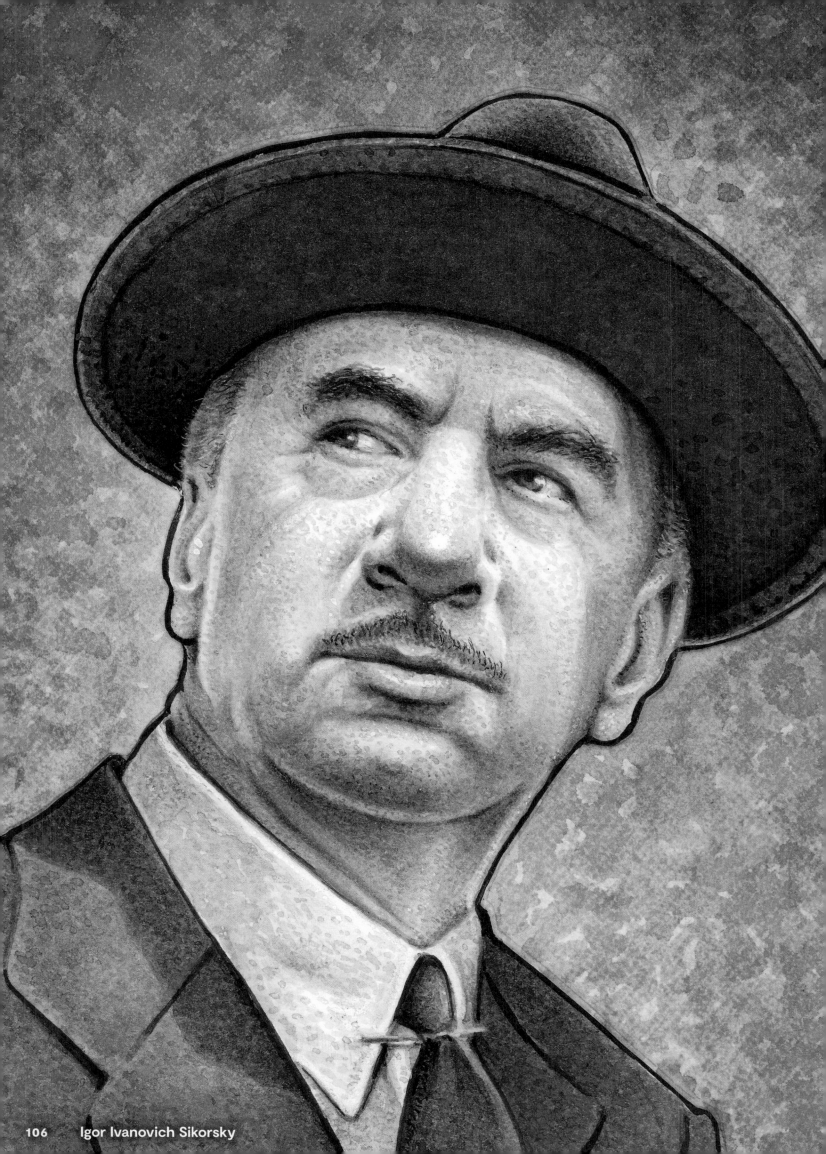

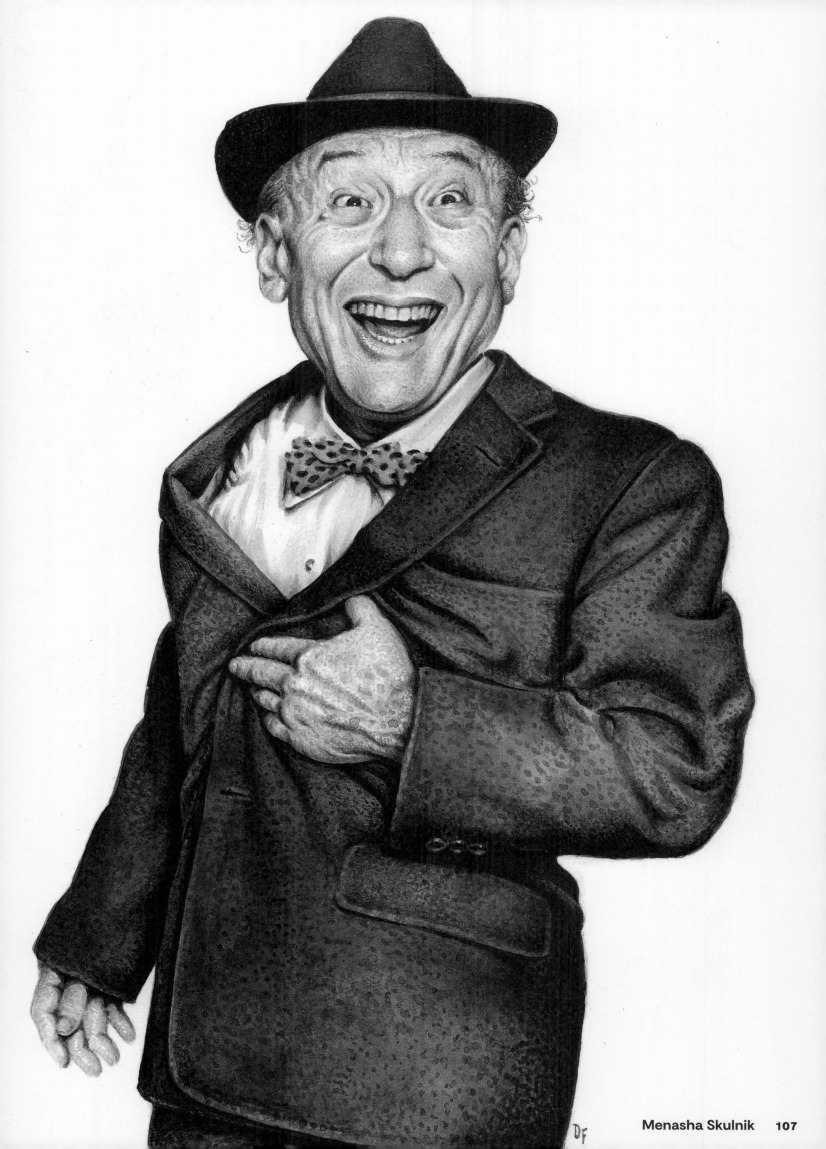

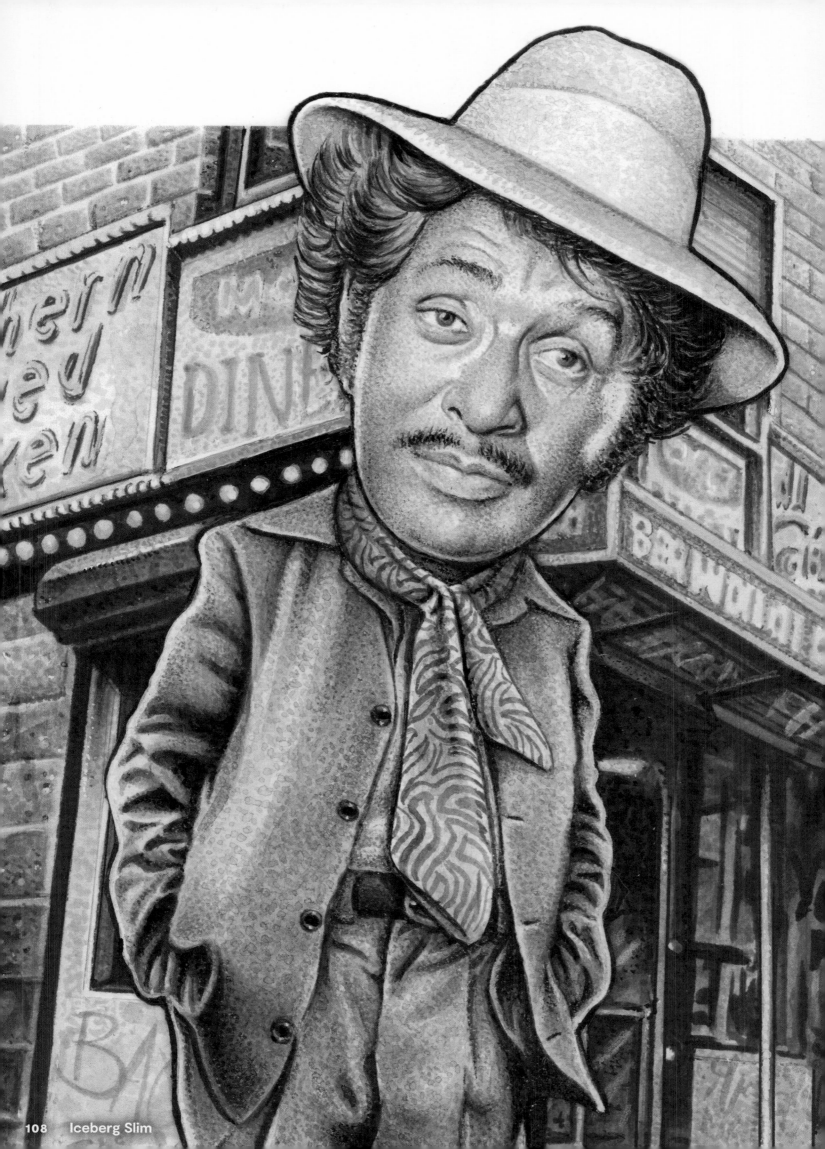

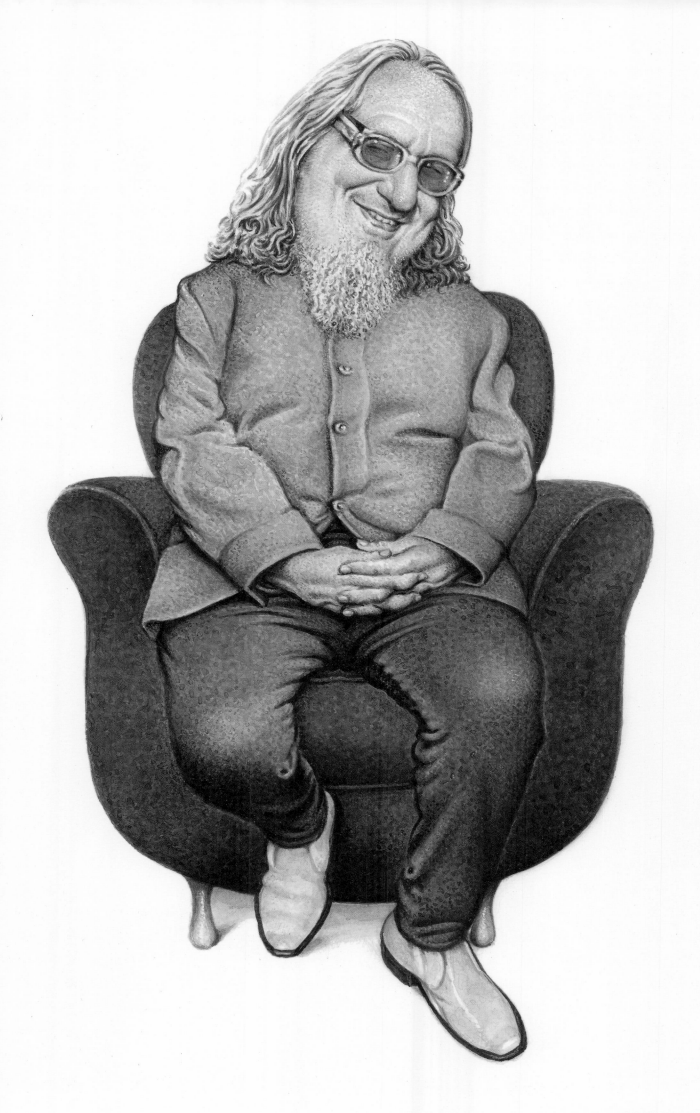

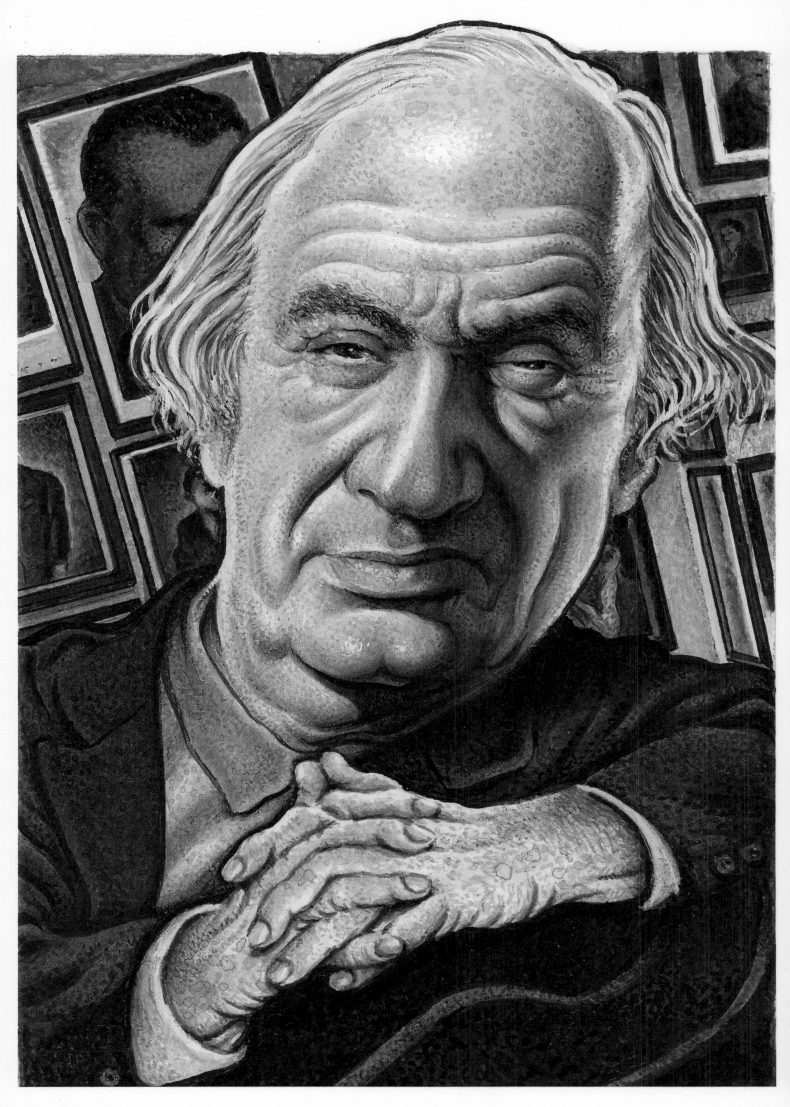

Sam Spiegel

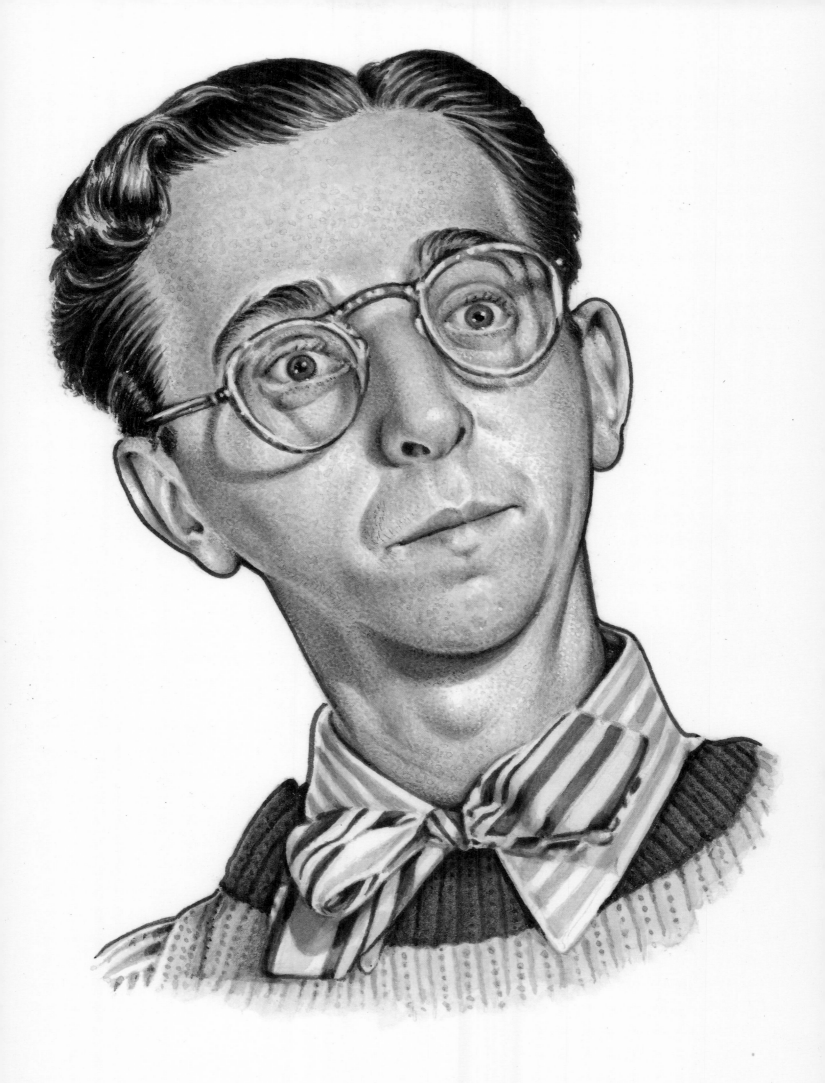

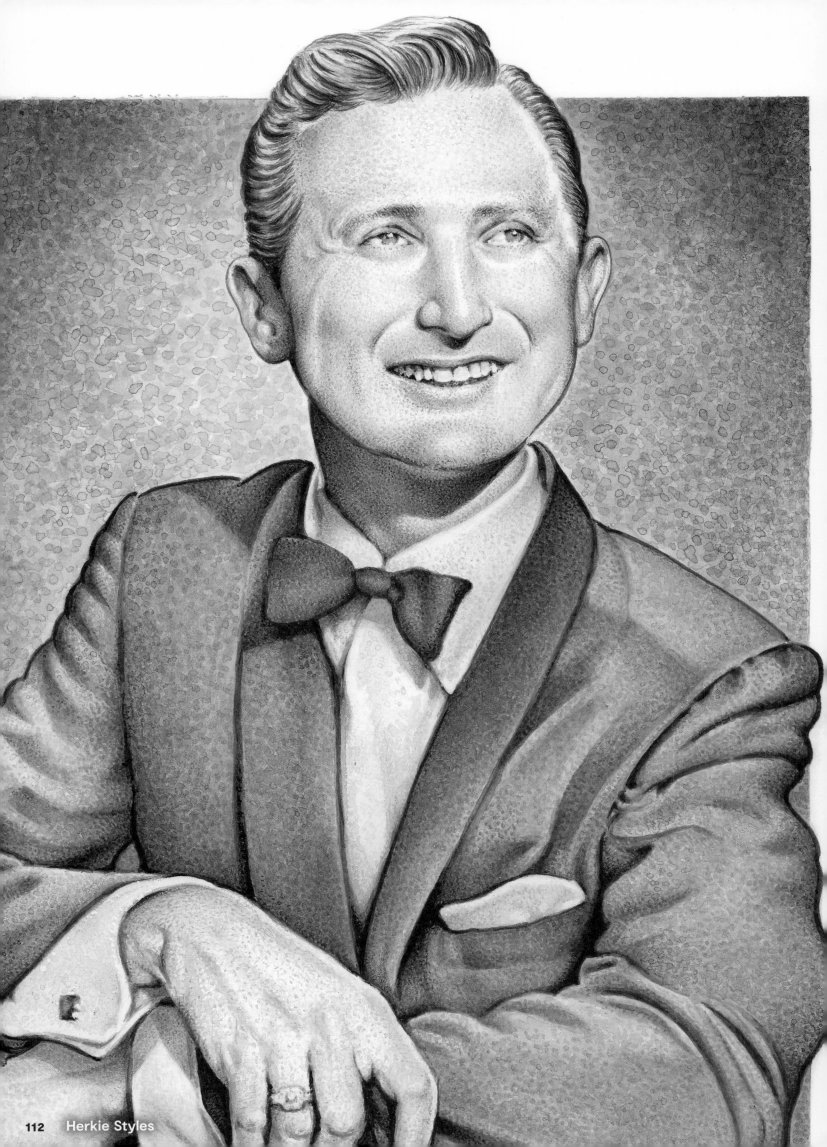

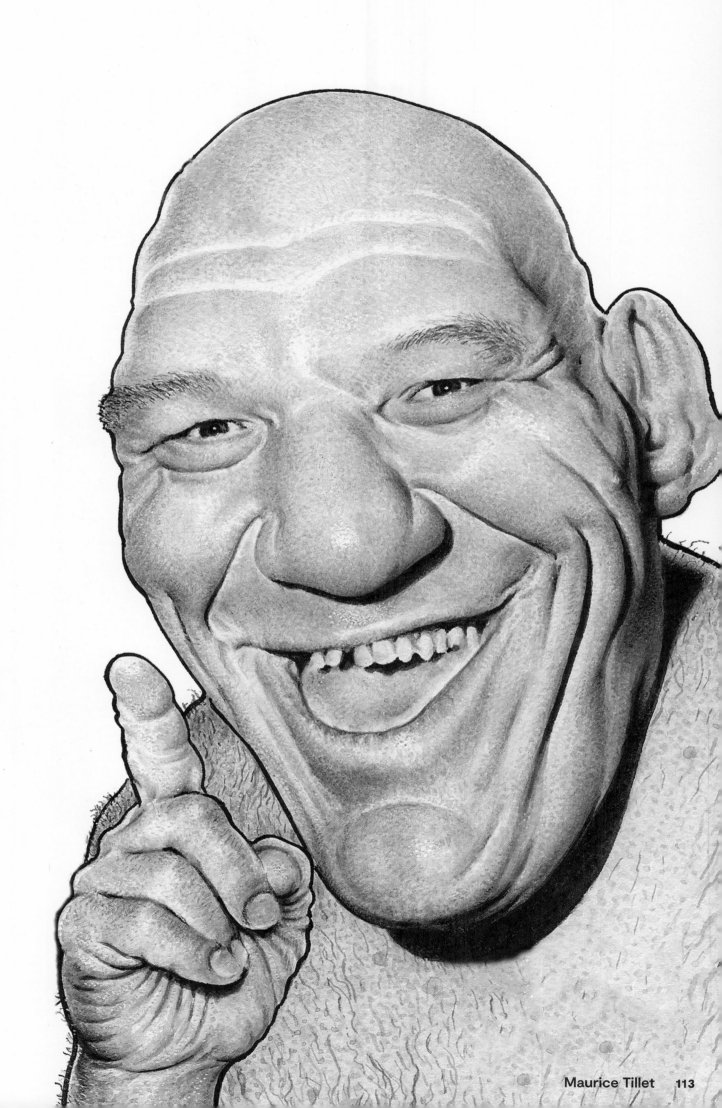

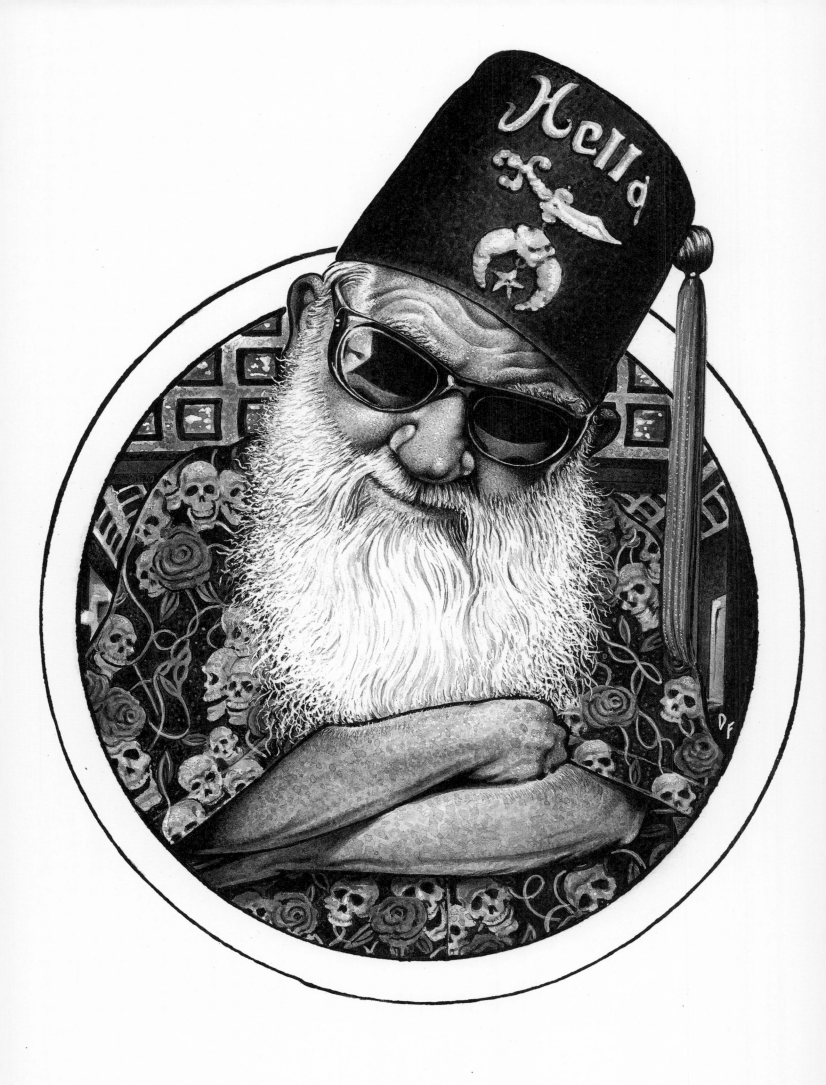

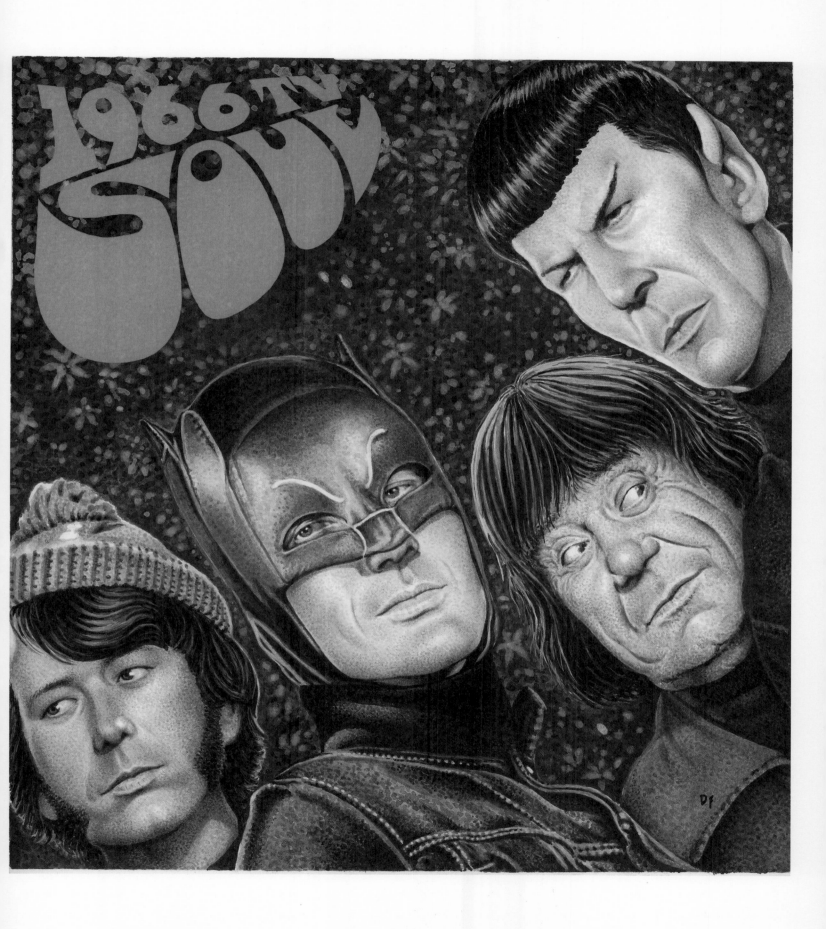

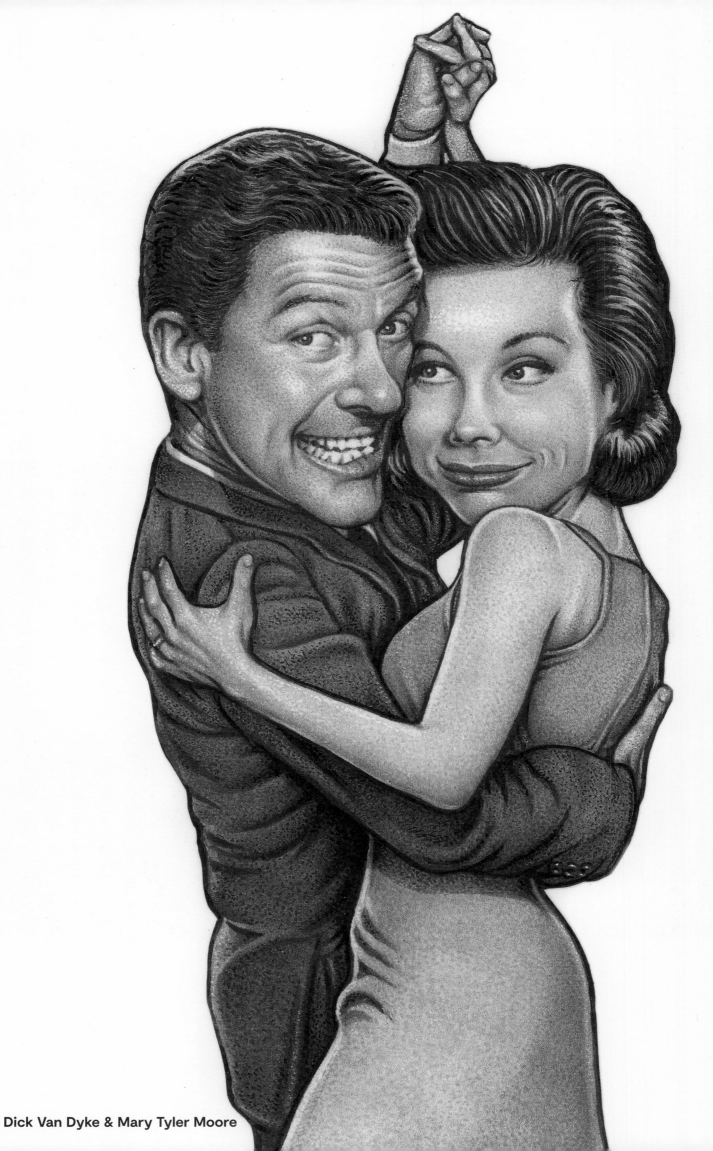

Dick Van Dyke & Mary Tyler Moore

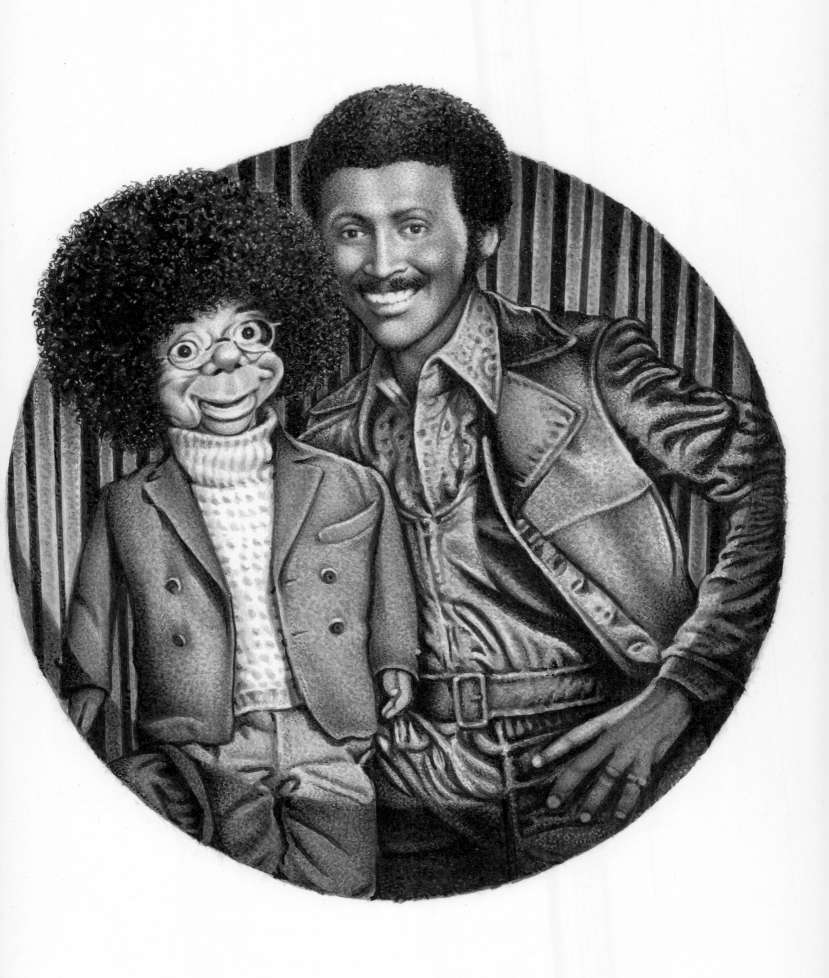

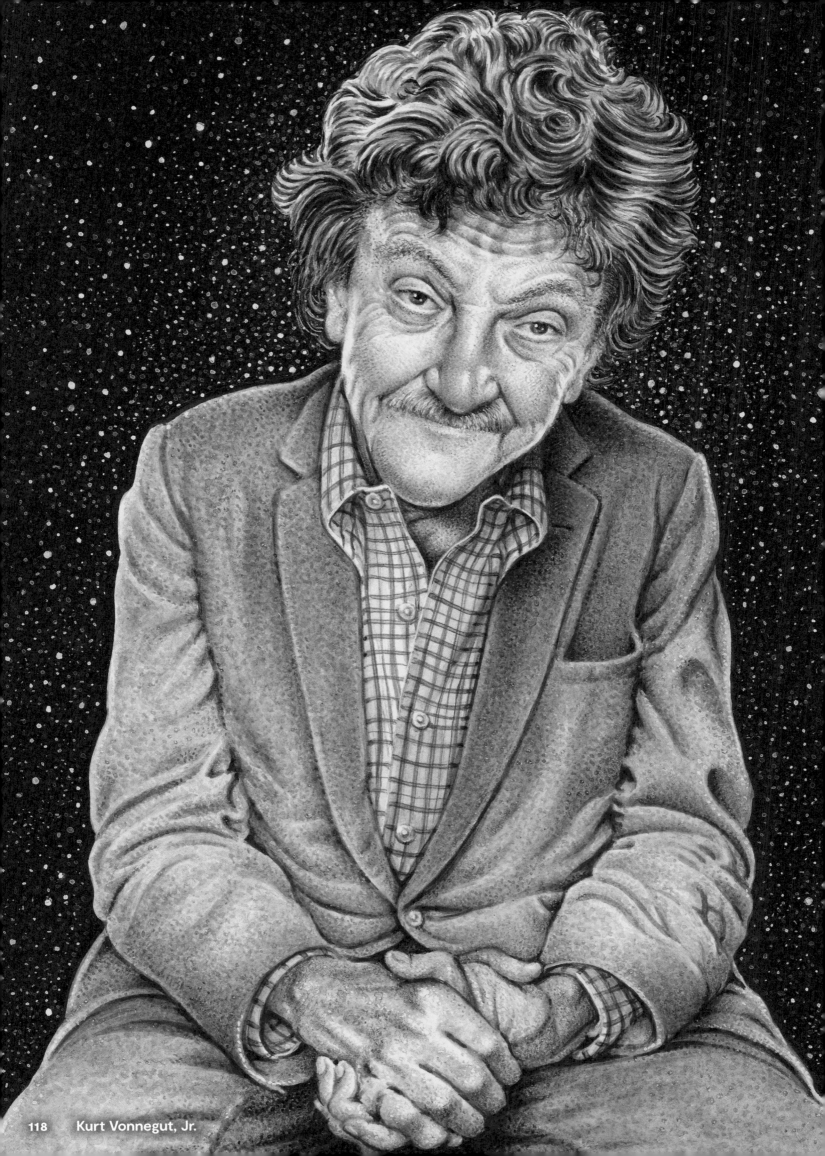

118 Kurt Vonnegut, Jr.

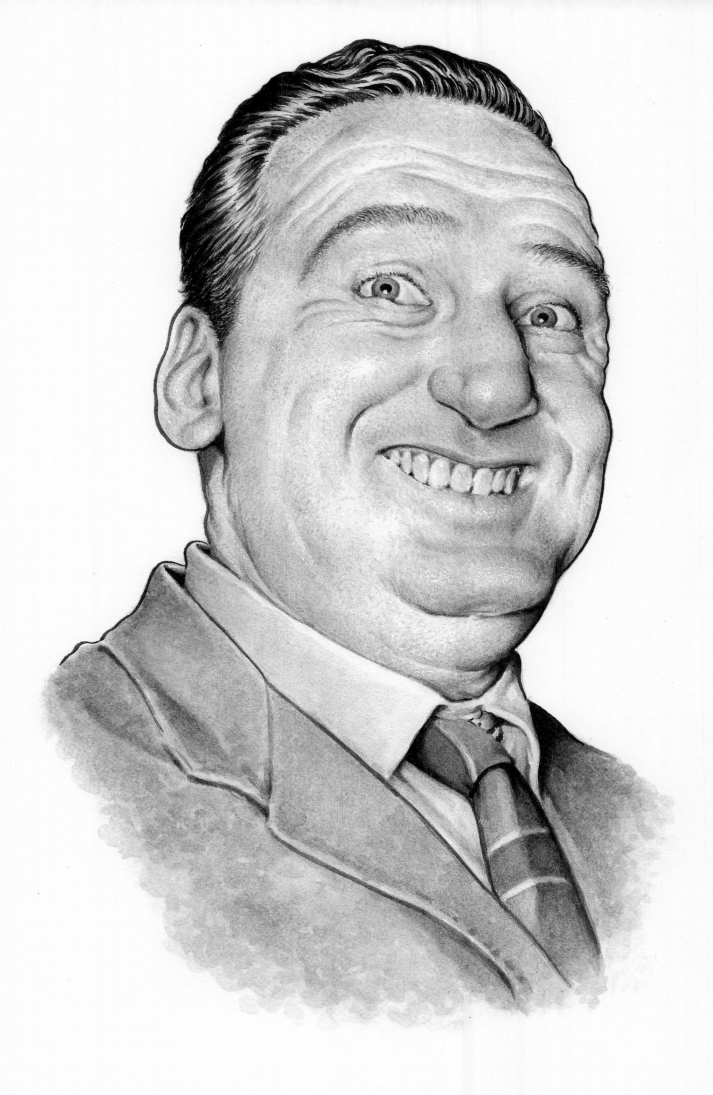

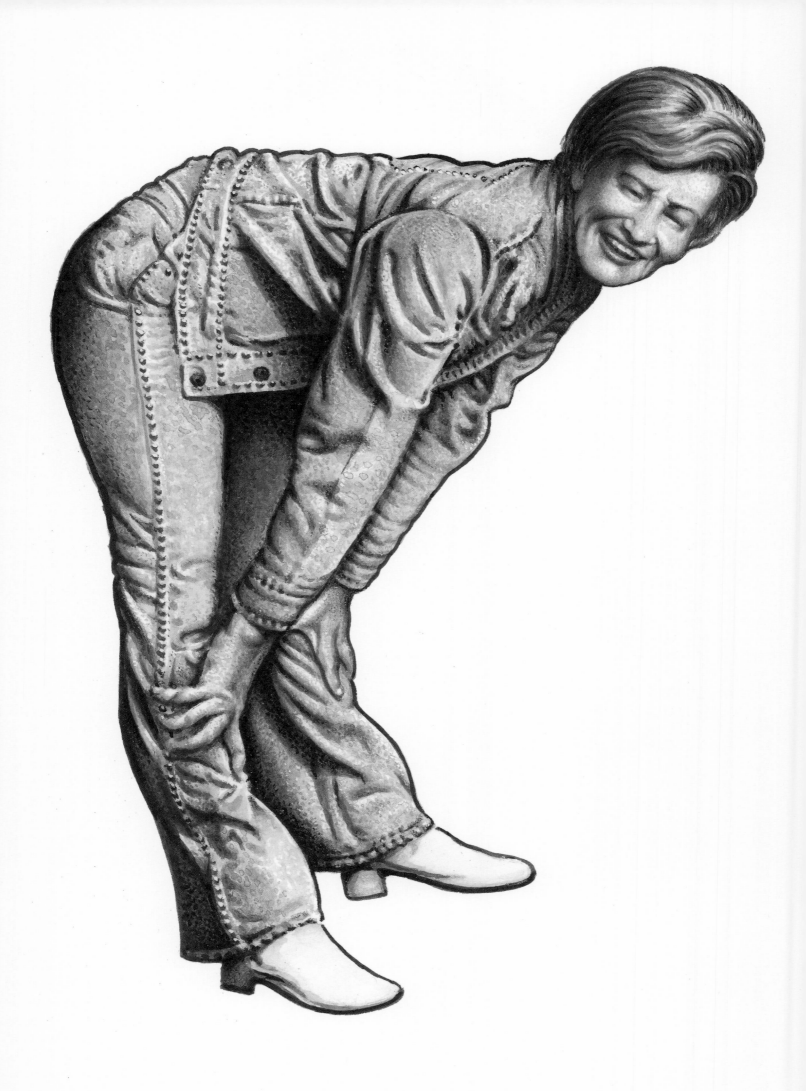

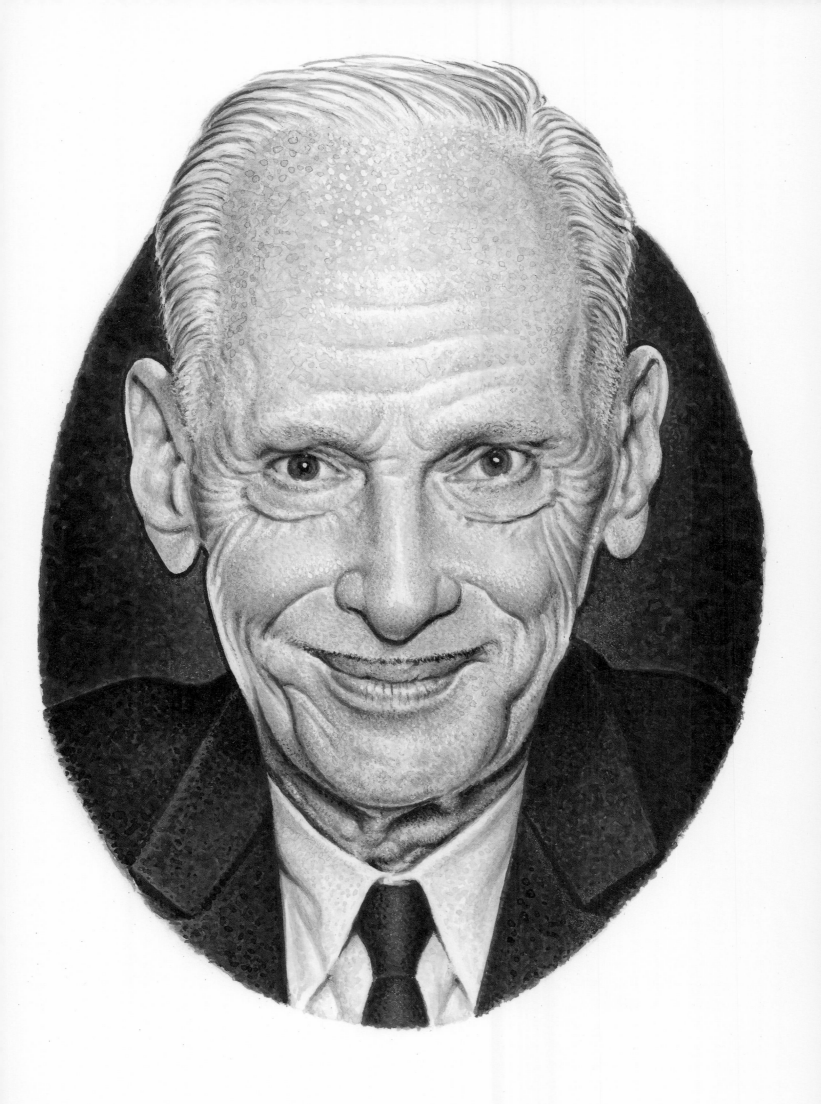

John Waters 121

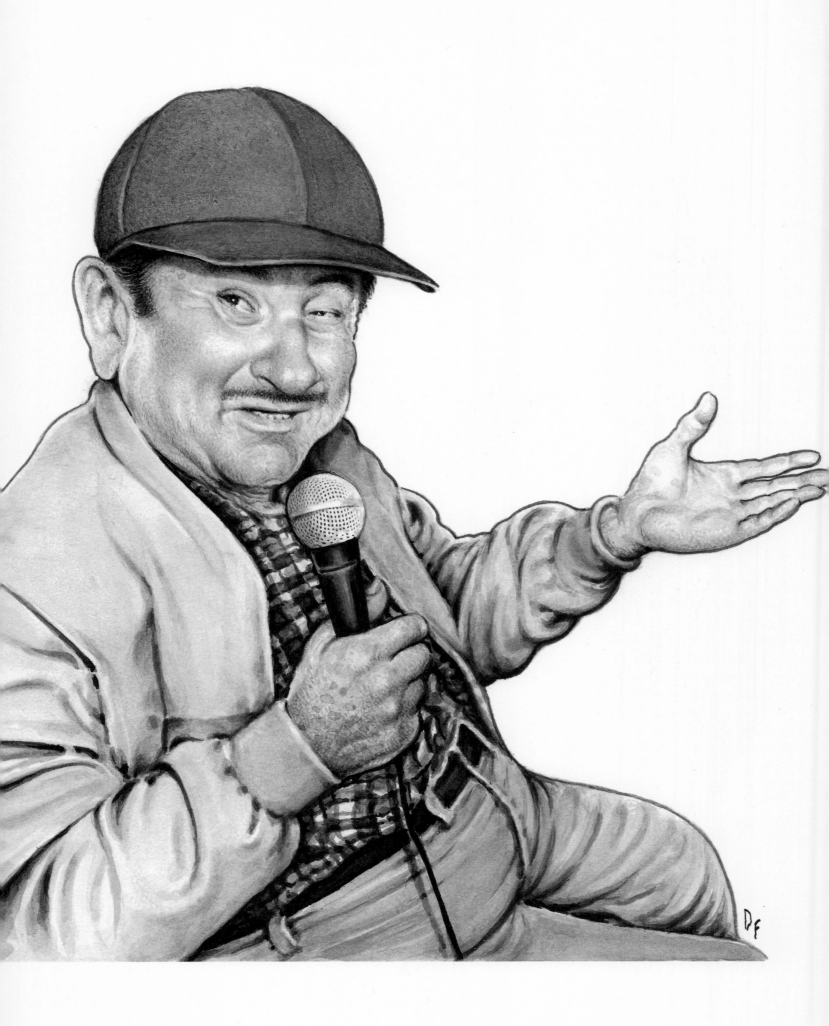

Murray Waxman

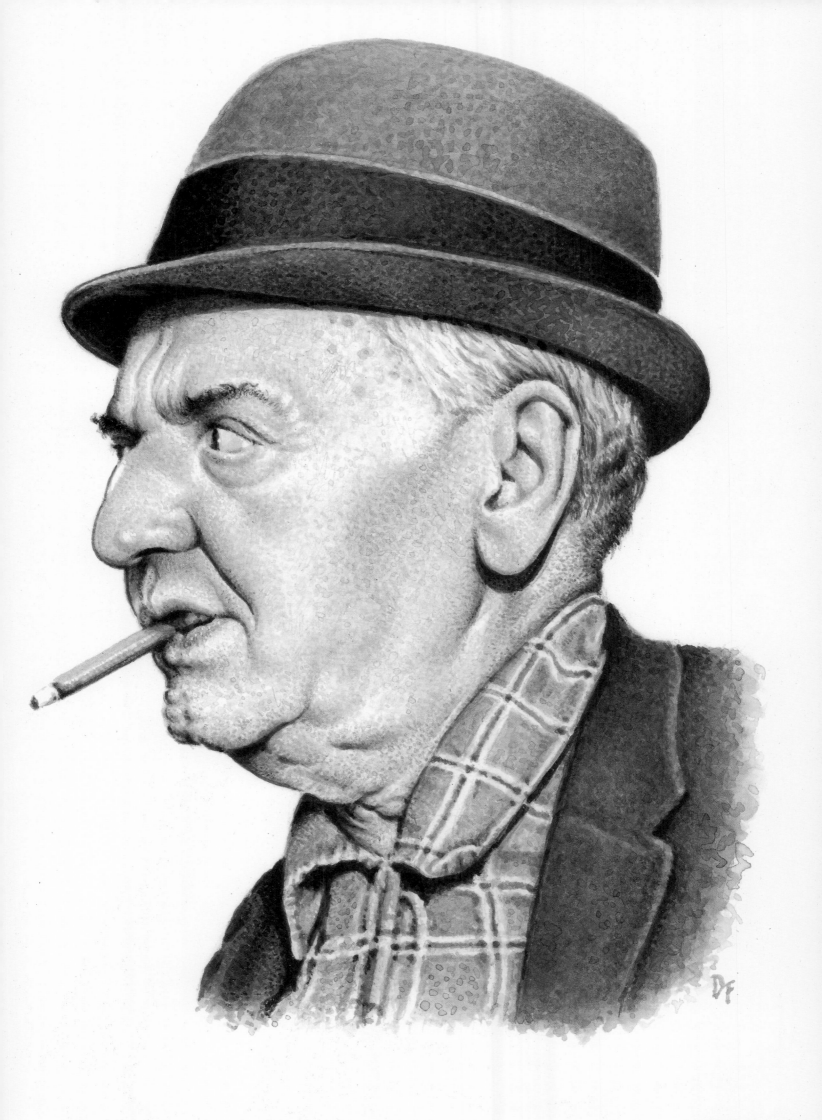

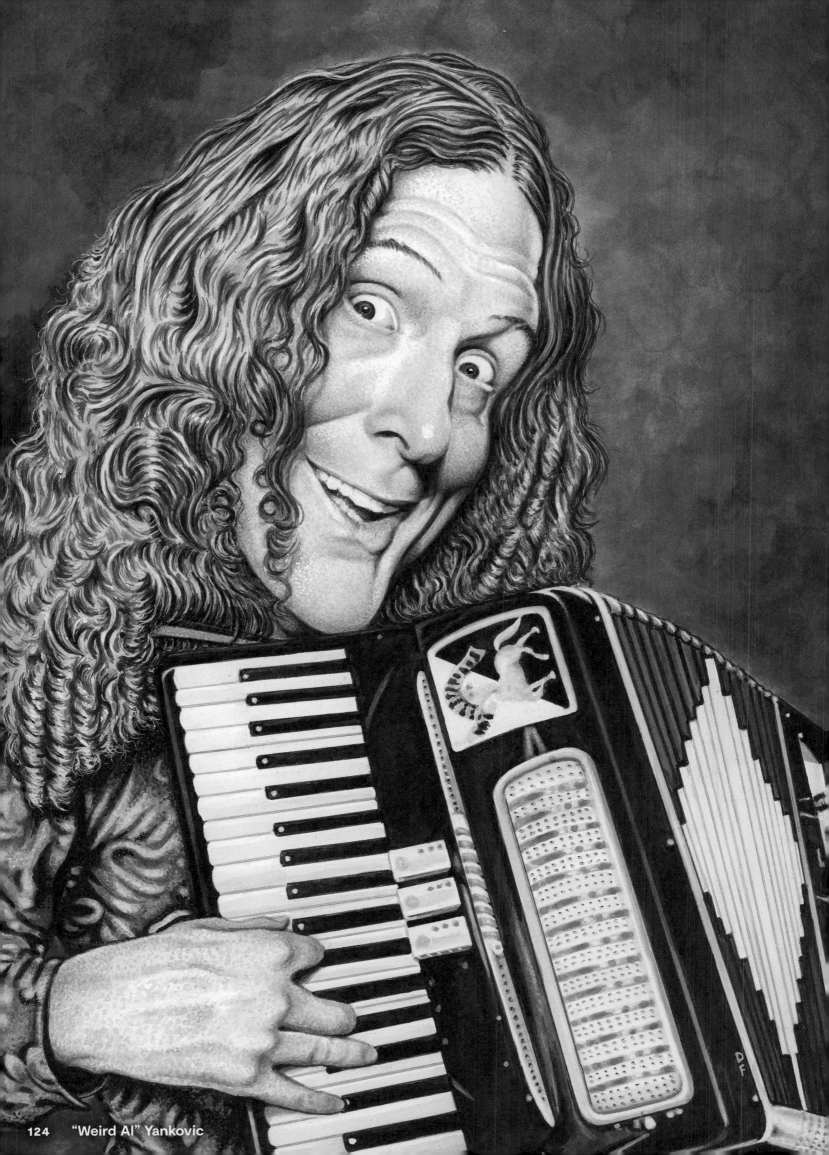

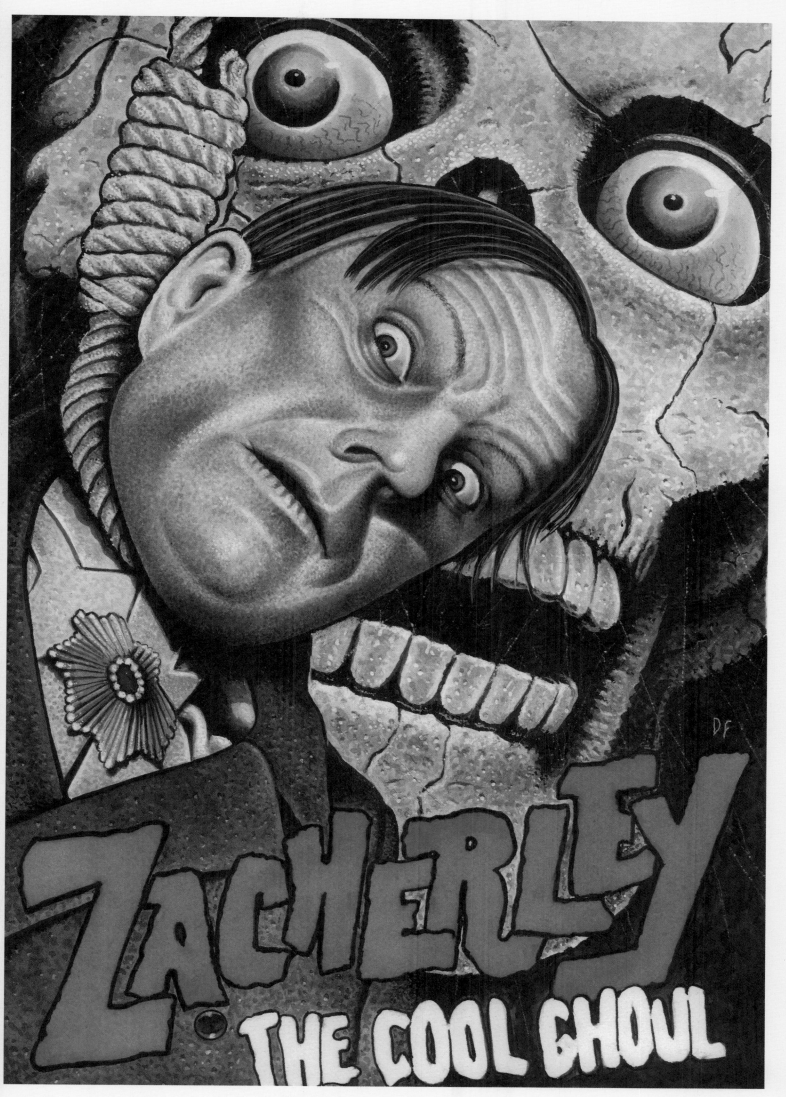

ZACHERLEY

THE COOL GHOUL

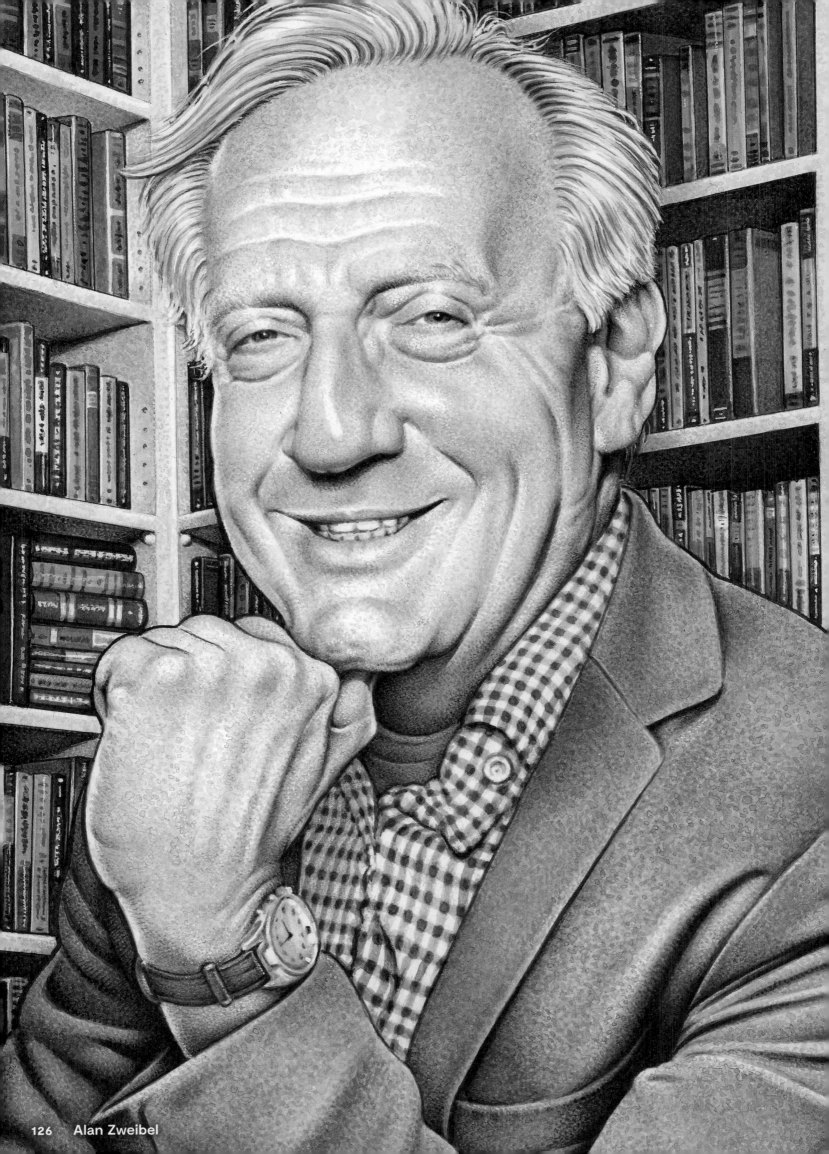

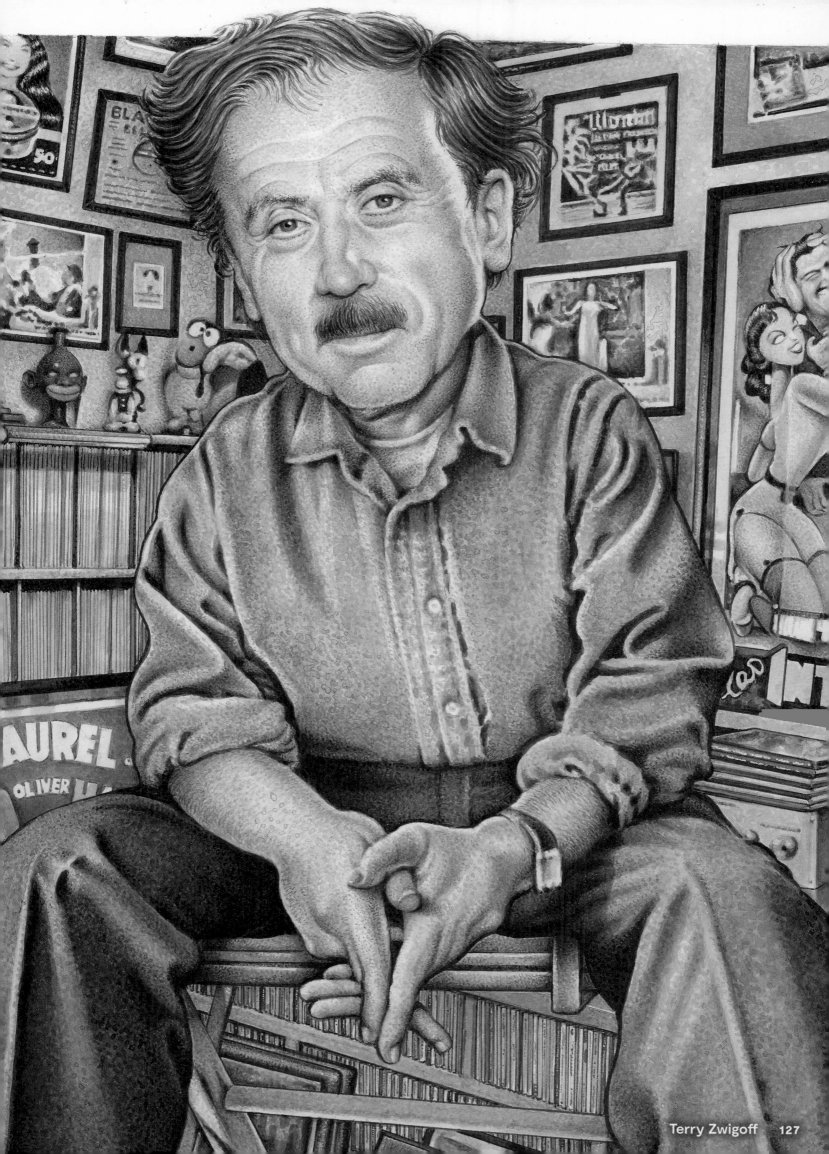

Biographies

All text by Drew Friedman except where noted.

BUD ABBOTT (1897–1974) The brash, taller straight man to shorter patsy Lou Costello; the two teamed up in the early '30s as a burlesque comedy duo, and, within a decade, would become huge comedy stars on the Broadway stage and in radio, films, and (later) television. The team would break up in 1957, and Costello died two years later.

CHARLES ADDAMS (1912–1988) The legendary macabre cartoonist whose creepy, nameless family appeared in *The New Yorker* for decades. In 1964, the family would be adapted for television as the NBC sitcom *The Addams Family*. Addams would finally bestow names on the family members, among them the two children, Wednesday (riffing on Tuesday Weld) and Pubert, which would be changed to Pugsley due to NBC's objections.

KURT ANDERSEN (1954–) An author, journalist, magazine editor (*SPY*), and the former host of public radio's Studio 360. Portrait drawn to accompany Andersen's foreword to *All the Presidents*.

DAVID BADDIEL (1964–) American-born British comedian, screenwriter, and author. Illustration commissioned as a gift for Baddiel's birthday by his friend, Jonathan Ross.

ELI BASSE (1904–1979) A gag and songwriter known as "The Funny Man's Funny Man," he wrote specialty material for many famous comics of the day, including Joe E. Lewis, Milton Berle, and Red Buttons. He also sang novelty songs with orchestras that were released on 45s, and recorded a 1962 album, *Basse-Ackwards*, featuring "hilariously funny stories and snappy songs written for the great comedy stars…"

GENE BAYLOS (1906–2005) Was a prominent New York City and Catskills resort comic for decades. Employing his "poor schnook" character, he was known as a "comedian's comedian." He appeared on TV variety shows (*The Hollywood Palace*, etc.), he played a hobo on *The Dick Van Dyke Show*, and had a recurring role as "Backdoor Benny" (a hapless petty criminal who spent most of his life happily inside Sing Sing) on *Car 54, Where Are You?*

MILTON BERLE (1908–2002) As the host of NBC's *Texaco Star Theater* (1948–55), he became the first major television star, known to millions as "Uncle Miltie" and "Mr. Television" during TV's original Golden Age. Berle's highly visual style, characterized by lowbrow burlesque slapstick and outlandish routines and costumes, proved ideal for the new medium. During his long career, he was featured on Broadway, in nightclubs, resorts, films, a TV bowling show, Friars roasts, and dinner theater.

LENNY BRUCE (1925–1966) A strip-show emcee, Z-movie screenwriter, actor, conman, satirist, social critic, and iconic stand-up comic. His no-holds-barred comedy integrated satire, politics, religion, language, and sex.

ERNESTO CABRAL (1890–1968) A celebrated Mexican painter, cartoonist, and caricaturist, he created many memorable film posters for Mexican musicals, and comedies. A larger-than-life character, he has been described by those who knew him as bohemian, non-conformist, a maestro, a genius, witty, sensitive, insightful, and passionate.

JIMMY CAESAR (1935–1998) Real name: Caesar Pasquale Tronolone. A singer, emcee, comic/impressionist from Buffalo. Early on, he billed himself as "Little Caesar." Caesar performed in nightclubs across the country and in Canada, sometimes with a straight man, and appeared occasionally on television, including *The Tonight Show with Steve Allen*. In the latter part of his career, Caesar lived and performed in Las Vegas, where he died.

SID CAESAR (1922-2014) A celebrated comedic actor, he began his career performing in the resorts of the Catskill mountains. Best known for starring in the early television show *Your Show of Shows*: a Saturday evening variety program which brought together the performing team of Caesar and (Imogene) Coca, and co-starred Carl Reiner and Howard Morris. Later, he starred in *Caesar's Hour*, a sketch/variety show. Caesar would also appear in movies (*It's a Mad, Mad, Mad, Mad World*, *The Busy Body*) and on Broadway (*Little Me*).

GEORGE CARLIN (1937-2008) Born in New York, he began his performing career as a radio DJ during a 3-year stint in the Air Force. Along with fellow DJ Jack Burns, they performed together as a comedy team before Carlin decided to pursue a solo career. For Carlin's early TV and nightclub appearances, he wore a suit and tie. But by the early '70s, he had transformed himself into a long-haired, counterculture comedy hero. Carlin's "Seven Words…" routine from his 1972 *Class Clown* LP was the focus of a U.S. Supreme Court ruling on indecency and obscenity. —*Kevin Dougherty*

LON CHANEY, JR. (1906-1973) A horror movie star and character actor. Gilbert Gottfried claimed that Chaney, Jr. was his favorite actor. Back in the '80s, I had an early VCR and a collection of schlocky VHS horror. Gilbert always wanted to watch films featuring Lon Chaney, Jr. So, together, in my small apartment in the East Village, we would sit in respectful silence and watch and rewatch *The Indestructible Man*, *The Cyclops*, *Dracula Vs. Frankenstein*, etc.

CHARLIE CHAPLIN FAKES: CHARLES AMADOR (1892-1974), BILLY WEST (1892-1975), RAY HUGHES (1899-1956), BILLY RITCHIE (1874-1921) Charlie Chaplin's early short silent film comedies were so popular that other performers decided to imitate the "Little Tramp" character in the hopes of cashing in. Depicted are four of the fake Chaplins who appeared in their own Chaplin-esque shorts: Charles Amador, who was Mexican; Billy West, who was the most popular Chaplin imitator; Ray Hughes; and Billy Ritchie, who claimed that he originated the character of the Little Tramp on the London music hall stage. For *Mineshaft*.

BOBBY CLARK (1888-1960) Performed in blackface for minstrel shows, in vaudeville, starred on Broadway, in films and on television. Famous for his brash, energetic comedy stylings and painted-on glasses, he was also half of the comedy team Clark and [Paul] McCullough.

IMOGENE COCA (1908-2001) During her 70-year career, she was a gifted comedic actress that appeared on stage, film, and television. She's best known for appearing opposite Sid Caesar on the hugely popular early 1950s variety program *Your Show of Shows*. In 1966, she co-starred with comic Joe E. Ross in the sitcom *It's About Time*. For *Mineshaft*.

CLIFF "SNUFFY" COCHRAN (1893-1963) Began his career in show business as a blackface comic in minstrel shows, calling himself "Jazz" Cochran. He spent most of his career performing as a burlesque comic, mainly working in the Cincinnati area. For the sake of decorum, his second wife, Helen, would claim that Cliff worked as a traveling salesman, so there was a bit of puzzlement at his wake when the funeral home was filled with aged burlesque queens (his first wife had been a burlesque dancer).

ROBERT CRUMB (1943–) One of the most celebrated artists of our times. The underground cartoonist, who has lived in France since 1991, revisited the United States in early 2023, crisscrossing the country by car with his nephew at the wheel, to see family and old friends. One of my favorite subjects, whether strumming his mandolin amongst his vast record collection in his home in France or, most recently, on the occasion of his 80th birthday in 2023 (for *Air Mail Online*). "R. Crumb and Me" was an eight-page comic strip detailing my long association (beginning with *Weirdo* magazine) and friendship with the man (the full strip appears in *Masterful Marks* from Simon & Schuster).

CASS DALEY (1915-1975) A brash singer and comedic actress of the 1930s and '40s, she began her career as a big band singer before evolving into a comedian. For *Mineshaft*.

SAMMY DAVIS, JR. (1925-1990) The legendary Black and Jewish singer, dancer, musician, actor, impressionist, rat-packer, talk show host and Nixon-hugging, Archie Bunker-kissing, gun-slinging, Satan-worshiping Candy Man. Sammy Davis managed to do it all during his 65 years on the planet.

JOAN DAVIS (1907-1961) A celebrated comedic actress and performer who began her career in vaudeville. She'd go on to have a successful career in movies, radio, and television, producing and starring in the madcap 1950's *I Love Lucy*-esque sitcom, *I Married Joan*, co-starring Jim Backus as the husband who married Joan.

AL DECLERCQ (1898-1952) From Chicago, he was a comedian/comic dancer who performed on radio, in the circus, and during the waning days of burlesque. DeClercq was occasionally billed as the "Hollywood Hillbilly" and worked the dwindling regional burlesque circuit and toured in Australia.

MICKEY DEEMS (1925-2014) A comedian and actor, he was featured on Broadway (*Little Me*) and television (*Car 54, Where Are You?, Get Smart, Three's Company*, etc.). He's probably best remembered for co-starring with Joey Faye in *Mack and Myer for Hire*, a TV show aimed at children that aired in syndication from 1963 to 1964. More than 100 episodes, each about 12 minutes long, were filmed.

CALVERT DEFOREST (1921-2007) Portrayed Larry "Bud" Melman (the name devised by Merrill Markoe), the dweeb-ish, roly-poly mascot of NBC's *Late Night with David Letterman*. His visage was the first thing unsuspecting viewers saw before the opening credits of the debut episode of *Late Night* on February 1, 1982, reciting a parody of Edward Van Sloan's prologue/warning that introduced James Whale's classic 1931 film *Frankenstein*.

JOE DERITA (1909-1993) Born Joseph Wardell, he began performing at age seven and worked as a burlesque comic for decades, mainly performing for the Minsky's circuit. In the mid-1940s he starred in four comedy shorts for Columbia pictures, but he would enjoy his greatest fame beginning in 1959, when he agreed to shave his head and become "Curly-Joe" of the Three Stooges, replacing Joe Besser as the "third Stooge." As a Stooge, Curly-Joe has been much maligned. True, he couldn't measure up to former third Stooges Curly Howard or Shemp Howard — those were impossibly large shoes to fill — but his clever and funny low-key gestures, reactions, and quips were easy to miss if you weren't paying attention.

SELMA DIAMOND (1920-1985) A comedian, writer, monologuist, and actress, she was a staff writer for *Your Show of Shows* and *Caesar's Hour*. She appeared in several films (*Miracle on 34th Street, Bang the Drum Slowly*, and as the voice of Spencer Tracy's abrasive wife heard offscreen in *It's a Mad, Mad, Mad, Mad World*) and would achieve her greatest fame as the feisty chain-smoking bailiff on the TV sitcom *Night Court*.

PHYLLIS DILLER (1917-2012) Referred to as the "First Lady of Stand-up Comedy." Diller was a master of self-mocking monology. She had hit records, performed in top nightclubs, appeared in movies, and was featured on television for decades, beginning with her first TV appearance on *You Bet Your Life* with Groucho Marx in 1958. Drawn for *Mineshaft*.

BOB DYLAN (1941-) The iconic singer, songwriter, and cultural icon as he looked in 1966. By this time, Dylan had forsaken the acoustic music that brought him initial fame and had gone electric. He'd angered old fans, attracted new ones, and was about to release the monumental double album, *Blonde on Blonde*. —*Irwin Chusid*

NICK EDENETTI (1938-1998) Real name: Lawrence Weistreich. He was a nightclub performer who created a one-man show imitating Frank Sinatra, including donning a tilted snap-brim hat, a raincoat over his shoulder and a dangling cigarette. He performed in small clubs and restaurants in the 1970s and '80s, mainly in the Los Angeles area, and hosted a nighttime cable TV talk show featuring his L.A. cronies. From his own publicity: "Nick is a multi-faceted performer who is known as a 'triple threat' among his peers."

HARRY EINSTEIN (1904-1958) A popular comedian and writer who gained fame as the Greek chef character "Parkyarkarkus" on the Eddie Cantor radio show in the 1930s. He would portray "Parky" for years on radio, in films, and on television. Einstein famously died of a heart attack at a 1958 Beverly Hills Friars Club testimonial to Lucille Ball and Desi Arnez. Moments after finishing his (hilarious) speech and retaking his seat on the dais, he slumped into Milton Berle's lap, and soon died. Einstein is entombed in a crypt in the Home of Peace Mausoleum and Chapel within the Home of Peace Cemetery in east Los Angeles. Directly above his crypt is Shemp Howard's crypt. His sons include the late comic actor Bob Einstein, and comedian/filmmaker Albert Einstein, aka Albert Brooks.

PETER FALK (1927-2011) The iconic Lieutenant Columbo from the 1970s NBC series *Columbo*. Drawn for the cover of a Falk biography.

JOEY FAYE (1909-1997) A comedian and comic actor, he appeared in vaudeville and on stage, films, and television, including co-starring in the 1963–64 series *Mack and Myer for Hire* with Mickey Deems. Full disclosure. I assumed Joey Faye was Jewish based on his name, his demeanor, and the many Jewish waiters he played over the years. I drew his portrait for my book *Old Jewish Comedians* but left it out of the final book when I discovered that he was Italian (Joey Palladino). This is a revised version of that orphaned portrait.

AL FELDSTEIN (1925–2014) Comic book artist, writer, and editor for EC Comics, he took over editing *MAD* magazine after Harvey Kurtzman departed in 1956 and helped transform it into America's top-selling humor publication. Created for the October 2023 cover of a *MAD* auction catalog.

FRANK FERRANTE (1963–) A comedic stage performer. In 1986, he portrayed the legendary Groucho Marx from age 15 to 85 in *Groucho: A Life in Review* at off-Broadway's Lucille Lortel Theatre, written by Groucho's son Arthur and Robert Fisher. The *New York Times* described his work as "artful." Over the last 35-plus years, he's toured the world portraying Groucho, culminating in the 2001 PBS broadcast of Frank Ferrante's *Groucho*. Portrait commissioned by Frank Ferrante.

TOTIE FIELDS (1930–1978) Ed Sullivan gave her national exposure on his show in the 1960s, and she'd become one of the most popular comedians in nightclubs and hotels, especially in Las Vegas. Fields appeared on countless TV variety shows and daytime panel shows. Self-deprecatory fat jokes were the center of Totie Fields' act, and she suffered from many health issues and would die at age 48.

FYVUSH FINKEL (1922–2016) Beginning his career in New York Yiddish theater and performing as a comedian in the Borscht Belt, Finkel is best known for his role as lawyer Douglas Wambaugh on the TV series *Picket Fences*, which won him an Emmy award in 1994. He's also known for his role of Harvey Lipschultz, the crotchety U.S. history teacher, on the TV series *Boston Public*.

FRANK "KELLY" FREAS (1922–2005) The 1959 *Son of MAD* paperback cover art, featuring a gorilla terrified by the approaching baby Alfred E. Neuman, was painted by the renowned science fiction/fantasy illustrator Kelly Freas, who was then *MAD*'s number one cover artist. The image poses the artist with his newly completed painting. Drawn for *MAD*.

WILLIAM "BILL" M. GAINES (1922–1992) With his loyal editor, Al Feldstein, the EC Comics publisher guided *MAD* magazine and its mascot, Alfred E. Neuman, into becoming American institutions. The eccentric Gaines would evolve into an unlikely hippie. He described his formula for success: "My staff and contributors create the magazine. What I create is the atmosphere."

MAX GAINES (1894–1947) In the mid-'30s, he basically invented the format for the comic book. He started his company, Educational Comics (EC), in the '40s. Gaines died in a tragic boating accident in 1947, and his son Bill reluctantly took over the family business, turned Educational Comics into Entertaining Comics, and the rest is history.

BILLY GILBERT (1894–1971) The son of singers in the Metropolitan Opera, began performing in vaudeville at age 12. He developed a drawn-out, explosive sneezing routine that became his trademark. In his long career, Gilbert appeared in more than 200 feature films and shorts and worked with the likes of Laurel & Hardy, Our Gang, Charley Chase, The Three Stooges, and Charlie Chaplin. He also was the voice of Sneezy in Walt Disney's *Snow White and the Seven Dwarfs*.

JACK GILFORD (1908–1990) A wistful, gentle-looking comedic actor, he was a favorite for many decades in vaudeville, on stage, screen, and television. Blacklisted in the 1950s, he would triumphantly return to appear on TV, in films, and stage productions *of A Funny Thing Happened on the Way to the Forum*, *Cabaret*, and *Sly Fox*. In the '60s, he became familiar to millions as the silent TV spokesman for Cracker Jack.

JACKIE GLEASON (1916–1987) The celebrated comedian featured in nightclubs, on Broadway and radio, in films, and especially on television. Gleason was dubbed "The Great One" for good reason.

BERT GORDON (1995–1974) A comedian (real name Barney Gorodetsky) who appeared in vaudeville and later on Broadway. He became most famous for portraying "The Mad Russian" on the Eddie Cantor radio show. The character became so popular he starred in his own film, titled with his then famous catchphrase, *How DOOOO You Do*. In 1964 he played himself on an episode *The Dick Van Dyke Show* that featured radio stars of the past.

GILBERT GOTTFRIED (1955–2022) A hyper, crazy-brilliant, and fearless comedian who occasionally and bravely joked "too soon." I met Gilbert up at the 1980s, not-very-funny version of the *National Lampoon*, which we were both creating work for. We hit it off because we shared a passion for old schlocky show business and, especially, old horror films, mainly featuring Bela Lugosi, John Carradine, Tor Johnson, George Zucco, Onslow Stevens, and especially Lon Chaney, Jr. Gilbert and Frank Santopadre hosted 640 episodes of

the funny and fascinating *Gilbert Gottfried's Amazing, Colossal Podcast*. Gilbert died, ironically, Too Soon. His family, friends, and fans miss him greatly. This piece was created for what was supposed to be the final issue of *The Village Voice* (but turned out not to be).

THEODORE GOTTLIEB (1906–2001) As Brother Theodore, he was a darkly funny monologuist. Born in Dusseldorf, Germany, the Nazis imprisoned him in Dachau until he signed over his family's wealth, and with help from some prestigious family friends he made his way to the United States. Most of his family members, including his parents, would perish in the Holocaust. His performing career (he called his routines "stand-up tragedy") began in the 1940s and reached national TV audiences when he appeared regularly on *The Merv Griffin Show* in the 1960s, including a memorable encounter with Jerry Lewis. In the 1980s, he became popular with a new generation of fans when he made several appearances on *Late Night with David Letterman* (introduced as a "philosopher, metaphysician, and podiatrist"). He also performed regularly for years at New York's 13th Street Theater.

STANLEY MYRON HANDELMAN (1929–2007) Known for his deadpan, nerdish demeanor, his trademark newsboy cap and oversize glasses, Handelman became a popular comic on TV variety shows of the 1970s, frequently appearing on *The Tonight Show* and *The Dean Martin Show*. He developed his comedy act in New York clubs in the 1950s, eventually becoming an opening act for Frank Sinatra. When his TV career finally ebbed, he taught stand-up comedy in Los Angeles.

MANUEL "VAN" HARRIS (1925–2014) A popular Borscht Belt nightclub resort comic, he also worked as the social director at the Pine View Hotel in Fallsburg, NY. In the 1960s, he appeared several times on *The Ed Sullivan Show* and *The Tonight Show with Johnny Carson*.

RONDO HATTON (1894–1946) Began as a journalist before the growth hormone disorder acromegaly transformed from misfortune into Hollywood fame. Hatton needed little to no facial makeup to portray "The Creeper" in a series of Universal Horror films of the 1940s. Drawn for the cover of *Rondo Hatton, Beauty Within the Beast* by Scott Gallinghouse (published by BearManor Media).

PERCY HELTON (1894–1971) Began performing on stage at age two. The diminutive Helton would appear in a play which required him to scream for much of the evening, resulting in a permanently raspy voice which would eventually serve him well in Hollywood. He would become one of the most recognized faces in films and television, usually cast as a creepy, sweaty, yet lovable character.

HANK HENRY (1906–1981) A large, rubbery-faced comic who began his comedy career performing at Grossinger's in the Catskills, joined Minsky's Burlesque, then had a four-year tour with "This is the Army " during WWII. He'd later become a popular Las Vegas comic, mainly appearing at The Silver Slipper in "The Hank Henry Review" and co-starring with a down-on-his-luck Bela Lugosi in "The Bela Lugosi Review." Known among his peers as "the comedian's comedian," Henry was a particular favorite of Frank Sinatra's, who had him hired for a half dozen of his films, including *The Joker is Wild*, *Pal Joey*, and *Ocean's 11*.

LOU HOLTZ (1893–1980) A renowned comic actor and singer, he began his career by telling Jewish dialect stories in blackface, before hitting the big time in the popular "George White's Scandals," and then headlining at New York's Palace Theatre. He would have a long career in Broadway musical comedies, radio, film, television (*The Ed Sullivan Show*), and real estate.

MOE HOWARD (1897–1975) Born Moses Harry Horwitz, he was the head Stooge of the legendary Three Stooges, the other members including stalwart Larry Fine, and at various times his older brother Shemp, younger brother Curly, Joe Besser, and Joe DeRita. No other comedic actor displayed such abject anger, annoyance, or exasperation, at times with little or no provocation, as Moe Howard. To be a Stooge under Moe was to suffer gratuitous slapstick abuse on a relentless basis.

SHEMP HOWARD (1895–1955) Legendary comic actor of film and Three Stooges fame. Samuel "Shemp" Howard looked like a real guy — maybe the lively relative you would see at large family gatherings (weddings, seders, bar mitzvahs), drinking, dancing, flirting, having too much fun, inevitably making a fool of himself until his poor wife had to drag him out. While Moe, Larry, and Curly looked like comedians — broad caricatures of human archetypes — Shemp was more accessible, a garrulous fellow you might see working in a crummy restaurant, shoe store, or cigar store. Shemp did have an expressive, rubbery comic face, but with

his greasy parted hair, baggy-eyed, pockmarked face, short stocky build, and wobbly gait, he came across as an old-fangled New York neighborhood character who had somehow wandered onto a Hollywood movie set.

WILLIE HOWARD (1886–1949) Partnering with his brother Eugene, the Howard Brothers became two of the most popular comedy vaudeville performers in the early 20th century. The brothers were two of the first openly Jewish performers, employing an exaggerated Jewish dialect for comedic effect. After Eugene retired from the act in 1940, Willie used double-talk comic Al Kelly as his sidekick. They starred in a short talkie poking fun at socialism, "Comes the Revolution." Willie also performed in Broadway shows and in nightclubs before his death in 1949.

JIMMY JEWEL (1909–1995) & BEN WARRIS (1909–1993) Jewel teamed up with first cousin and fellow comic Warris in the 1930s, and they became a celebrated comedy team for decades, topping the bill at the London Palladium several times. Their BBC radio series *Up the Pole* included musical interludes by a teenage Julie Andrews.

MILT KAMEN (1921–1977) A popular stand-up comic who began his career performing in Catskill Mountain resorts. In the 1950s he would be hired as Sid Caesar's stand-in on *Caesar's Hour* and later appeared in numerous TV shows, films, and on stage, including a production of *The Odd Couple* co-starring Arnold Stang.

BORIS KARLOFF (1887–1969) As a British boy, he was bow-legged, lisped, and stuttered. While acting in Canadian theater, William Henry Pratt reinvented himself as Boris Karloff. After he arrived in Hollywood, he eventually found stardom in the films *Frankenstein*, *The Mummy*, and *The Old Dark House*. He continued to dominate the horror film genre, starring in *The Black Cat*, *The Raven*, and — extending the franchise — *Bride of Frankenstein* and *Son of Frankenstein*. He enjoyed a lengthy career on stage and in films, radio, and records, and doing animation voiceovers and performing on television variety shows. —*Irwin Chusid*

JACAEBER KASTOR (1955–) Artist and founder/owner of the Psychedelic Solution Gallery (1986–1995), once located near the corner of West 8th Street and Sixth Avenue in New York, posed in his apartment above the gallery. Private commission.

GEORGE S. KAUFMAN (1889–1961) The celebrated playwright, director, producer, humorist, and drama critic — he also wrote several musicals for The Marx Brothers. The illustration depicts him in the early 1950s when he appeared as a regular panelist on the CBS show *This is Show Business*.

BUSTER KEATON (1895–1966) The legendary actor/comedian/director depicted during the mid-1950s. At this stage, long past his silent-film prime and an unfortunate Hollywood has-been, the "Great Stone Face" had a modest resurgence on TV, including a silent-film parody on a memorable episode of *The Twilight Zone*. —*Irwin Chusid*

ALAN KING (1927–2004) His career began in the Catskills, with jokes centering on Jews and mothers-in-law. His comedy changed when he saw Danny Thomas perform in the early '50s, talking to his audience, not at them. His material became more conversational, centering on his day-to-day life and family. His career began to take off in nightclubs and on television, where he became a regular on *The Ed Sullivan Show*. He became one of the top stand-up comedians of his generation and starred on Broadway (*The Impossible Years*) and in several films.

B.B. KING (1925–2015) Redefined soulful blues in the second half of the 20th century. His style was smooth and impassioned, dignified and direct. His guitar was ever-present, but while King sang, the guitar was essentially an ornament. When he stopped singing, he made the guitar sing. —*Irwin Chusid*

ARNIE KOGEN (1934–) A top TV comedy writer, among the many shows he's written for include *The Jackie Gleason Show*, *The Tonight Show*, *The Dean Martin Show*, and *The Mary Tyler Moore Show*. He won three Emmy awards for his writing on *The Carol Burnett Show*. He started writing for *MAD* magazine in 1959 and appeared in 179 issues. Illustration commissioned by Arnie Kogen.

AL KOOPER (1944–) A songwriter ("This Diamond Ring," "I Can't Quit Her," etc.), record producer, and musician, known for organizing The Blues Project and Blood, Sweat & Tears, providing studio support for Bob Dylan when he went electric (including playing the memorable organ on "Like A Rolling Stone"), and bringing together guitarists Mike Bloomfield and Stephen Stills to record the *Super Session* album. In the 1970s, he became a successful recording artist, manager, and producer, notably recording Lynyrd Skynyrd's first three albums. He's also had a successful solo career, touring and performing live and writing music for film and television.

HARVEY KURTZMAN (1924–1993) Cartoonist, writer, editor, and teacher, he was the creator and editor of *MAD*, *Trump*, *Humbug*, and *Help!* Along with his longtime partner, cartoonist Will Elder, he spent 20 years (1964–84) producing the lushly painted comic strip, *Little Annie Fanny*, for *Playboy*.

GIL LAMB (1904–1995) An eccentric comedic dancer and performer, known for his lean, lanky, impossibly bendable body, he began his career performing in vaudeville and would enjoy a long career on stage, screen, and television.

FRAN LEBOWITZ (1950–) New Jersey-born, New York-based author, essayist, public speaker, and confirmed smoker, she's known for her sardonic and acerbic social commentary on current events, the media, American life, and "foodies."

OSCAR LEVANT (1906–1972) Pianist, composer, author, radio and television host/panelist, and film actor (featured in *An American in Paris* and *The Band Wagon*). A raconteur known for his sardonic wit, he was dubbed the "verbal vampire." Several of his quips: "I don't drink water, fish screw in it." "When I can't sleep, I read a book by Steve Allen." "I knew Doris Day before she was a virgin."

ALBERT LEVINSON (1895–1976) Aka Al Flosso, aka the "Coney Island Fakir" (dubbed by Milton Berle), stood 5'2" and was a magician and entertainer and the proprietor of New York's leading magic shop. Beginning as a street corner shill, carnival pitchman, puppeteer, and sideshow musician, he would move on to Broadway, film, and television, and worked with the likes of The Marx Brothers, Bud Abbott, and Ed Sullivan.

MARTIN "BLIMP" LEVY (1905–1961) A Jewish wrestler, he was a major attraction on the wrestling circuit in the 1930s and '40s. Discovered in the mid-'30s working as a fat man in a Coney Island sideshow, by wrestling impresario Jack Pfefer, "Blimp" tipped the scales somewhere between 600 and 700 pounds. Nobody knew exactly how much he weighed because normal scales couldn't contain him. With the larger men in the mat game weighing in somewhere between 200 and 300 pounds, Blimp, with his ample corpus and bug eyes, was one of the first "freaks" in professional wrestling. —*Eddy Portnoy*

JERRY LEWIS (1926–2017) The one and only King of Comedy. As Kliph Nesteroff has put it: "The comedian you love to hate and hate to love." He first honed his comedy as a solo act in the resorts of the Catskill mountains before conquering all facets of show business with partner Dean Martin. For more than 70 years, Jerry Lewis did it all, from brash, crazed comedian, sentimental clown, Hollywood movie star, innovative film director, Broadway star, telethon host, and Vegas icon.

JERRY LEWIS / *SLAPSTICK* Jerry Lewis, in his initial test make-up for the inevitably bad 1984 film *Slapstick of Another Kind*, based on Kurt Vonnegut's novel, *Slapstick*. Vonnegut would have his name removed from the film and all of its advertising.

MOMS MABLEY (1894–1975) Regarded as one of the most important and greatest entertainers that ever lived, and the first bona fide stand-up comedy superstar. At her peak, she was making $10,000 a week for stage appearances alone. —*Kliph Nesteroff*

RICHARD MANITOBA (1954–) Bronx born and raised Richard Blum, aka "Handsome" Dick Manitoba, was the legendary lead singer for the punk band The Dictators from 1974 to 2008 and is a New York icon.

PIGMEAT MARKHAM (1904–1981) A crowd-pleasing Black burlesque comedian who early in his career worked in blackface. He appeared in vaudeville, night clubs, films, and later television, where his catch phrase "Here Comes the Judge" would bring him national fame after Sammy Davis, Jr. popularized it on *Rowan and Martin's Laugh-In* in the late 1960s.

GUY MARKS (1923–1987) A TV and nightclub comic who had the ability to distort his body into bizarre, ostrich-like creatures, as seen on a memorable episode of *The Dick Van Dyke Show*. He was also a brilliant mimic: his Humphrey Bogart impression is unparalleled. His novelty song, "Loving You is Making Me Bananas," became a 1970s hit in his hometown of Philadelphia.

MARC MARON (1963–) After 20 years as a stand-up comic, his career really took off after he began podcasting from his Los Angeles garage in 2009. More than 1,400 episodes later, *WTF* is still spontaneous, lively, and honest. Maron continues his stand-up career and has become an in-demand actor in film and television. —*Kevin Dougherty*

GROUCHO MARX (1890–1977) Known as a master of quick wit and widely considered one of the greatest comedians of all time, if not the greatest, his often-impromptu delivery and innuendo-laden patter earned him worldwide fame. He appeared in 13 films as a member of The Marx Brothers, and he'd later enjoy a successful solo career as a performer in films and on radio, as an author of numerous books, and most notably as the host of the radio and TV game show *You Bet Your Life*.

ELAINE MAY (1932–) She made her initial comedic impact in the 1950s, teaming with Mike Nichols as the improvisational comedy duo "Nichols and May." She would branch out to theater and film acting (*Luv*, *Enter Laughing*, etc.) and screenwriting and directing (*A New Leaf*, *The Heartbreak Kid*, *The Birdcage*, etc.). For *Air Mail Online*.

NICK MEGLIN (1935–2018) Was a magazine writer, educator, artist, humorist, lyricist, and the author of 14 books, including the essential *The Art of Humorous Illustration*. He was also a longtime editor of *MAD* magazine.

MILT MOSS (1922–2016) A well-liked nightclub comic and master of ceremonies, he also appeared on *The Merv Griffin Show* and in several films. Best remembered for delivering the rueful catchphrase, "I can't believe I ate the whole thing," in a 1972 Alka-Seltzer TV commercial.

ZERO MOSTEL (1915–1977) Early in his career, he had some false starts and struggled as a comedian. But after the bombing of Pearl Harbor and the start of World War II, he was hired by the popular New York nightclub Cafe Society, the owner of the club reasoning that his patrons could "use some laughs." The club's press agent gave Sam Mostel his new name "Zero," stating: "Here's a guy who started with nothing." The manic Mostel would become a top comic actor, appearing on radio, in films and on stage, leading to his staring turns as the milkman Tevye in the original Broadway production of *Fiddler on the Roof* and as Pseudolus in the stage and screen versions of *A Funny Thing Happened on the Way to the Forum*. For *Air Mail Online*.

EDWARD R. MURROW (1908–1965) Arguably the most esteemed and influential broadcaster on radio and television during the '40s, '50s, and early '60s. From 1953 to 1961, he hosted *Person to Person*, interviewing everyone from John F. Kennedy to Jerry Lewis to Harpo Marx in their homes from the comfort of his studio in New York. Updated image, originally drawn for the *New York Observer*.

BURT MUSTIN (1884–1977) Began as an amateur actor appearing on stage, in a barbershop quartet, and as a radio announcer. He then worked as a salesman while occasionally appearing in uncredited bit parts in Hollywood movies. In the 1950s, as he was approaching seventy, his acting career began to accelerate and he became a reliable, familiar "old man" in countless films and TV shows till the end of his life.

JERRY OHLINGER (1943–2018) A New York movie memorabilia dealer specializing in movie stills, press books, magazines, and film posters — all crammed into his tiny store. Over the years, due to rising rents, Jerry Ohlinger's Movie Memorabilia Shop would move locations several times. But the eccentric Ohlinger remained omnipresent, holding court and engaging his customers and staff, always with an unlit cigar (he didn't like smoking them) jammed in his mouth.

MORRIS OSSEN (1911–2003) A felicitous Catskills resort comic who recorded two live albums at Kutsher's Country Club in the 1970s: *The Wit and Wisdom of Morris Ossen* and *Jewish Humor*.

PATTON OSWALT (1969–) The stand-up comedian made his television acting debut as a video store clerk in a 1994 *Seinfeld* episode. Since then, Oswalt has charted an enjoyably eccentric career path. He is equally at home in network sitcoms like *The King of Queens* or the darkly comic indie film *Big Fan*. Oswalt has written extensively about cinema obsessions in his books *Zombie Spaceship Wasteland* and *Silver Screen Fiend: Learning About Life from An Addiction to Film*. —Kevin Dougherty

ADAM PARFREY (1957–2018) He was a journalist and the founding publisher of Feral House, whose books earned praise as provocative and groundbreaking. He was the author of numerous books and the editor of many more. His father was character actor Woodrow Parfrey. Portrait created for the *Apocalypse Omnibus* cover (Feral House), a book collecting Parfrey's early writings.

HANK PATTERSON (1888–1975) In show business, he began as a vaudeville pianist and would enjoy a long career playing gruff, cantankerous roles in mostly western films and television shows. He's best remem-

bered as quizzical, henpecked Hooterville farmer Fred Ziffel on the TV series *Green Acres*. His son, Arnold, was portrayed by a series of trained pigs, varying in size and talent.

ALICE PIERCE (1917-1966) A nightclub comedian, she played Lucy Schmeeler in the original Broadway production of *On The Town*. Gene Kelly insisted she repeat her role in the 1949 film version. She'd continue to act on Broadway and in films. She is best remembered for originating the role of nosey neighbor Gladys Kravitz on the popular sitcom *Bewitched*.

PLAN 9 FROM OUTER SPACE In the early 1960s, in *Chiller Theatre's* opening, I first discovered Vampira. The montage begins with her staggering toward the camera in Ed Wood Jr.'s 1959 *Plan 9 from Outer Space*. *Chiller Theatre* had apparently removed it from rotation by then. However, that brief scene, as well as another quick clip of Vampira, teamed with giant, blank-eyed zombie Tor Johnson, roaming through a graveyard, convinced me that whenever I did actually get to see *Plan 9*, it would live up to my expectations as the greatest horror film ever made.

I finally got to watch the entire *Plan 9* on TV late one night in the 1970s. It wasn't the greatest horror film ever made, but it was far from the worst-ever film (as proclaimed in the Golden Turkey Awards). The Wood screenplay and some acting is obviously inept, but the film is absorbing, fun, sincere — never boring. The beautifully filmed graveyard scenes with Vampira, Tor, and chiropractor Dr. Tom Mason (a stand-in for Bela Lugosi, who had died prior to the film's completion) are truly memorable, as is the over-the-top narration by Criswell. Art commissioned for comedian Dana Gould's live, staged readings of *Plan 9*. (Title lettering by Kevin Dougherty.)

MARTHA RAYE (1916-1994) Was a wide-mouthed, crass, and boisterous actress, singer, and one of America's top comedians for several decades. Nicknamed "The Big Mouth," she appeared on radio, television, on stage, and in films.

DANNY RIO (1916-1980) Real name, Daniel Caprio, a large-nosed Chicago-based comic-pantomimist, he performed in nightclubs and restaurants for several decades and was known for imitating Jimmy Durante: "I put the hat on, I throw the voice around, and people think it's Jimmy." For *Mineshaft*.

JIMMY RITZ (1904-1985) The second born of the three energetic Ritz Brothers (there were actually four Ritz brothers and one sister), a zany comedy team in the 1930s, '40s and '50s who rivaled The Marx Brothers in popularity. The team appeared in nightclubs, radio and films, their act consisting of wild, precision dancing, tongue-twisting patter, ethnic humor, and physical schtick — anything for a laugh.

CHARLIE ROBINSON (1907-1967) Real name: Julian Rabinovich. A bug-eyed, bowl haired, burlesque comedian known for performing sketches from the classic "Crazy House" routine, made famous by Abbott and Costello. In 1943, he performed in a show called *Burlesque Queens* at Cleveland's famed Roxy Theater, and later appeared in the original 1962 New York production of Ann Corio's *This Was Burlesque*. Drawn for the cover of *Mineshaft*.

TIMMIE ROGERS (1914-2006) A talented comedian who started performing in the waning days of vaudeville in the 1940s. He gained enormous popularity, appearing as a frequent guest on *The Jackie Gleason Show* in the early 1960s. His infectious catchphrase, "Oh yeah!" punctuated most of his routines.

PHILIP RUBIN (1949-) Collector of original comix art, graphics related books, old toy robots, and vintage guitars, including the 1957 Les Paul Special depicted. Retired Science Advisor in the Obama White House. Currently the president of the Federation of Associations in Behavioral and Brain Sciences. Illustration commissioned by Philip Rubin. For *Mineshaft*.

S. Z. "CUDDLES" SAKALL (1883-1955) Born Jakab Grünwald, he was a Hungarian stage actor who fled Hitler's Germany to become a beloved Hollywood character actor. Signed to Warner Brothers, studio chief Jack Warner nicknamed the rotund actor "Cuddles," based on his lovable, combustible cuteness. In 1954, he published his autobiography: *The Story of Cuddles: My Life under the Emperor Francis Joseph, Adolf Hitler and the Warner Brothers*.

BILL SALUGA (1937-2023) A comedian and founding member of the improvisational comedy troupe, the Ace Truck Company. He's best remembered for his cigar-chomping, zoot-suited character, Raymond J. Johnson, Jr., triggered by someone calling him "Mr. Johnson." Feigning outrage, he'd soon launch into his

catchphrase, "You can call me Ray, or you can call me Jay, or you can call me…" finishing with: "… but you doesn't has to call me Johnson!" Private commission.

IGOR IVANOVICH SIKORSKY (1889–1972) A Russian born aviation pioneer who in 1939 designed and flew the first practical American helicopter in Stratford, Connecticut. In 1942, it would become the world's first mass-produced helicopter. Updated portrait of Sikorsky originally created for the logo of Igor's Dream, a limited edition Russian imperial stout.

MENASHA SKULNIK (1890–1970) A beloved Yiddish comic actor known primarily for his roles in the Yiddish theater and later starring on Broadway, Skulnik was also popular on radio, playing Uncle David on *The Goldbergs* for 19 years. Skulnik summed up his role in comedy: "I play a pure schlemiel, a dope." For *American Bystander*.

ICEBERG SLIM (1918–1992) Aka Robert Beck. He was a pimp in Chicago and served several terms in jail before turning to writing. He published seven groundbreaking books based on his life.

LARRY "RATSO" SLOMAN (1950–) Biographer, author, magazine editor (*High Times*, *National Lampoon*), journalist, singer/songwriter, raconteur, and the quintessential New York Jew. He's probably best known as Howard Stern's collaborator on his books *Private Parts* and *Miss America*.

SAM SPIEGEL (1901–1985) An independent film producer unaffiliated with any of the top Hollywood movie studios. Spiegel fled Nazi-Germany after Hitler rose to power. Between 1935 and 1954, he billed himself as S.P. Eagle. Some of his films include *The African Queen*, *On the Waterfront*, and *The Bridge on the River Kwai*, all three Academy Award winners for Best Picture of the year.

ARNOLD STANG (1918–2009) A comic, an actor, and a beloved cartoon voiceover artist for many decades. Wearing his thick black glasses, he was the ultimate show business nebbish. He began his long career on radio before branching out to cartoons (*Popeye*, *Herman and Catnip*, etc.), films (*The Man with the Golden Arm*, *Hercules in New York*, etc.), and TV (*Texaco Star Theater*, *Top Cat*, etc.).

HERKIE STYLES (1921–1986) A crowd-pleasing nightclub comedian in the '50s and '60s, he also appeared on many TV shows, including *The Dick Van Dyke Show*, *The Addams Family*, and *Gomer Pyle*. In the 1960 Jerry Lewis film *The Bellboy*, he played the role of "Herkie."

MAURICE TILLET (1903–1954) A Russian-born French wrestler of the 1940s and early '50s, who was known as "the French Angel." Cover art for *Mineshaft*.

RON TURNER (1940–) Fez-wearing, founding publisher of Last Gasp of San Francisco, aka Baba Ron. Drawn to accompany Turner's introduction to *Slow Death Zero* (Last Gasp).

"TV SOUL" (1966) The 1966–1967 prime-time lineup marked the first season in which every show across the three major networks (ABC, NBC, and CBS) aired in full color. Four of the shows that debuted that year — *Star Trek*, *Batman*, *The Monkees*, and *It's About Time* — became ratings hits. Adapting the iconic cover for the Beatles' album *Rubber Soul* (released in December 1965/charting in early '66), this image features Mike Nesmith of *The Monkees*, Adam West of *Batman*, Joe E. Ross of *It's About Time*, and Leonard Nimoy of *Star Trek* channeling the Fab Four. (Lettering by Phil Felix.)

WILLIE TYLER (1940–) & LESTER Tyler was the most acclaimed Black ventriloquist of all time, performing on tour with popular Motown musical acts of the '60s and later in nightclubs and on television. He's the subject of an upcoming documentary about his life and career, titled *Hello Dummy!*, which was his dummy Lester's signature greeting for his partner Willie.

MARY TYLER MOORE (1936–2017) & DICK VAN DYKE (1925–) Dick Van Dyke and Mary Tyler Moore embracing as loving couple Rob and Laura Petrie of *The Dick Van Dyke Show*. Private commission.

KURT VONNEGUT, JR. (1922–2007) A novelist, playwright, short story writer, humorist, essayist, satirist, science fiction icon, philosopher, "frustrated idealist," and wry observer of American society.

JACK WAKEFIELD (1924–2010) A Borscht Belt comedian who performed in Catskill resorts for more than 50 years (recording an album live from the Concord Hotel, *Jack Wakefield Takes Concord*). He also opened for

Sammy Davis Jr., Engelbert Humperdink, and other top stars. He appeared on Broadway with Buddy Hackett in *I Had a Ball* and played Robert Petrie's boss "Alan Strudy" on Carl Reiner's original TV pilot (Reiner played Petrie) for what would later become *The Dick Van Dyke Show*. For *Mineshaft*.

RUSTY WARREN (1931–2021) Real name Ilean Goldman, she was a bawdy 1950s–'70s nightclub comic. Her act was too racy for her to appear regularly on television, and her best-selling records, among them *Sin-Sational*, *Knockers Up*, and *Bottoms Up*, rarely received airplay. Still, she was an immensely popular comedian.

JOHN WATERS (1946-) The cult cinema living-legend from Baltimore, his early films include *Mondo Trasho*, *Pink Flamingos*, and *Female Trouble* — all three featuring his friend, fellow Baltimorean Glenn Milstead, aka Divine.

MURRAY WAXMAN (1916–2006) For more than 60 years, a Catskill Mountains resort comedian, storyteller, and tummler who did everything required of the job: jumping into swimming pools in a tux, organizing bingo games, and singing and performing comedy schtick nightly, pulling audience members onto the stage. He moved from one now-defunct Borscht Belt hotel to another, among them Rubel's, Gibber's, Grossinger's, the Aladdin, and the Concord. Waxman: "I've closed more hotels than the health department." For *Mineshaft*.

WEEGEE (1899–1968) Arthur Felig, better known as Weegee, began as a news photographer in New York City, working on the police beat, where he specialized in crimes and catastrophes. He became one of the first photographers to truly capture New York's seedy underbelly — and overbelly.

"WEIRD AL" YANKOVIC (1959-) California teenager Alfred Matthew Yankovic was an accordion playing nerd who loved *MAD* magazine and *The Dr. Demento Radio Show*. When the Doctor made an appearance at Yankovic's high school, young Alfred passed him a cassette tape of his self-recorded song parodies and original music. On that day, mild-mannered Alfred Yankovic started his journey to becoming "Weird Al," the biggest selling comedy recording artist of all time. In 2018, Dr. Demento was on hand as Al was honored with his very own star on Hollywood Boulevard. Cover art for *The Illustrated Al* (Z2 Comics). —*Kevin Dougherty*

JOHN ZACHERLE (1918–2016) Aka Zacherley. He was a fixture of late-night television in the late '50s/ early '60s, a spooky sardonic monster of ceremonies whose chilling puns and weird sight gags inspired a generation of kids into taking a walk on the weird side. Zacherley was the Ernie Kovacs of TV horror show hosts. His gimmick of breaking into scenes of horror movies, all while mumbling brilliant stream-of-consciousness commentary, was groundbreaking entertainment for 1957. At the height of his fame, he received a thousand fan letters a week, and his personal appearances often erupted in riots. Zacherley was also a Top 10 recording artist, a late-night freeform FM disc jockey, and a sought-after emcee for gigs that often were bettered by his macabre touch. Cover art for *Filmfax* magazine. —*Irwin Chusid*

ALAN ZWEIBEL (1950-) An original *Saturday Night Live* writer, he has won five Emmy awards for his work in television, including *It's Garry Shandling's Show* (which he co-created and produced), *Late Show with David Letterman*, and *Curb Your Enthusiasm*. He's also written several films — *Dragnet* amongst them — and 11 books.

TERRY ZWIGOFF (1949-) Played cello in his friend R. Crumb's Cheap Suit Serenaders band and wrote a regular column offering advice to the lovelorn for Crumb's *WEIRDO* magazine. Zwigoff's first film was an hour-long documentary titled *Louie Bluie*. His follow-up was *Crumb*, a celebrated chronicle of Crumb and the cartooning legend's dysfunctional family. The film won the Grand Jury Prize at Sundance and earned citations and accolades from the New York and Los Angeles Film Critics and the Directors Guild of America. Zwigoff's next film was an adaptation of Daniel Clowes's graphic novel *Ghost World*, which became an arthouse hit. Zwigoff and co-screenwriter Clowes were both nominated for Academy Awards for Best Adapted Screenplay. His subsequent films were the black comedy *Bad Santa* and *Art School Confidential*. —*Irwin Chusid*

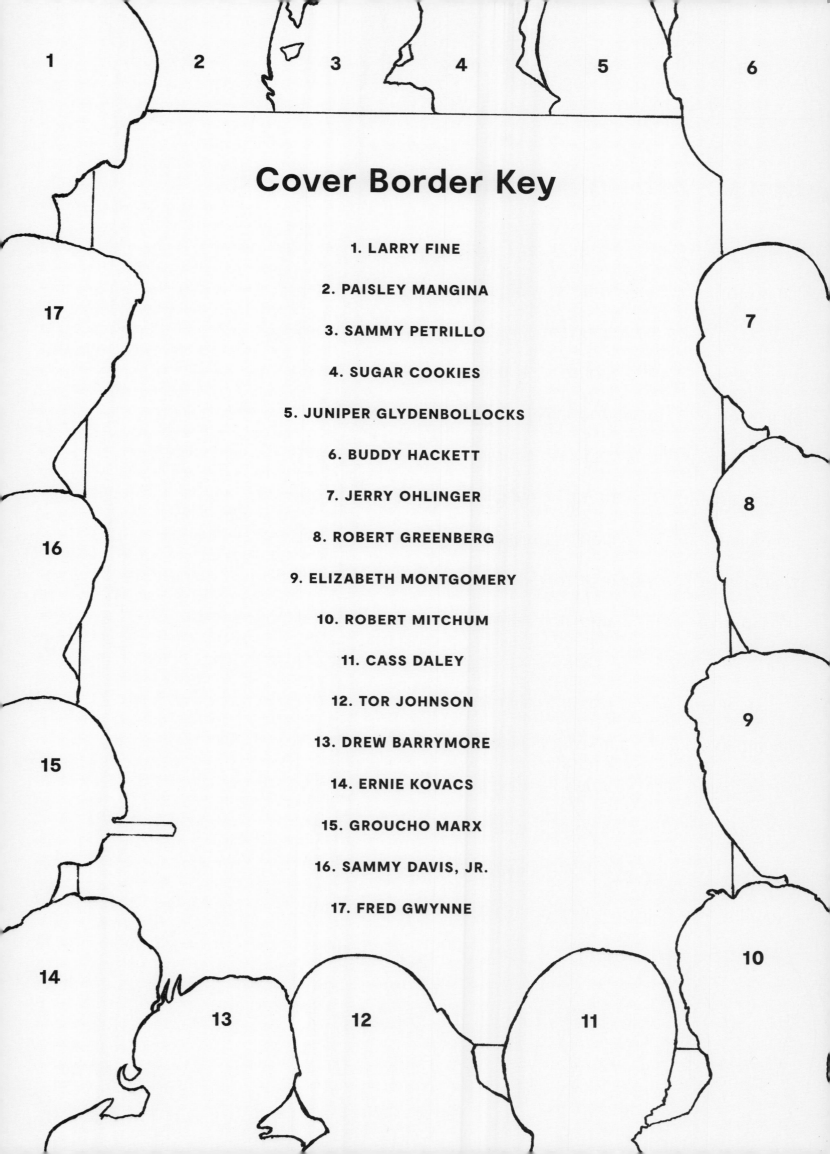

Cover Border Key

1. LARRY FINE

2. PAISLEY MANGINA

3. SAMMY PETRILLO

4. SUGAR COOKIES

5. JUNIPER GLYDENBOLLOCKS

6. BUDDY HACKETT

7. JERRY OHLINGER

8. ROBERT GREENBERG

9. ELIZABETH MONTGOMERY

10. ROBERT MITCHUM

11. CASS DALEY

12. TOR JOHNSON

13. DREW BARRYMORE

14. ERNIE KOVACS

15. GROUCHO MARX

16. SAMMY DAVIS, JR.

17. FRED GWYNNE

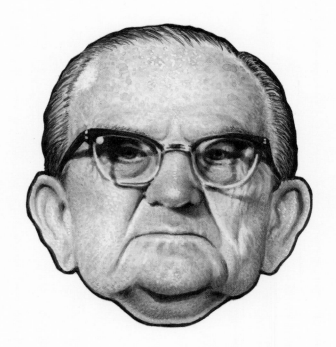

About the Author

DREW FRIEDMAN'S illustrations and comics have appeared in *RAW, Weirdo, BLAB!, Heavy Metal, National Lampoon, SPY, MAD, The New Yorker, The New York Times, The New York Observer, The Village Voice, The Wall Street Journal, Rolling Stone, Time, Entertainment Weekly, Mineshaft, Air Mail Online,* etc., as well as art created for the covers of numerous books, CDs, DVDs and prints.

In his *New York Times* Book Review of Friedman's *Old Jewish Comedians,* Steven Heller wrote: "A festival of drawing virtuosity and fabulous craggy faces. Drew Friedman might very well be the Vermeer of the Borscht Belt." The Society of Illustrators hosted a main gallery showing of Friedman's *Old Jewish Comedians* illustrations in 2014. The Billy Ireland Cartoon Library & Museum at Ohio State University held an exhibition of all the artwork created for his book *All The Presidents* in fall 2019.

Friedman is the author and artist behind 15 books and anthologies, the first two co-written by Josh Alan Friedman. His most recent book was *Maverix & Lunatix: Icons of Underground Comix.* A documentary about Drew Friedman's life and work, *Vermeer of the Borscht Belt,* directed by Kevin Dougherty, is coming soon. He lives with his wife, Kathy, and beagle, Dela, in an undisclosed location in these United States. Drew Friedman limited edition prints can be ordered at www.drewfriedman.net.

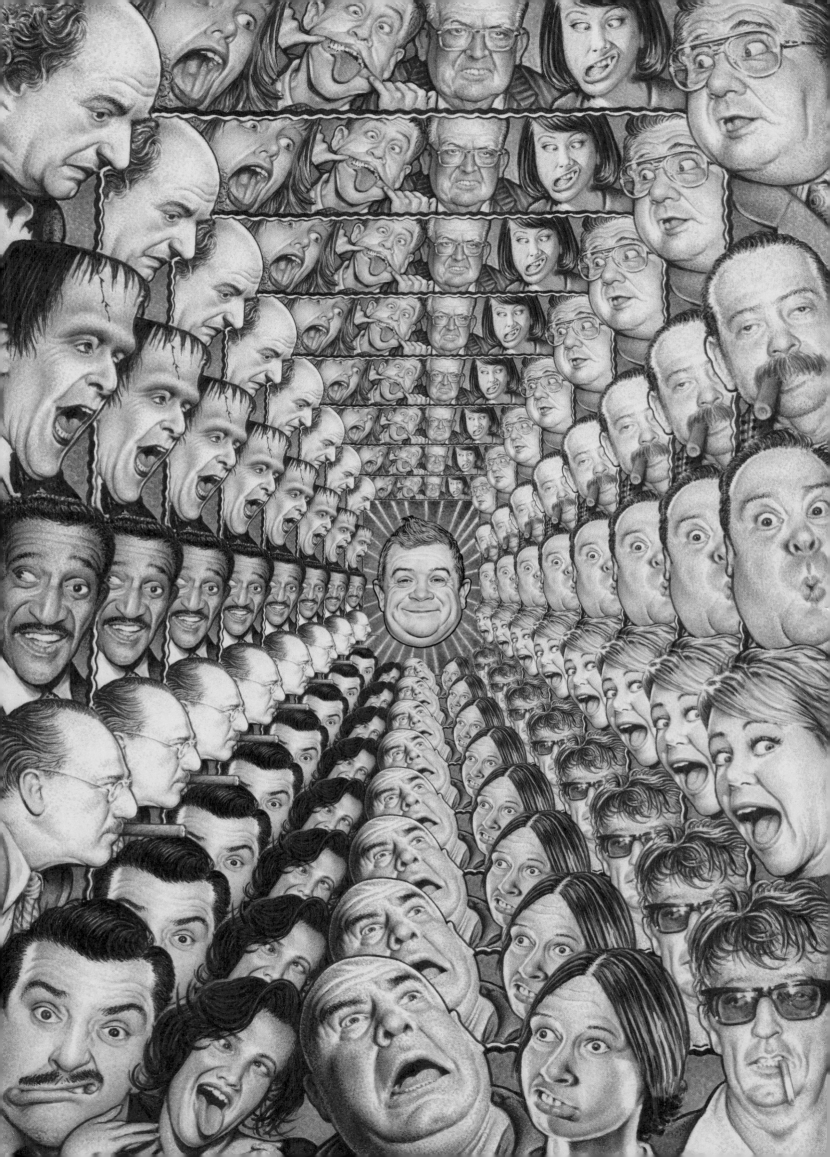